SHE'S GOT A GUN

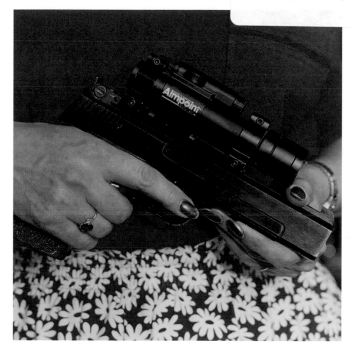

SHE'S GOT A GUN

NANCY FLOYD

TEMPLE UNIVERSITY PRESS • PHILADELPHIA

Temple University Press
1601 North Broad Street
Philadelphia PA 19122
www.temple.edu/tempress

Title page photograph: From the hand series, 1993-2007, by Nancy Floyd.

Unless otherwise noted, all illustrations are from the author's collection.

Designed by Kate Nichols

Printed in China

This book was printed on acid-free paper for greater strength and durability.

Library of Congress Cataloging-in-Publication Data

Floyd, Nancy, 1956-
She's got a gun / Nancy Floyd.
p. cm.
Includes bibliographical references and index.
ISBN-13: 978-1-59213-154-9 (cloth : alk. paper)
ISBN-10: 1-59213-154-9 (cloth : alk. paper)
ISBN-13: 978-1-59213-155-6 (pbk. : alk. paper)
ISBN-10: 1-59213-155-7 (pbk. : alk. paper)
1. Women—United States—History—Pictorial works 2. Firearms owners—
United States—History. 3. Shooters of firearms—United States—History. 4.
Women in popular culture—United States—History. I. Title.
HQ1418.F56 2008
305.48'96920973--dc22
2007018434

2 4 6 8 9 7 5 3 1

IN MEMORY OF JIMMY AND HIS DOGS,

WEAGLE THE BEAGLE AND FLEAPORT JAMES

CONTENTS

........................

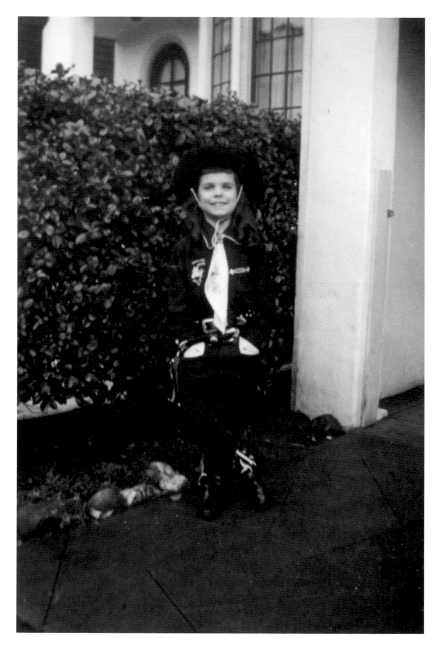

Cowgirl, ca. 1950-60.

[Silver gelatin print, 2 x 2 ⁵⁄₁₆" × 3 ³⁄₁₆".]

. .

ACKNOWLEDGMENTS

.........................

I'm deeply indebted to many people for their kindness and generosity over the course of writing this book. I'm especially grateful to the women who shared their stories with me, with a special nod to my old shooting buddies at the On Target Shooting Range in Laguna Niguel, California: Barbara, Margie, Lily, and Gail. They're the reason I found shooting so enjoyable. Gail and her husband, Tony, along with employees Mike and Rudy answered every gun question I asked with patience and in detail—and I asked a lot of questions. My pals Rick Steadry, Ken Slosberg, Robin Lasser, Constance Thalken, and Helena Reckitt were willing to take the journey with me for a while, listening to my stories, asking questions and supplying important insights about guns. Thank you, Jane Blocker, for getting me into this book-writing mess, first, by suggesting I turn my research into a book, and second by helping me begin the process. Richard Morrison of the University of Minnesota Press helped tremendously while I was working up an idea for an anthology. He offered advice and suggestions in many hour-long phone conversations. Once it was clear that an anthology wasn't possible, he encouraged and helped me to begin writing my own book.

I've received generous financial support over the years, including a University Research Initiation Award and numerous Ernest G. Welch School of Art and Design Faculty Research Grants from Georgia State University. In 1995, while employed at California State University, Long Beach, I received a Sum-

mer Stipend Award. An artist residency at Light Works in Syracuse, New York, and the Hambidge Center for the Arts and Sciences in Rabun Gap, Georgia, allowed for time away to photograph, work, and write.

Public affairs officers Paula J. Randall Pagán of the U.S. Army Marksmanship Unit at Fort Benning, and Lieutenant Jennifer Gerhardt and Captain Gary E. Arasin Jr. of the Moody Air Force Base gave me assistance with military information and access to servicewomen. Don Kates and Academics for the Second Amendment offered me the opportunity to participate in one of their weekend conferences, and I learned a great deal from those involved in gun politics.

I'm grateful to the gatekeepers of the museums, libraries, and archives where I did my research. You'll find a complete list of the collections in the bibliography, but I'd like to acknowledge a few people who gave me individual assistance: Dawn Letson, Tracey Mac Gowan, and Dortha Ocher (student assistant), Texas Woman's University Special Collections; Ginny Daley and Elizabeth Dunn, Duke University's Special Collections Library; Rosemary Haynes, Motion Picture and Television Reading Room, Library of Congress; Susan Strange, Kay Peterson, and David Haberstich, Archives Center, Margaret Vining Division of the History of Technology, Smithsonian Institution's National Museum of American History; Michael Roudette (General Research and Reference), Mary Yearwood (Photos and Prints), and Steven Fullwood (Manuscripts), the Schomburg Center for Research in Black Culture, New York; Bess Edwards, Annie Oakley Foundation; Darlene Platt, Marland's Grand Home in Ponca, Oklahoma; Rebecca Larsen Brave, Pioneer Woman Museum, Ponca City, Oklahoma; Lloyd M. Bishop, Ponca City Library; John R. Lovett, University of Oklahoma Western History Collection; Judy Shofner and Christina Stopka, Texas Rangers Research Center, Waco, Texas; Nathan Bender (former Housel Curator), McCracken Research Library, Buffalo Bill Historical Center, Cody, Oklahoma; and Lee Hockman, the Adams Museum, Deadwood, South Dakota.

It was a privilege to have readers review my initial proposal and the first draft of my manuscript. Their insightful comments, criticisms, and suggestions were extremely helpful. Micah Kleit has been a source of encouragement for the past three years. I'm thankful for his support and his belief in this book.

The interlibrary loan team of Georgia State's Pullen Library walks on water. Maggie McMillan, Jena Powell, Sheryl Williams (head), and Matthew Stembridge (student assistant), went above and beyond my expectations, continuing to search for citations long after I had given up and moved on. Valerie Gilbert,

Stacie Lindner, and Kristy Whitley were terrific graduate student assistants. They deciphered my scribbled notes, dutifully searched out all my obscure requests, and provided their own insights on materials and ideas for my book.

Identifying the types of firearms in the illustrations and photographs collected here proved to be difficult. Luckily, firearms expert Warren Newman of the Cody Firearms Museum kindly came to my aid, and I am deeply grateful. Emily Horton, who read through an early version of the manuscript, and Liz Throop, Joan Tysinger, Carolyn Bishop, and Lyn Bates, who read chapter drafts, gave invaluable criticism and suggestions. Jan Zita Grover traveled the last year and a half of the manuscript journey alongside me as friend, editor, and writing mentor. I've been influenced by her love of writing for more than twenty-five years. As is always the case in any creative endeavor, while many have helped me with my research, any errors in this book are my own.

My family has felt the greatest impact from my sixteen-year interest in guns. Cathy, Pam, Jaina, Donna, Dijon, Vanessa, and Amanda graciously agreed to pose in some early photographs. Mom and Dad, as always, supported whatever I did. Mom also provided much needed League City research, and Dad provided timelines and information about Jimmy and his guns. On the home front, Ripley, Fang, Spike, Pooh, and Andy kept me going late nights at the computer by reminding me to pet, walk, and feed, them. It's been a tough trail to blaze, this book writing, with mountain ranges, precipices, storms, floods, and unmapped trails along the way. I thank my pard Robin for his guidance and support.

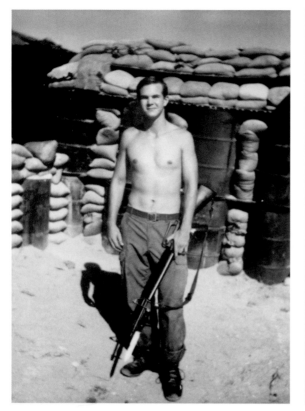

left: Jimmy with M-16, Vietnam, 1969.

[Polaroid, 2¾" × 3½".]

right: Nancy with M-1 carbine and Ruger SP101 .38 special, Southern California, 1994.

[Chromogenic print, 4⅝" × 7". Photograph by Robin Smith.]

............................

INTRODUCTION

.........................

On June 30, 1991, I bought a gun. I did not buy it for self-defense, sport, or hobby. I bought it because I missed my brother. The catalyst was Desert Storm. People I knew were being sent to fight in Iraq, and this stirred up strong memories of Jimmy and the Vietnam War. An excellent marksman who had had hopes of becoming a gunsmith, Jimmy left for boot camp when I was nine and died in Vietnam when I was twelve—he was all of twenty-one years of age. Guns were always a part of his life. I bought my gun because I wanted to understand what he loved about firearms. By doing what he loved most, I thought I might learn more about him.

I bought my revolver out of curiosity, with no intention of becoming a long-term gun owner. I had ideas of what gun people were like, and I wasn't going to become one of them. I thought I would shoot for a while and then sell my gun. This didn't happen. I grew to enjoy shooting for a number of reasons; being in the company of gun women played a major role. I enjoyed target practice—shooting at paper targets and learning how to improve my skills. My gun range welcomed women, and a few of us formed a club and met weekly to shoot. Nothing formal. We talked about our accomplishments and failures, and we encouraged each other. We even invited a female police officer to talk to us about her experience as a cop, and some of us took a shooting class together. I found myself hanging out after practice, talking about different types of firearms.

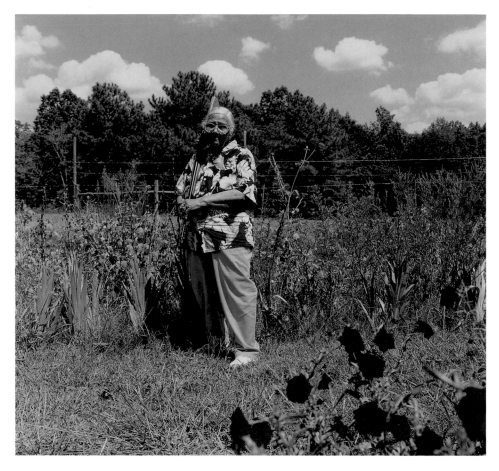

Maggie C. Brown in her garden with her Remington Single Shot .22, Farmington, Georgia; 1997.
[Chromogenic print. Photograph by Nancy Floyd.]

Maggie Brown: My mother had eleven children. I'm the baby. The youngest sister left home when I was eight years old and I grew up with my brothers. They would take me hunting and they got me a .22 rifle. We'd hunt sometimes two or three times a week. And I finally learned how to shoot as good as they did, even better.

...........................

Off the range we didn't know each other, but on the range we were a small collective with a focus. Our group was not an anomaly: around the country, in various places, women shooters in the 1990s were seeking the company of other women and looking for information and training to meet their needs.

The first year I spent with my revolver I read everything I could find on guns, including *Women & Guns* magazine (1989 to present) and Paxton Quigley's best seller, *Armed and Female* (1989). *Thelma and Louise* (1991) and *Terminator 2: Judgment Day* (1991), new movies my gun friends and my feminist friends

INTRODUCTION

talked about, provoked debate over definitions of self-defense and the reasons behind Hollywood's increased interest in armed female characters. Because my own documentary projects as a photographer often included research about social or cultural issues, armed women interested me, and in 1993 I began interviewing and photographing some of the women I met at the range.

I was curious—I wanted to know who these women were and what motivated them to pick up a gun. I wanted to know how they handled their difference at a mostly male shooting range, police precinct, or military base. Where did they get their training? What kinds of guns did they shoot? Even the clothing they wore and the types of carrying cases they chose interested me. Why were they entering, in many cases, troubled waters where "no women allowed" signs were posted in most people's minds?

My interviews and photographs evolved over the years, moving far beyond my initial gun range contacts. Since that first visit to the gun range, I've conducted more than fifty interviews and made portraits of women from California, Georgia, New York, Massachusetts, South Dakota, and Wyoming, and I've amassed hundreds of photographs of gun-related activities. While a few of these women are well known in the gun world, most are not. They come from all walks of life, and their stories include those of a woman whose grandmother was killed by an intruder, an eleven-year-old girl competing in her first gun competition, and a woman who experienced firefights in Iraq.

By the second half of the 1990s I was traveling to archives and libraries to further my research. Because of my interest in visual materials, I focused on the period from the Civil War to the present. Since the mid-nineteenth century, advances in publishing and photographic technology have allowed stories, photographs, and illustrations of armed females to be circulated widely in the popular press, in fiction, and in advertising. For the past 150 years American women have acquired guns for hunting, competition, and self-defense. They've gone to war, some by cross-dressing, and they've joined police departments when allowed to. Because their actions are still contrary to standard notions of femininity and female behavior, these wives, abolitionists, feisty girls, rioters, suffragists, feminists, and military wannabes have often been thought of as curiosities, novelties, and, sometimes, freaks of nature. These women, especially those who bucked oppressive systems or chose their own path, regardless of the challenge, captivated me.

The gun I bought in 1991 was a revolver, a Ruger .38 Special. After the fifteen-day waiting period required by California law, the gun became legally mine, even though I had never before owned or fired a firearm. For six months I flinched with each trigger pull; a year passed before I knew that I was keeping my gun, and

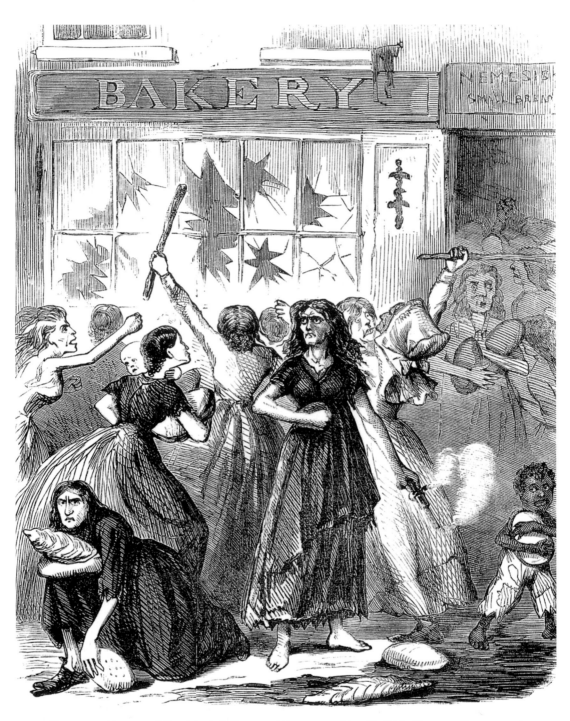

"Sowing and Reaping." *Frank Leslie's Illustrated Newspaper*, May 23, 1863. This is an illustration of Confederate women during the Richmond Bread Riot of April 2, 1863. The Richmond riot was one of many that occurred during the war, when local food supplies ran low in the south.

[Reprint courtesy of Special Collections, University of Virginia Library.]

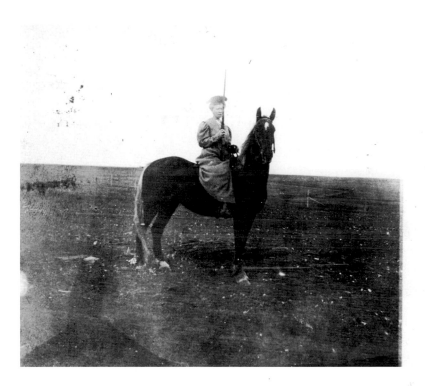

Woman with rifle on horseback, 1907. "Hello Grace. Here I am ready for a chase…"
[Real photo postcard, 3½" x 5⁷⁄₁₆".]

. .

Mocassin Bill's Daughter, ca. 1870–1920.
[Stereo view card. Reprint courtesy of the Robert N. Dennis Collection of Stereoscopic Views, Miriam and Ira D. Wallach
Division of Art, Prints and Photographs, The New York Public Library, Astor, Lenox and Tilden Foundation.]

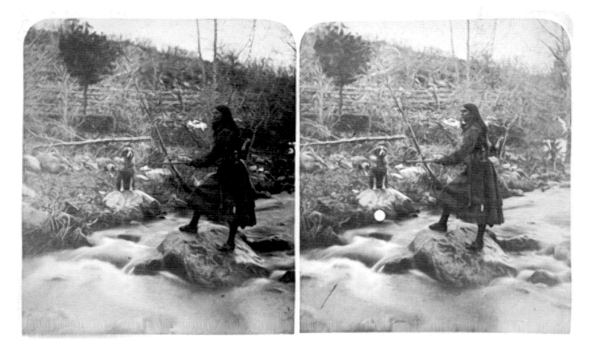

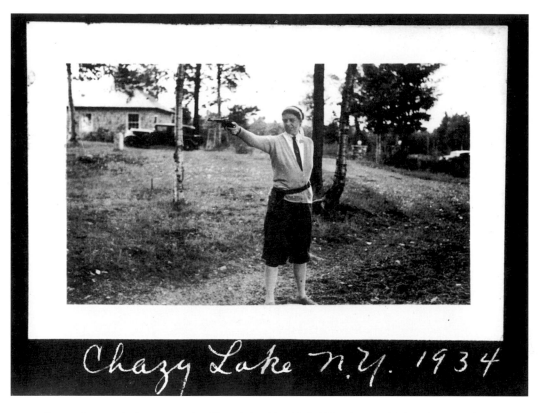

Chazy Lake n.y. 1934

Eleanor Roosevelt shoots pistol at Chazy Lake, New York, 1934. Roosevelt's handgun may be a Smith & Wesson .38 Military and Police Model 1905, 4th change.

[Silver gelatin print. Reprint courtesy of the Franklin D. Roosevelt Presidential Library, Hyde Park, New York.]

According to Roosevelt biographer Blanche Wiesen Cook, Roosevelt "came to enjoy target practice, especially in the country, on an open range, where she wore a holster and shot from the hip." —Blanche Wiesen Cook, *Eleanor Roosevelt, Volume One, 1884-1933*, p. 431.

..........................

Three women with pistols and one woman with what may be a 12-gauge pump shotgun, and hidden man, ca. 1908-1918.

[Silver gelatin print, 5 1/8" x 3".]

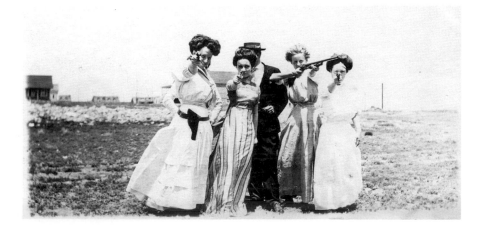

I needed three more years before I knew I wanted to shoot competitively.

When Mother learned that I wanted to enter competitions, her response was, "Just like Jimmy." And on the surface, it did seem as though I were following in my brother's footsteps. But there were significant differences: my interest in guns has not erased my ambivalence and, at times, my contradictory feelings toward firearms. Unlike Jimmy, I do not like John Wayne movies, nor am I interested in hunting. Additionally, because I am a woman, I cannot blend in easily at a gun range, and I cannot ignore the sexism and malevolence that sometimes erupts when women attempt to enter a male environment.

Culture and upbringing play an important role in my overall thoughts about firearms. I grew up in a small Texas town in the 1960s and 1970s, in a time and place where hunting was common and rifles decorated many pickup interiors and the walls of many homes. Most prepubescent girls I knew, including me, owned a cowgirl outfit. Some of our costumes came with a sidearm. For years, my brother, sisters, and I played shootout with the neighborhood kids; our arsenal included popguns, cap guns, rubber-band guns, and water pistols. I even owned a glass gun containing candy that I sucked out through its barrel. Before Jimmy left for Vietnam, it was common practice for him and his best friend, Wesley, to practice quick draw, emulating *Gunsmoke*'s Marshal Dillon. I was impressed by their mastery.

My family watched TV Westerns while I was growing up, even though Dad was often quick to editorialize, pointing out that the horses weren't breathing heavily after a long chase, or remarking on the amazing ability of the cowboy to be so well groomed after living on the trail for a month without a bath or change of clothes. My brother, sisters, and I were under the spell of the mascu-

left: Joy Wasson playing with younger brother Charles on Christmas Day, ca. 1962.
[Chromogenic print, 3″ x 3″. Reprint courtesy of Joy Wasson.]

right: Joy Wasson at her grandparent's house, ca. early 1960s.
[Silver gelatin print, 3″ x 3″. Reprint courtesy of Joy Wasson.]

Joy Wasson: My parents saved a letter I had written when I was about six. It read 'Dear Santa: I want all of these,' followed by pictures of every toy gun in the Sears catalog. I had cut out rifles and pistols and pasted them down, hoping I'd get my very own arsenal for playing cowboys with my little brother. Santa was good to me and gave me a toy rifle and the western wear to go with it. In the very gender-specific "wish book" I was always craving the boys' stuff—which appealed to me much more than dolls ever did. It amuses me now that I was so into playing with guns since I became a pacifist and very anti-gun as soon as I got a little older.

..........................

line, gun-toting persona projected by many of the actors, but we also laughed at our heroes because Dad's critiques were in a language we could understand. His disparaging comments allowed me to see the absurdity in our melodramas, but they did not stop me from experiencing the excitement of an action-packed Western. Until my brother's death, bravado excited my fancy.

I'm not quite sure why unsupervised twelve- and thirteen-year-old boys were allowed to travel around the town I grew up in carrying .22 rifles, but my one and only real fistfight occurred when I caught my enemy and his friends shooting birds in the pasture where I kept my horse. While many places in

and around League City were designated for hunting, horse pastures were not among them. I didn't like my nemesis shooting birds, and I didn't like his rifle carelessly pointing in the direction of the horses in the distance. It never crossed my mind that he might point the rifle in my direction. I chastised him for improper handling of a firearm; his cocky attitude toward my criticism made me angry, and I challenged him to a fistfight. There are two explanations for my fearlessness: I saw no connection between Hollywood portrayals of armed bad guys and armed boys from my neighborhood, and I was a bit naïve. Luckily, after a brief heated argument, my enemy disarmed and we proceeded to slug it out bare-fisted.

Like many Texas families, mine visited the Alamo, and I learned about heroism and fighting until the last man falls. Like all American schoolchildren, I studied the American Revolution in history class, with teachers and textbooks stressing the importance of the militia and armed rebellion. We were also told that the North won the Civil War because, among other things, Northerners had better access to artillery, rifles, and revolvers. In government class, the militia came up again when we learned about the Second Amendment to the Constitution. Then as now, American children were taught that our victories over belligerent and evil foreign foes were due to America's democracy and superior firepower. American history is loaded with stories of armed resistance.

In the late 1960s and 1970s I occasionally watched *The Avengers* (1961 to 1969), *Policewoman* (1974 to 1978), and *Charlie's Angels* (1976 to 1981) on television, but footage of female Black Panthers and other armed women on the nightly news made the biggest impact on me. Women angry with America surprised and interested this "peace, love, and understanding" antiwar teen.

In 1979 and again in 1986, Sigourney Weaver's supertough character in *Alien* and *Aliens* won my emerging feminist heart. Ellen Ripley was smart, tough, powerful, and she could save herself. She also looked really good in her underwear, and she loved her cat. I'd fight aliens with her any day.

What I didn't know at the time was that while Hollywood's armed women entertained Americans, police and military women were fighting for economic parity in precincts and bases across the country. These women had advantages their previous sisters did not—the feminist movement had influenced mainstream attitudes about equal opportunity, and the 1972 Amendment to Title VII of the 1964 Civil Rights Act mandated equal access to jobs in both the private and the public sectors. Also helpful were understaffed police forces and a volunteer military looking for more recruits. Letting women in was one thing, but allowing them opportunities on par with men was another. Female cops

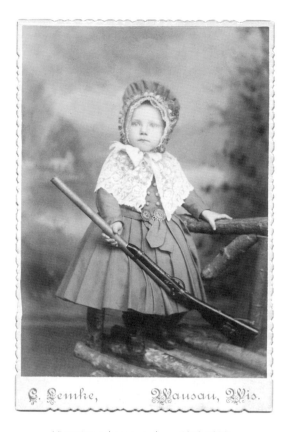

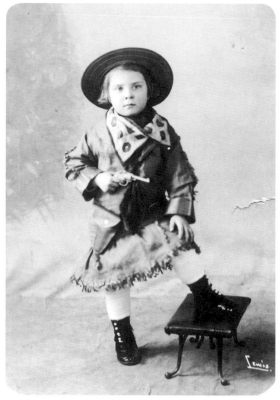

Victorian cabinet card, ca. 1860-1900.

[Photograph by Carl Lemke, Wausau, Wisconsin. 4¼" × 6½".]

Studio portrait of cowgirl, no postmark, ca. 1909-18.

[Postcard by Louis. Real photo postcard, 3⅜" × 5⅜".]

and servicewomen still threatened manhood, masculinity, and definitions of the American warrior. And while women were needed in the military, America was not quite ready to let them fight and die in combat.

During the 1980s, women who exerted power and influence impressed me: a friend joined the police force, gun-toting feminist politician Ann Richards was elected governor of Texas, and the television show *Cagney and Lacy* (1982 to 1988) featured strong female characters using their intellect, their skills, and, on occasion, their guns to catch the bad guys.

Americans had become increasingly preoccupied with gun violence by the 1990s, with activists for and against gun control taking to the airwaves to promote their points of view. No one seemed to want to compromise. The National Rifle Association (NRA) and other pro-gun groups worked to ensure that all law-abiding citizens could arm themselves and carry weapons whenever and wherever they felt threatened. They opposed the passage of the Fed-

eral Violent Crime Control and Law Enforcement Act of 1994. Among other things, the act banned certain types of firearms and set limits on the number of rounds allowed in magazines. With a Democratic Congress in power throughout much of the 1990s, the NRA's supporters grew increasingly concerned about further firearm restrictions.

Antigun groups saw things differently. With upward of thirty thousand deaths by firearms a year—half by suicide—and children taking guns to school and using them on their peers, with gang activity and workplace shootings receiving persistent media attention, they were outraged to discover how easy it was to acquire firearms. The topic of firearm possession became a media frenzy.

Like other groups in the 1990s, the NRA became interested in gun women (female NRA members played a significant part in this) and targeted women for the group's own agenda. At the NRA's 1995 annual meeting in Phoenix, Arizona, for example, I was encouraged by some male members to become active in the organization. At an evening banquet, I was informed by the man sitting next to me that I could become a powerful woman if I were to head an NRA chapter in California. Unfortunately, I didn't get a chance to find out what kind of power he thought I might acquire, because our honored speaker of the evening was introduced just then. Per-

haps my friend meant that I could chair local meetings with a couple of Colt .45 revolvers at my side, looking cool and well equipped. If someone got out of line, I'd just shoot 'em—after all, starting fistfights was now in my past.

Women in the NRA were no joke, however, and their presence was all the buzz that year for two reasons. Marion Hammer became the NRA's first female president (1996 to 1998), reigning a few years alongside the executive director of the NRA's Institute for Legislative Action, Tanya Metaksa (1994 to 1998). For the first time in its history, the NRA leadership included a public female face. These two strong women had battled in the trenches with the

..............................

Girl with flintlock muzzle-loading musket, ca. 1911.
[Silver gelatin print, 3 ⅛" × 5 ⁷/₁₆".]

men for years and were now coming into their own. Even while my political views collided with theirs, I was impressed by their fortitude and their influence on other women—I'm pretty sure it wasn't an easy job being female figureheads in the NRA.

The NRA leadership became the butt of many antigun jokes because of its efforts to recruit more women. Leaders freely admitted that they needed us to join because female members would improve the group's weakened image as an all-American family organization. I was disappointed that one of the oldest, most conservative mens' clubs in America didn't want my membership because of my pleasant personality, excellent shooting skills, and ability to get along with others. Even though women were active within the NRA, the organization certainly wasn't known for embracing women's particular needs.

Now as then, while the NRA keeps trying to get our memberships, antigun leaders tell us that we're being duped by the gun industry, that we're being sold a false sense of security, and that armed women will further break down the safety of our society. I interpret this antigun argument to read: women who choose to own a gun are really dumb and need help making decisions when it comes to issues involving violence and men's toys. Antigunners seem especially critical of gun women with children, which in turn angers many gun moms for good reason. As Sharon Higashi forcefully asked me in an interview in 1996,

> Why is that line drawn, the line that says I can have all this dangerous stuff in my home: knives, poisons, a swimming pool, a car, but not a gun? You can depend on me to teach my children not to drink the bleach, not to stab themselves with a knife, and not to use the power saw on themselves. So why is it when it comes to firearms all of a sudden I'm an inept bimbo?[1]

My journey into armed citizenship began around the same time that women with guns became front-page media fodder. While pro- and antigun groups were going at it in Washington, women with firearms were being "discovered" by the press, and gun-toting women of all types and backgrounds were being paraded on talk shows and news programs, explaining to stunned audiences why they owned firearms. Usually an antigun spokesperson or a woman with a bad gun experience would be trotted out alongside a pro-gun woman. "Balance" was the host's excuse, but it was hard to get good information, because the strategy on each side was to deliver the best sound bite.[2] Mean-spirited low blows and a confusing barrage of statistics proving that everyone in the room was right didn't help. For example, the antigunner would state the number of people killed that

year by firearms, and then the pro-gunner would state how many lives had been saved that year with firearms. Or one would give a personal story about a firearm tragedy and the other would tell a tale of survival thanks to a firearm. Complex issues were raised occasionally, but the dog-and-pony shows informed no one. Stories and opinions about these women appeared in both popular and academic journals, with politicians, gun lobbyists, feminists, and antigun groups weighing in. Guns are a part of American culture, yet many people seemed surprised and concerned to learn that more than 10 million women were armed and that some aspired to careers that require the use of firearms.[3]

While Americans were battling over arming or disarming on the home front, a war abroad was changing our understanding of women who wanted equal access to traditionally male professions. For the first time in our history, large numbers of servicewomen, some trained in weapons and fighter-pilot roles, left their families to participate in the United States' first war with Iraq in 1991. More than thirty thousand female personnel were sent: some received medals; a few were wounded or killed.

A profusion of books and other publications about armed women began to appear in the 1990s. Mystery novels take top prize for true diversity in developing armed female characters. Today, mystery books come in all flavors and for every female audience: black and white, young and old, rich and poor, gay and straight. Popular history books include *An Uncommon Soldier* (1994), *Amazons and Military Maids* (1989), and *They Fought Like Demons: Women Soldiers in the American Civil War* (2002).[4] Books for self-defense enthusiasts include *Effective Defense: The Woman, the Plan, the Gun* (1994), *Not an Easy Target* (1995), and *Safety for Stalking Victims* (2001).[5] Books about women with guns include *Woman the Hunter* (1997), *Gun Women* (2000), *Women and Guns* (2001), *Silk and Steel* (2003), *Blown Away* (2004), and *Her Best Shot* (2006).[6]

In fact, the armed woman appears throughout our history—in pop culture, literature, criminology, sociology, military and police history, advertising, social history, and art. Sensationalist press coverage and political agendas merely made us a hot topic for a short time in the 1990s. Interest declined, however, once the stories began to repeat themselves, and most gun women's lives did not change dramatically, with the exception of police officers and servicewomen. The media frenzy ended, and the fact that some armed women continued to use their weapons wisely, some continued to use their weapons stupidly, and most we never heard from at all, apparently interested few people.

Sensationalist stories are nothing new, and sometimes it's fun to watch how far a scoop can go. But the media focused primarily on one question: did fire-

arms empower women or not? Such a simple question turned an individual who had made a complex decision to arm herself into a one-dimensional caricature. Across the spectrum of American pundits who made armed women a topic of discussion, conversations tended to focus more on the host's own baggage; women's own experience proved to be secondary, at best.

She's Got a Gun is about my experience with guns and some of the gun women I've met over the past fifteen years. I've combined this with a brief and select history of women and guns in America from the mid-1850s to the present. The women who interest me most, and the ones who figure most prominently in this book, are the ones who openly or clandestinely (e.g., women who cross-dressed in order to serve as soldiers) claimed their right to have guns for pleasure, power, or profession. Part I, "Pleasure," looks at the act of shooting at targets for recreation or in competition, as well as the act of watching shooting superstars and fictional gun women perform on stage, in an arena, on television, and on the big screen; Part II, "Power," looks at women who took up arms because they were concerned about personal safety and self-defense; and Part III, "Professional," looks at women who chose careers that require the use of a gun, including police officers and military servicewomen.

I begin with an introduction to firearms and my forays into shooting and becoming a gun woman. Chapter 1, "Guns 101" is part personal journey and part factual information about guns. It serves two purposes: it covers the ways in which my interest in and initial fear of my gun changed over time, and it explains to the uninitiated what shooting a gun and entering a gun range are like. Because the captions for many of the images in this book include the type of gun and the caliber and power of firearms that women use, "Guns 101" fills in gaps in experience and knowledge for people who don't own or use guns.

Over the years I've spent a lot of time talking with others about firearms. These conversations haven't always been pleasant, nor am I any more comfortable in the hot seat than most people. However, I have chosen to listen to those with whom I don't agree—some pro-gun, some anti, as well as many who fall in between—and by doing so, I've come to understand the complicated nature of armed resistance, personal desires, and fear. This book includes a journey through some women's lives and how they negotiate their choices as gun women.

Because I focus on gun issues relevant to the gun women I interviewed and photographed, some categories of gun women have not been covered. I've omitted hunters because there are many good books about female hunters—you will find these listed in the bibliography. I do include a few photographs and illustrations of hunters, however, because female hunters have been

represented in sports magazines, targeted by advertisers since the 1800s, and popularized in theater, film, and books. I have also omitted farmers and ranchers; female criminals; women anarchists (for example, the Montana Militia) and racists (for example, the Ku Klux Klan); women who commit suicide with firearms; women portrayed naked or seminaked with guns; and female characters in the video gaming industry and mainstream comic books.

The only women whom I discuss who handle weapons only occasionally or transitionally are found in Chapter 5, on self-defense; these are women who may possess weapons for defensive purposes only. I've included them because approximately two-thirds of American gun women have firearms for self-protection.[7] Another exception is female entertainers; I'm interested in their performance with a gun, how they are represented, and how their representation affects culture.

I've been a visual artist for more than twenty years, producing work that mostly reflects my own background and experience. In 1986, for example, I completed a memorial room installation about Jimmy and his death at the age of twenty-one (*The James M. Floyd Memorial,* 1985–86). In 1992 I completed a photo documentary on nuclear power workers and their families—at the time my husband was an instrument technician at the San Onofre Nuclear Generating Station in Southern California (*Nuclear Families,* 1988–92); in 2002 I completed a photo/video installation about the passage of time on both my body and my childhood home (*Weathering Time,* 1982–2002); and *She's Got a Gun* evolved out of my wish to revisit Jimmy's past and learn more about him.

Because of my interest in images and how they are used in our culture, *She's Got a Gun* is also a picture book. As a photographer and a teacher I grapple professionally with the power of images. Images of people, whether painted, photographed, or computer generated, are commonly constructed to tell us something about individuals. In the right context, the producer of the image is able to make us feel affinity with and compassion for someone we don't know or understand. The producer of an image can also exaggerate the image to tell half-truths or lies. The image can be designed to keep certain groups of people down while empowering others. Through the repetition of certain types of images in the mass media, what is socially and culturally learned comes to seem natural. For this reason, it is important to look at images critically and to analyze the types of messages they send about race, class, gender, sexuality, values, taste, and acceptable modes of behavior. One of my goals for this book is to look at how images of women with guns have changed over time, primarily in mainstream popular culture—from Annie Oakley to Foxy Brown to the slew of female action heroes seen today—and to make connections between these mass-produced images of

armed women and changes in our culture, which influence the way we think about women's ability to handle firearms in the real world.

We all assign a certain amount of veracity to photographs—that person was standing in that space in that outfit, she held her gun that way, and those are her belongings in the background. Like all artists, however, I am the creator of my images—I've chosen a particular style in an attempt to convey certain types of information to viewers. While my photographs may appear unmanipulated (as opposed to a collage, montage, or altered digital images), there is a formula to their construction. I knew in advance how I wanted my portraits to look: what camera angle to use, what type of lighting, and how I would place the women inside the frame. With rare exceptions, I positioned the camera at, or slightly below, the eye level of the subject (not too low, not too high), giving the viewer a straight-on view. The lighting is almost always diffused (no bright white spots or shadows), allowing detail in all parts of the image to show clearly. It's a flattering style of lighting, used heavily in studio portraiture to hide wrinkles and flaws in the face (due to a lack of shadows that can create texture on the skin). The women are centered in the frame, creating a sort of bull's-eye view, like a target. Because I prefer some collaboration with my subjects, I tried not to control their pose any more than necessary, encouraging them to guide me in the making of their images. I'd say things like, "Stand over there and hold your gun any way you wish," or "Show me your gun." This strategy didn't always work, because not all the women knew how they wished to be represented. When possible, however, their input was part of the process. In exhibition, the photographs are printed large, at least 15" × 15", because I want the viewer to spend time looking at the portraits and studying the subject's demeanor, her choice of gun, and her environment.

Excerpts from interviews with gun women either accompany my photographs or are included within the text of this book. While their statements are only a fraction of each thirty-plus-minute conversation, and while they're edited for sentence flow, I tried to pick out passages that reflected the sentiments or personality of the individual—something that stood out in my mind, something I wanted the viewer to know about them. What I hoped to produce was a series of portraits that others would find engaging both because of the straightforward manner in which the women were photographed and because of the individual stories they tell or the opinions they express. These women, like many of the historical women I write about, will tell you straight up—they have guns for pleasure, power, and/or profession.

I was not trained as a historian, and one of my challenges when looking at old newspapers and magazines has been to assess what I read in them about

women with guns. When I've been lucky, I have been able to find verifiable information to confirm the accuracy or inaccuracy of reported events or stories, but often the accounts I've found appear to have been created for commercial purposes—for example, to sell tickets to an event, to increase newspaper, magazine, or book sales, or to sway public opinion. After generations of storytelling, these tales begin to assume the aura of fact. Some stories contain no hint of truth, and I know it—they're complete fabrications, all facts be damned; that's entertainment! Even when the armed woman tells her own story, I'm not always sure of the truthfulness of her statements.

This question of truthfulness matters to me: I want to believe that the real Calamity Jane—not the one in dime novels—enjoyed all the drinking, men, and wild adventures she partook of, even though evidence seems to suggest that she was a loud-mouthed, disagreeable drunk for much of her life. She still has a lot to offer me as a historical figure, however, because of what she tells us about her life and what the press tells us about her. While I'll never know the "real" Calamity Jane and do not intend to romanticize her life, I'm nonetheless intrigued by the image of a woman in the late 1800s doing what she pleased at a time when most women's activities were highly restricted.

I focus on armed women who make up part of the American imagination, both the famous and the not so famous. By looking at women whom we find endearing (Annie Oakley), who excite us by their daring (armed professionals), and who scared people with their acts of defiance (Black Panthers), I have gained a complex picture of armed women in American history. Using pictures and text dating back to the Civil War era, I look at how armed women have positioned themselves within or against the mainstream culture of their time.

A woman with a gun is a powerful symbol in America. A woman who arms herself is often held up not as an individual but as an example of what women should or should not aspire to. Until the 1980s most armed women, both fictional and real, were a novelty, and both purposefully stayed within mainstream ideas of femininity and behavior, even while armed. Those who stepped outside the norm, asking for equal opportunities with men or behaving in a manner deemed inappropriate for a lady, were often ostracized, and in many cases demonized. For women of all backgrounds, the message was clear: society might accept a woman who armed herself to protect her children, but not those who wanted to be in charge.

Significant change for armed women came slowly through the first half of the twentieth century and gathered momentum in the 1960s through the 1980s. Gun women have always been around. However, by the 1980s

and continuing today, a new and seemingly diverse group of armed females, including myself, emerged on the scene. Some of these women became activists in the 1980s, taking on issues of armed self-defense, the opportunity to compete in sports, and better job opportunities in traditionally male professions. Change was upon the country, and one of the most notable changes occurred among professional women: servicewomen and police officers. The change was most visible among female military personnel because of two wars with Iraq. While some Americans still believe that women in war are a bad idea, military women didn't seem to agree: today, one out of seven of the troops in Iraq is female.

Military women have experienced many firsts in the past fifteen years, and their efforts have paralleled those of the first female police officers. Today, while both continue to battle for equal opportunities, servicewomen take part in firefights in Iraq and female officers walk beats fully armed and prepared to shoot if necessary. At the beginning of the twentieth century, shooting phenomenon Annie Oakley encouraged girls and women to shoot for recreation, to protect themselves, and to protect the home front should men be away at war; at the dawn of the twenty-first century, female professionals are encouraging girls and women to set their career sites higher and aspire to leadership roles in community or national defense, where they may be asked to shoot to kill.

This past Christmas my brother Tom told me about a conversation he had with Jimmy sometime between 1965 and 1967. Tom was home from college and Jimmy spoke about his attempt to make an automatic weapon out of a cheap, semiautomatic pistol as part of his practice to be a gunsmith. Apparently the first attempt to modify and install an auto sear (a part that makes the pistol fully automatic) had failed, and he was in the process of ordering a new part to try again. No one in my family remembers whether Jimmy was successful or not.

My knowledge and experience with firearms has expanded greatly over the years, allowing me to better imagine Jimmy sitting at the big oak desk in his bedroom. The table lamp is set close to provide adequate light, gun parts are carefully strewn on the surface before him, and the fragrance of gunmetal and oil permeates the air. His rifles rest on the racks close to the entrance of his room and his handguns are hidden in a box in the closet. A small bookshelf holds books and magazines, including the 1954 two-volume set of Funk and Wagnall's *The Modern Gunsmith* by James Virgil Howe and *American Rifleman* magazines published by the NRA. A marmot skin with head intact stares at

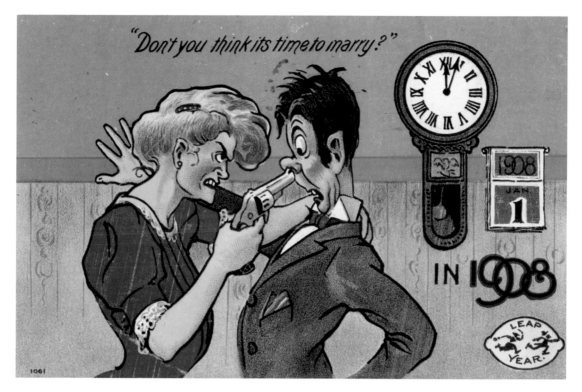

Don't You Think it's Time to Marry?, 1908.

[Postcard, 3½" x 5⁷⁄₁₆".]

............................

Two masked women, a rifle, and a man, 1933.

[Silver gelatin print, 4⅛" x 2⅜".]

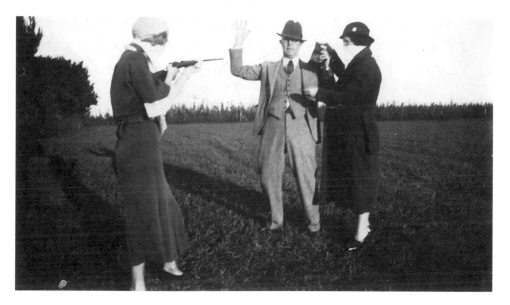

him from the headboard of his bed. There are other hides as well. I can picture the hours passing while a teenage boy with black-rimmed glasses focuses on the job at hand, undeterred by setbacks. You see, he was a perfectionist who loved altering firearms—and he was curious about everything related to his chosen craft. He worked hard to better himself as a marksman, hunter, and gunsmith, and while in Vietnam as a small-arms repairman. The last five months of his life he was a gunner on a Chinook helicopter. Yes, he was passionate about firearms.

I do know Jimmy better because I have guns, and I'll tell you more about this in Chapter 6. But I would like to disclose my most valuable discovery here. Not only do I share Jimmy's interest in guns; I've discovered that we share personality traits. Jimmy's enthusiasm for gunsmithing and his determination to alter the semiautomatic pistol is similar to what an artist must do: accept failure as important to growth. Like Jimmy, I can spend long periods of time without distraction while I'm taking photographs, printing in the darkroom, creating three-dimensional objects, and constructing my installations. I too am a perfectionist; my passion is making art.

Jimmy left home when I was nine. I didn't know him as one adult to another, but today, as a gun woman and an artist, I feel a deeper connection with him—Jimmy's essence will always be with me when I pick up a firearm or tell a gun story.

It's 1998. I decide to act out a Marshal Dillon pose—the stance he takes right before he draws his gun and shoots the bad guy on Dodge's Main Street. You know: hands at his side, elbows slightly bent, preparing to grab the pistol fast. I want to create a photograph of myself, an image that says, "Don't mess with MY town, you no-good scoundrel!"

The photo shoot is in my studio. Donning a black outfit and holster, with my Para-Ordnance P-16 race gun and high-capacity magazines, I endeavor to alter my countenance. I have no badge, but a string of pearls establishes my authority. I take off my glasses so the bad guy can see the whites of my eyes.

I stand on a black sweep. A mirror by the lens allows me to see what the camera sees. I go through poses swiftly. If I don't smile, I look mean, in a grumpy sort of way. If I smile, I'm too easygoing. If I try the squinty grin Dillon does so well, I look just plain goofy. Disappointed, I acknowledge that no one's going to pay attention to a grumpy, easygoing, goofy female marshal. Marshals like me get killed off in the first scene. After three rolls of film, I'm forced to

left: Cowgirl with rifle, ca. 1903-8.

[Embossed postcard with silk appliqué, 3½" × 5".]

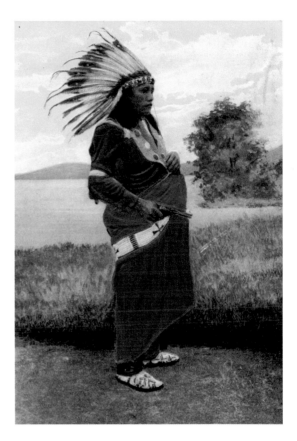

above: Pregnant Native American with revolver, 1907.

[Embossed satin postcard, 3½" × 5½".]

left: Cowgirl with revolver, ca. 1903-8.

[Embossed postcard with silk appliqué, 3½" × 5".]

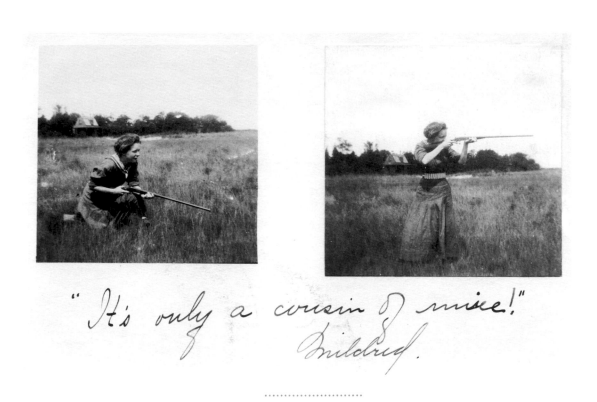

"It's only a cousin of mine!"
Mildred.

accept the truth: I will never have the tough look—the look that townspeople respect in Marshal Dillon.

I imagine Jimmy standing in front of a mirror posing like Marshal Dillon.

He certainly would look a lot more convincing. Jimmy would also practice his quick draw, trying to beat his own image in the mirror.

I imagine Dad catching us in Marshal Dillon poses.

He'd tell us the bad guy isn't going to participate in a fair fight. Bad guys aren't fair. More likely, the no-good thievin' varmint will hightail it out of Dodge, circle around, sneak back in, and shoot us in the back. No glamour or heroism in that.

I imagine me and Jimmy leaving Dodge, galloping off into the sunset on powerful steeds.

In our clean clothes, on our calm horses, we discuss the action-packed Western we're going to make. We'll create our own Dodge City, where Jim will be the fastest gun in the West, and I'll look tough, in a respected sort of way. Dad will be on the film's oversight and small-details committee. Because this is my fantasy, women will take the starring roles in our melodrama, experience lots of adventures, and own their own guns. Ripley, Thelma, and Louise will be featured. Aliens and truckers will be optional.

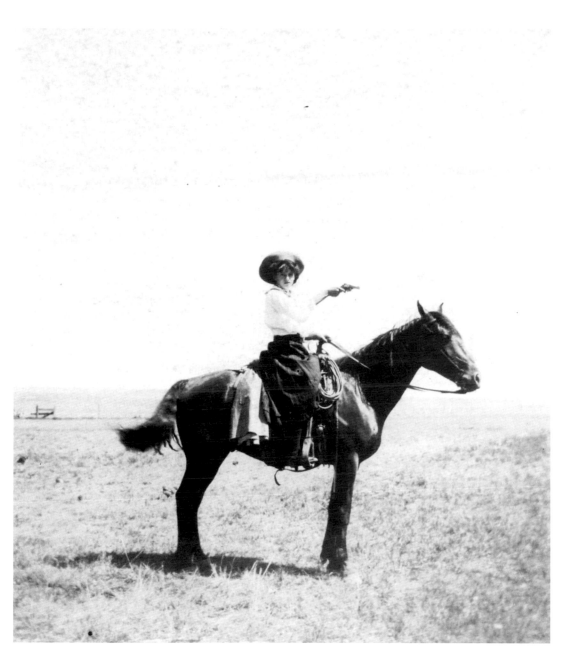

above: Inez, 1908. "Dear Friend:-Do you think you would run if you saw me now. Write soon, Your Friend Inez."
[Real photo postcard, 3 7/16" × 5 1/8".]

· ·

facing page, top: "It's only a cousin of mine!" n.d.
[Real photo postcard, 3 3/8" × 5 1/4".]

PLEASURE

SPORTS SHOOTING,
ENTERTAINMENT,
FICTION

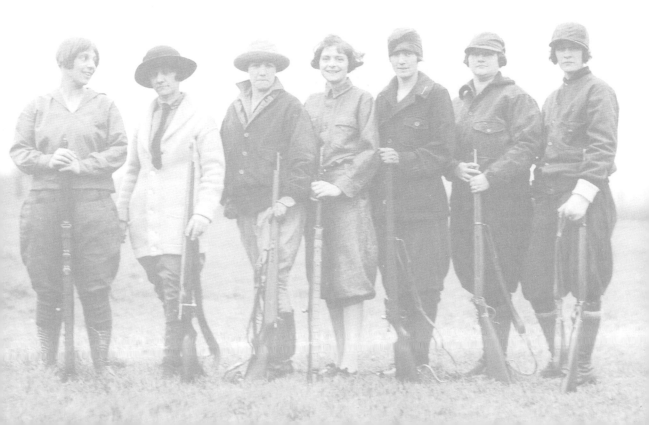

Lily Mendoza with .380 Sig Sauer, On Target Shooting Range, Laguna Niguel, California, 1993.

[Chromogenic print. Photograph by Nancy Floyd.]

.........................

previous page: Members of the Minneapolis Girls Rifle Team, ca 1923. The two women
on the right are holding Winchester Model 1885 single-shot muskets, chambered for the .22 long rifle cartridge.

[Reprint courtesy of the *Minneapolis Journal*, Minnesota Historical Society, image number GV3.53 r11.]

GUNS 101

..........................

I don't know why I wanted a semiauto. I knew right away I didn't
want a revolver—I didn't like the way it fit in my hand. Of course,
the people I talked to were all men, the ones who were selling the
guns. They wanted me to buy a revolver after they had me try all
the 9s and the 45s and even the .380, the Beretta.

They had me pull the slide to see if I could, and I couldn't. I'm
not strong enough. I couldn't pull the slide, and they were telling
me, "See, so why do you want a semiautomatic?" They were even
telling me to do weights first, before I buy a gun.

Anyway, I thought, if I'm not going to buy a semi, I'm not
going to buy a gun at all. Then one day I saw one .380 that looked
very nice, and I asked about it—even though the salesman was
pointing to the revolvers again. And I pulled it so easily. It's a Sig
Sauer, .380 caliber, seven rounds. It's very light. Actually it's number
one in that caliber, and very accurate. Because it's very light, it's
easy to use and easy to be comfortable with. It's important that you
know what your gun is and how to shoot it.

Lily, interview by author, 22 September 1993, Laguna Niguel, California

It is an understatement to say that it took me a while to get comfortable
with the gun I purchased in 1991. I was scared. However, in my first year of
shooting I learned a lot about firearms, gun people, and myself. This chap-
ter is about my experience with firearms and shooting ranges and includes
technical information for those who've never held a gun or wanted to shoot
one. While the reader needn't shoot a gun to gain an understanding of gun
women, basic information is useful for understanding some of the firearms
discussed.

The blast and recoil of my first handgun took me by surprise. Until the
moment when I squeezed the trigger for the first time, on 16 July 1991, my
instinct had been to run whenever I heard gunshots. I didn't know what to

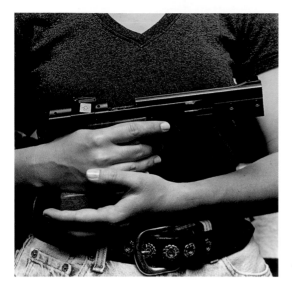
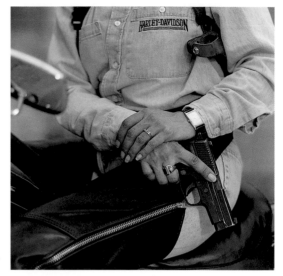
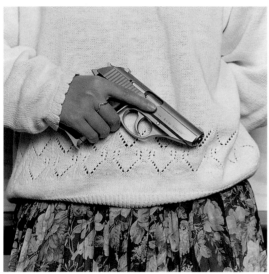
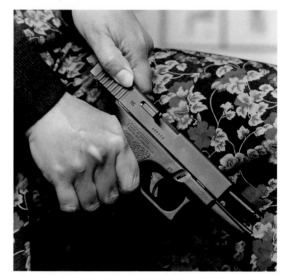

..........................

expect, but it wasn't fear. I'm sure the guy with the .44 magnum in the next lane didn't help matters: when he squeezed the trigger there was an explosive THUD, the walls vibrated, and I swear I saw flames—even with a four-foot-deep wall panel between us. Flames, blasts, and wall vibrations made it hard to concentrate. I flinched each time I squeezed the trigger, each time the .44 magnum guy squeezed the trigger, and each time I thought one of us was going to squeeze the trigger. I was a Mexican jumping bean during my first shooting lesson. All I wanted was to get through the fifty-round box of ammo as fast as possible and get the hell out of there. After forty-five rounds, I called it a day.

After the first three months with my gun I no longer worried (too much) about injury or death. I wish I could say that those first months were easy, that I became a pro, both fearless and confident, and that my eventual proficiency with a handgun, along with the proficiency of other people with their guns, made my fear vanish. Poof!

What happened instead was this: I became desensitized. I went to the range every week and shot two hundred to three hundred rounds of ammo at a pop. I didn't care if I hit the target; I just didn't want to flinch anymore. So I shot until I stopped jumping. At first, it took the entire two hundred to three hundred rounds, but after a few months it only took a hundred rounds. It wasn't just my own gun making me flinch; it was mine and everyone else's. I was seldom on the range alone. After six months, my flinch had become minimal, and I was tuning out most of the other shooters.

During those months of flinch-reduction exercises, curiosity began to replace fear. I was learning about different kinds of firearms, I was meeting women shooters, and I was asking women about their experiences with guns. I eventually began shooting with some of them, and pleasure began to accompany curiosity. Their enthusiasm for shooting wore off on me.

I've shot a lot of guns since 1991, from small .22 handguns to a fully automatic .50-caliber Browning M2 machine gun used in warfare. This is my story, and my experience with guns and ammo. It's about pleasure—the pleasure of owning and shooting a quality firearm at inanimate targets, and about power—the power of the bullet to tear through paper targets and (potentially) flesh.

Here's some of what I've learned over the years about guns, stopping power, and firing ranges. I prefer handguns. Handguns are sized by caliber—a measure

of the size of the hole in the barrel, in inches. So a .22-caliber handgun is a gun with a .22-inch-diameter barrel that shoots a .22-inch-diameter (more or less) bullet. Handguns come in many sizes, but basically small means .22 to .32 caliber, medium ranges include .357, .38, and .40, large is .45, and extra large are all magnum .44s on up, plus .50 calibers. I prefer small or medium. Large is too large. Extra large, forget it. Twenty-two-caliber handguns have little kick (felt recoil) or sound; and we gun people give them to children and skittish beginners so we don't scare them away their first time around. A .45-caliber bullet is almost half an inch in diameter; hence it fits a bigger, more powerful gun.

Magnum refers to a round with enough gunpowder to build extra pressure, giving the bullet more speed and power and making more noise when fired. For example, a .44-magnum handgun takes a smaller bullet than a .45, but it has a lot more gunpowder in the cartridge, making it more powerful than a .45.

When my brother went to Vietnam, he was issued a .45 ACP M1911 handgun. ACP stands for Automatic Colt Pistol Cartridge, and 1911, the model number, refers to a style of semiauto first introduced in 1911. The military used the .45 semiauto as its standard issue handgun until they replaced it with a 9mm in 1985. After more than seventy years of going it alone with the .45, the Department of Defense decided to join the rest of the world and have our military handguns chamber NATO's standard cartridge. A 9mm is equivalent to a .354 caliber, so it's not as powerful as a .45. Not all military personnel were happy with the change, preferring the .45's stopping power.

Back in 1995 I watched a woman at an outdoor range shoot an extralarge handgun: the .50 caliber Desert Eagle semiauto. The Desert Eagle is a monster, at least eleven inches long and six inches high, and weighs in at a hefty seventy ounces, unloaded, depending on style. This gun has a macho reputation and is used in shoot-'em-up action films like *The Matrix* and featured in hip-hop videos as the ultimate bad weapon. The woman I saw shoot the Desert Eagle didn't look like a female action figure, nor was she into hip-hop, as far as I could tell. She was a fifty-something woman, standing about five foot two. This small woman aimed the gun, leaned heavily forward to brace for the recoil, and squeezed the trigger. The front of the barrel jerked skyward, but because she had prepared for this, the force just pushed her backward after each shot. She laughed, stepped back into place, leaned in again, and shot. Over and over. I was wrong. Small, middle-aged women could be action figures, too.

Handguns come in two styles: the revolver and the semiautomatic pistol. The revolver is simpler to use and easier to understand. The modern revolver has a cylinder that swivels out from the frame of the gun, so the shooter can

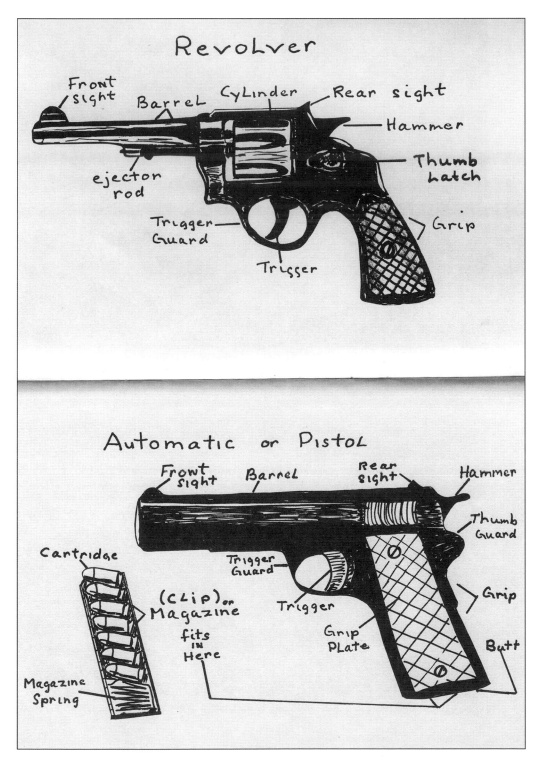

From *The Women's Gun Pamphlet: By and for Women*

[San Francisco: Women's Press Collective, 1975. 5 ½" × 8 ½". Used by permission of Judy Grahn.]

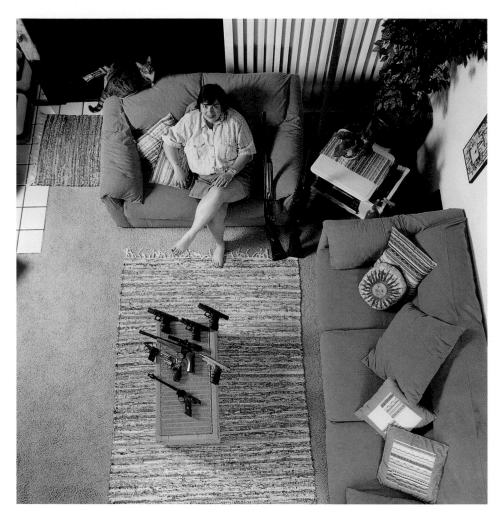

Susan Mokski-Earl, Orange, California, 1996. Firearms: Glock 17, 19, 20, and 26; Beretta 21; Smith & Wesson 60 LG and 1006; .22-caliber Hi Standard Trophy Match; T/C Thompson Center Arms; Browning BPS, and 20-gauge Goldhunter.

[Chromogenic print. Photograph by Nancy Floyd.]

......................

immediately see if the weapon is loaded or not. My first gun was a revolver; since I was new to guns and would be teaching myself to shoot after an initial training session, I thought a revolver was a good idea. Generally the revolver holds five or six cartridges, also referred to as rounds, in the cylinder. A few types of revolvers hold seven or eight rounds. I chose my particular revolver because it had a double action, which means that squeezing the trigger takes some effort, because during most of the trigger pull, the hammer is cocking before it drops onto the firing pin. The cylinder turns when the hammer is cocked, placing a live round in line with the barrel. I could use my gun in single

action mode if I cocked the hammer first, making the trigger pull much lighter, but I believed that having some resistance when firing a lethal weapon made sense. After firing, the empty casing was still aligned with the barrel. I liked knowing there wasn't a live round in the cylinder unless I manually put it there. The revolver's mechanical simplicity was its selling point.

I had also considered the semiautomatic pistol when searching for my first gun. Briefly. Being new to guns, however, I felt as if the semiauto had a life of its own. Basically, cartridges are loaded into a spring-loaded magazine and inserted into the butt of the pistol's grip. Then the slide on top of the pistol is pulled back. When let go, the slide slams forward, forcing a cartridge into the chamber. What concerned me was how the pistol works after a round is chambered. With each squeeze of the trigger, the bullet shoots out of the barrel, the slide racks back, ejecting the empty shell, and on return loads a new cartridge. Each trigger squeeze repeats this operation until the magazine is empty. It was the semiauto's automatic cocking that concerned me most, although the empty hot casings shooting over my head, occasionally hitting me, didn't help. At the time, the semiauto just seemed to perform too many actions without me.

The average weight of a handgun, unloaded, is twenty-five to thirty ounces. The most powerful handgun today, introduced in 2003, is the Smith & Wesson Model 500 revolver. With the standard barrel, the 500 measures fifteen inches and fires a .500 magnum round. This .50-caliber handgun weighs in at more than seventy-two ounces without ammo, and like most extralarge-caliber handguns, it's designed for hunting.

Caliber is only one indicator of a bullet's potential power. The power of a fired bullet is generally based on how much the bullet weighs, its shape, what it's made of, and how much gunpowder is used—the last determines bullet speed. If you're not familiar with guns, you can't know the precise power of a gun by its name alone. For example, there are guns that hold a .38-inch round, but the .38 Special and the .380 are not among them; these guns have the same bore diameter as the 9mm and the .357 handgun: .357 inches. If this kind of stuff drives you nuts, you're not alone. The .38 Special, .380, 9mm, and .357 all have the same casing diameter, but the length of the casing, the bullet size, and the shape vary. Basically, if you're interested in acquiring power, or in not having too much, you'll want to get to know a lot of gun terminology first.

How the bullet works is quite simple: a cartridge comprises a metal casing, usually made of brass, which holds the bullet at one end, a primer at the other end, and some gunpowder between them. The amount of the powder charge varies according to the cartridge type, the bullet, and the type of powder used. A

similar-sized bullet can have a different charge if used in a different casing. When a cartridge is loaded into the chamber or cylinder of a handgun, the bullet points away from the shooter. The cartridge primer is nearest to the shooter and contains a shock-sensitive explosive substance. On most guns, a firing pin is located in the body of the weapon, between the cartridge's primer and the gun's hammer. When the hammer is down in a resting position, a small piece of metal blocks the hammer from pressing on the firing pin. This means the gun will not go off if it's dropped. This is not the case with older guns, and without the metal plate, it's really scary when a gun is dropped. Bottom line: never drop a gun. The hammer is the lever at the back of the gun, and it starts the chain reaction. Once the hammer is cocked either by hand (single action) or by pulling the trigger (double action), the metal plate moves out of the way. When the trigger is squeezed, the hammer slams into the firing pin. The firing pin strikes the primer, igniting the explosive substance, which then ignites the gunpowder. Burning rapidly, the gunpowder builds up tremendous pressure and forces the bullet out of the cartridge and down the barrel. The barrels of modern handguns and rifles have spiral grooves running their length. The bullet follows the spiral, which makes it spin. This spin continues after the bullet exits the gun, stabilizing the bullet in flight toward its target. The muzzle flash (flame) of the .44 magnum and the .50 Desert Eagle is the excess gunpowder flaming when the bullet exits the gun.

The bullet is called the business end of a shooting cartridge. Bullets are generally made of lead and other metals (e.g., tin, copper, or steel), depending on the desired effect. There are different weights, shapes, and chemical compositions of bullets for different applications. Most bullets are made of a lead compound, though some modern bullets are lead free. A soft lead core allows the bullet to expand on impact. This is important in bullet performance. A full metal jacket bullet has a hard metal surface coated over a lead core. The jacket helps keep the gun barrel from getting dirty from the lead and also helps the bullet penetrate the target, if needed. Armor-piercing bullets are used in war. They have a full metal jacket, along with a hardened steel core inside the lead, for additional strength. This allows the bullet to penetrate steel. A wadcutter or semiwadcutter bullet is designed for shooting at paper targets. It makes a clean hole in a target because of its almost flat tip. Hollow points are used for self-defense and have an open cavity at the tip. When the bullet penetrates soft tissue, it expands out on the edges, creating a mushroom-shape. The bullet stops relatively quickly, because it's tearing up someone's insides. Police officers use hollow-point bullets because there's less chance the bullet will pass through someone to an unintended target, and if they miss their target, there's

less ricochet. Civilians also use hollow points: should the bullet pass through a bad guy's body, it won't go through the wall behind him, potentially hitting someone in the next room. Another reason for the hollow point's popularity is its superior stopping power. The bullet tears up internal organs and causes more blunt trauma, thereby causing more bleeding. Of course, physicians hate all gunshot wounds, but I'm told they especially hate the extra damage caused by self-defense bullets.

Stopping power is an arbitrary self-defense term used to describe the ability of a bullet to stop an assailant in his tracks. Over the years I've asked what stopping power means to folks, and this is generally the way it's described: Sure, a .22 can kill someone. However, he (and it's always *he*), will have to bleed to death, and while this is happening, he's still a threat. So if the bad guy is six foot three, strung out on crack (almost all self-defense scenarios have the guy on drugs), is really pissed off or crazy, and doesn't notice the gun in my hand (or realizes that my weapon is a "tiny" .22), then he may keep coming after I shoot him six times. Whereas a .38 or .40 is more powerful and fewer shots are necessary. And a .357 or .44 magnum or a shotgun is even better! We gun people are very dramatic with our descriptions. In the right environment, a cannon would also work well.

Some gun folks prefer shotguns to handguns for home protection, because shotgun shells contain small metal balls that spray outward when fired, so you don't need to aim quite as well to hit your target. People mistakenly believe you don't need to aim at all to hit your target, but that's not correct. Shotguns are sized by gauge. The number of lead balls with a diameter equal to the barrel size it takes to make up a pound determines the gauge. For example, twelve lead balls the size of a 12-gauge's barrel weigh one pound. A 12-gauge is a big shotgun with a good-sized kick. It's the most popular. Other gauges include 10, 16, 20, and 28. The smaller gauges are given to children and smaller people, but gauge really depends on the shotgun's use. For home defense, gun folks seem to prefer the 12-gauge, and for competition and hunting, 12- and 20-gauge shotguns are the most common. Shotgun ammo can contain other types of materials, but I'm not covering those here.

Rifles are primarily used for hunting, competition, and warfare. Rifle bullets work the same way as handgun bullets, but they come in longer cartridges and they contain a lot more gunpowder. More gunpowder makes the bullet spin incredibly fast as it exits the long barrel, stabilizing the projectile as it shoots toward the target. The bullets tend to be more conical in shape, creating less drag than rounded bullets. In essence, a bullet inside a pointy copper jacket, inside a cartridge with a lot more gunpowder, shot out of a long barrel, has a lot more

the form is really meaningless for that kind of litigation. But the meaning behind the signing is important: it's part of what makes the gun range different from, say, a tennis court. Sure, I can be injured on a tennis court, but death by direct hit of a tennis ball is unlikely. No one asks me to sign an injury waiver at a tennis court. In contrast, shooting is a serious endeavor. Mistakes can be costly at a range, so the job of the RO is to remind customers of the rules. By having customers sign waivers, by putting up signs about safe handling, by encouraging all shooters to help enforce the rules, and by kicking people out for unsafe behavior, most ranges achieve remarkable safety records, and injuries are extremely rare.

I enter or exit the shooting area by passing through a small room designed to muffle gun blasts. No one wants to shop, take classes, or chat about guns while wearing ear protection. This in-between room keeps the general gathering areas (customers, classroom, store for guns and ammo) relatively noise free. After I'm assigned a firing lane, I gather all my shooting paraphernalia and enter the in-between room. I shut the first baffled door behind me completely before opening the second one. If I forget, and both doors are opened, the blast enters the quiet zone. It happens. The in-between room is just a passageway. It varies in size, but it's generally just big enough to let two or three people in at one time.

Before passing through the first baffled door, I put on hearing and eye protection. When I was new to the range I would ask myself, "Are you sure this is what you want?" I tried to imagine myself as Ellen Ripley keeping the earth safe from aliens (*Alien,* 1979; *Aliens,* 1986), or V. I. Warshawski keeping Chicago safe from bad guys in Sarah Paretsky's detective novels. But it was hard keeping up my superhero fantasy. My mind drifted from imagining myself as a superhero to imagining myself as a gun range accident statistic.

Things are different today when I enter the in-between room with the baffled doors. Now I'm Ripley, Warshawski, and half a dozen other female action figures combined. I enter hoping for good groupings—bullet holes clustered tightly in one area on a target, hopefully in the area I'm aiming for.

The sound of gunfire is louder in the in-between room, for obvious reasons. Being in this room is like stepping into the transporter booth and standing frozen, waiting to be transported to another world in a *Star Trek* episode. I step into it, and then stand frozen momentarily, while door one closes before I engage door two. Opening the baffled door to the range usually requires a tug, because good ranges are thoroughly ventilated, and I'm fighting against the powerful air-return vents. When the door opens I transport myself into the shooting world of gunpowder residue, gun oil, spent casings, loud sporadic noises, and occasional flames from muzzle flash.

It's markedly different here. The range walls are generally bland: beige or gray with gray or black partitions (stall walls) between shooters. Rustic benches or tables with metal chairs run parallel to the firing line against the back wall. Brass and steel shell casings litter the floor. Conscientious shooters clean up often, but if the ROs don't stay on top of it, a few slobs can make the place a mess. The whirling sound of wind from the air ducts, even with ear protection, is noticeable.

Most people at ranges are shooting handguns, and a good number of them bought their handguns for self-defense. Handguns are popular for self-defense because they are easy to conceal and fit under a car seat, in a glove compartment, or in a handbag. For the same reason, handguns are also popular with criminals. When I'm at a range, I sometimes wonder about the other shooters and what they do for a living.

Indoor ranges are generally designed for handguns and small-bore rifles and are no more than twenty-five yards deep. If the range allows high-powered rifles, additional fortification for the wall(s) may be necessary to stop bullets from piercing the wall behind the targets. This is because a rifle bullet's velocity at twenty-five yards is much greater than a handgun's.

The number of lanes varies. Each is about four feet wide, with a small bench a little above waist height, just large enough to hold one or two handguns and ammo. Short walls, usually made of plastic but lined with steel, divide lanes. The walls protrude into the gun range about two feet and behind about two feet. In essence, the shooting stall is a four-foot wall on either side of the shooter. The height of the walls is around seven feet and the ceiling is generally ten to twelve feet.

My gun bag holds all sorts of stuff I use while at the range: my gun, ammo, hearing protection, little red dots to put on my targets, masking tape to repair the holes in them—I don't like wasting paper, so there are lots of holes in one target before I throw it away—a brush to clean out the grip of my semiauto if it gets gunked up, a few tools, and a red towel. My stainless steel Para-Ordnance P-16, purchased in 1997, looks good on red. I now own more than one gun, but this is my favorite. It's a 1911-style .40-caliber semiauto. The magazine holds sixteen rounds. Unloaded, it weighs forty ounces. The Para is big in my hands, but to me it feels just right.

I pile my case and targets on a table against the back wall. After removing my unloaded Para and red towel from my case, I cross the three to five feet to the firing line. Weapons are always pointed away from people when we walk to our designated lane. On the firing line the barrel of the gun always points downrange. The basic rules never change: always assume a gun is loaded, always keep the gun

pleasurable. My ears are muffed the whole time, so there's nothing to distract me—unless there's a .44 magnum or .50-caliber Desert Eagle on the range. I still don't like those guns being around.

The amount of time I spend on the range varies from thirty minutes to two hours, depending on when I run out of ammo or lose my focus. I return my unloaded Para to its case, collect the last of the casings, and exit the way I entered. I'm relaxed. I think about groupings and what I need to improve. After washing my hands with soap to remove lead and gunpowder, I pick up my driver's license, sometimes stopping to chat with an RO or another shooter, and leave. I can still hear gunshots as I drive out of the parking lot, and I hope they're coming from the firing line and not from a nearby neighborhood.

Outdoor ranges are usually located in rural areas because most people don't want to live next to them. I find them pleasant because of their relatively rural environment and the fresh air. Shooting stations tend to be spread out more, and there's more space to put your stuff. The gun blasts aren't as loud outside, either. Except for gunfire, it's quiet and peaceful. One particular outdoor range close to where I lived in Southern California was built in an unpopulated canyon, but by the time I left Orange County in 1996, the range's backyard had become a suburb. Some of the new neighbors were attempting to close the place, complaining about the sound of gunfire and the dangers of bullets going astray. I wonder what the new neighbors thought about the sounds of gunfire when they first checked out the neighborhood, walking through the model homes on a Sunday afternoon. Gunshots are loud and have a distinct sound. There's no evidence that the complaints shut the range down, but I haven't been able to find a listing for the range online, nor does their old number work anymore. If the range is gone, I hope it was because the value of the land escalated rapidly owing to the coming of the suburbs, and that the owners decided to make a profit on their real estate.

I shoot alone now. It's not my preference, but none of my friends in Atlanta are shooters. For me, shooting is a ritual, and I like everything about it. It brings me great pleasure to handle a quality handgun, train for better groupings, and occasionally enter a competition to challenge myself. I like shooting for many of the same reasons I like tennis. When I make a controlled shot on the tennis court and win the point from my opponent, I am exhilarated. As in tennis, if my body works right and my mind is focused while I shoot, my groupings come together. To be consistent on the court or at the range, I must keep mind and body together. It's always a challenge, and I like challenges.

I'm also easy with contradictions. Guns are not tennis rackets, and bullets

are not balls. I am an American with a gun, and with it come responsibilities. Michael Moore tells me this in *Bowling for Columbine* (2002), the NRA tells me this when gun bans or regulations are making their way through Congress, and the antigun group Handgun Control, Inc., tells me this every time a person is murdered or dies of a self-inflicted gunshot. I don't ignore any of them. I juggle different points of view and wrestle the issues about guns in America because I like the challenge—that's my nature.

It's also my nature to acknowledge the bad things that come with having access to guns. Not everything about a gun range or about shooting is nice and safe and fun, and so, while I continue to shoot, I also acknowledge that there are inherent risks and tragedies associated with firearms. Accidents do happen. Strangers at gun ranges still scare me, so I try to avoid peak shooting times. Even people with special gun skills—ROs, gun instructors, police officers, and competitive shooters—have accidentally shot themselves or others because they've let their guard down. Suicides also happen. About half of all firearm deaths are suicides, and while it's extremely rare, a few have occurred at gun ranges.

Being around safety-conscious gun folks with a passion for shooting is what put me at ease at the shooting range. They were familiar with how their guns worked, and safety was ingrained in everything they did. The gun folks I knew consistently followed the safety rules they'd learned as novices—the same rules taught to beginners a hundred years ago. They did this because they understood the ramifications of a stupid mistake. In 1907 shooting sensation Annie Oakley put it this way: "although you are sure your rifle is not loaded, it is the supposedly unloaded weapon that nearly always maims or kills."[2]

The joys of shooting were mine once my fears subsided, and I eventually became interested in competition shooting, purchasing the Para-Ordnance with the idea that I would participate in one of the newer shooting sports. I also began researching competitive shooters and was delighted to learn that women had been shooting competitively since the 1800s. Shooting star Annie Oakley proposed in 1920 that women could compete with men and win medals: "As I have taught nearly 15,000 women how to shoot, I modestly feel that I have some right to speak with assurance on this subject. Individual for individual, women can shoot as well as men."[3] American shooter Margaret Thompson Murdock proved this to the world when she shot alongside men at the 1976 Olympic Games, bringing home the silver medal. In Chapter 2 I discuss sports shooting and a few of the women who found great pleasure in competition.

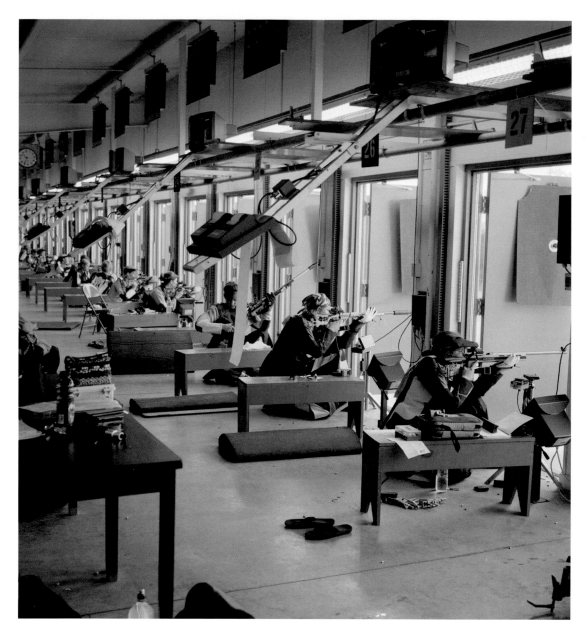

Women with Anshutz 1913 rifles during the 50m rifle 3 position competition,
final Olympic selection matches, Fort Benning, Georgia, May 2004.
[Chromogenic print. Photograph by Nancy Floyd.]

SHOOTING
LIKE A WOMAN

2

. .

Sports shooting became a popular pastime with wealthy Americans in the late 1800s. Gun clubs were fashionable places for shooting and socializing, and late nineteenth- and early twentieth-century newspapers reported on "ladies" shooting alongside their fathers, boyfriends, or husbands at local gun clubs. Throughout the twentieth century, women's participation at the range has largely depended on their fathers' and husbands' interest in firearms, the woman's enthusiasm for sports shooting, and the club's willingness to welcome women as shooters. Those who had the opportunity to shoot often, and wanted to, became good markswomen.

Historically women have been excluded from many local, national, and international competitions. Over time, though, this has changed. Today, some sports allow women to compete against men—others give women their own leagues; and they participate in professional-level competitions worldwide. Twenty-first-century gun women, like their female predecessors, put their best shot forward at shooting stages; they shoot like women; and sometimes they're the best on the range. This chapter is about a few women who take great pleasure in competition.

Because sports shooting covers a multitude of styles and techniques, requiring different types of firearms and distinctly different rule sets, I've chosen to focus on only a few types of competition and a few of the women who have stood out for their accomplishments. I've also included some women I've met in

Barbara Wilbourn with a .22 Smith & Wesson Kit gun and Remington Model 511 rifle,
and Margie Wise with .22 Springfield rifle and a Harrison & Richardson .22 revolver,
On Target Shooting Range, Laguna Niguel, California, 1994.

[Chromogenic print. Photograph by Nancy Floyd.]

Margie: I received my first gun at age nine. I had asked for an archery set, but my father felt
that owning an archery set was too dangerous, so he bought me this little .22 rifle.

Barbara: I bought my first gun in December of last year—'93. Margie wouldn't go kayaking
unless I went shooting. It's just a hobby, competitive sport.

Margie: It's like some people bowl one night a week—we prefer shooting rifles or guns.

..........................

my travels—the ones who've impressed me because of their enjoyment of their
sport, regardless of their skill level.

In 1920 Plinky Topperwein had already made a name for herself as a trap-
shooter extraordinaire and member of the Winchester rifle team when the *Win-
chester Record* reported on the disruption she allegedly caused for an unsuspecting
manager of a Coney Island shooting gallery. According to the *Record*, "Mrs. Top-

Sharpshooter Karen Bowker with Smith & Wesson Model 41, Santa Ana, California, 1994.
[Chromogenic print. Photograph by Nancy Floyd.]

...........................

perwein picked up a rifle and dismantled a few things and the manager said:
'Young lady, you have shot before.' Mrs. 'Topp' told him that she had, but that she
wanted a little practice, so broke everything that he had in the place. The manager
may recognize his visitor if he reads this note."[1] Throughout her life Topperwein
would illustrate, again and again, what shooting like a woman really meant.

The first time I tested my shooting ability outside of an indoor shooting
range was in 1994, using a lousy toy pistol at the penny arcade on the Santa
Monica Pier. While I didn't clean the place out the way Topperwein did in 1920,
the experience nevertheless made a lasting impact on me. I knew the odds against
success were high, but there I was, paying my two bucks to shoot at small bowl-
ing pins with fuzzy edges. I knew the pin was almost all fuzzy edge, with just

enough of a solid middle to keep the pin standing up. But I felt lucky. The pins were only ten feet away, and my shooting skills at ten feet were pretty good. I shot my four fifty-cent shots, missed all, and walked away. Losing didn't bother me, but while my husband, Robin, and I took in the other carnival offerings, including my favorite, Whack-a-Mole (moles pop out of holes and you hit them over the head with a giant mallet), I mentioned being perplexed that I had missed all four bowling pins. Robin responded, "You missed because the darts aren't shooting straight." *Ah,* I thought. *So it wasn't ME.* I felt lucky again.

Robin agreed to help me compensate for the angle discrepancy, and we returned to the shooting booth. The person behind the table loaded the darts, leaving me no opportunity to set the dart straight. I sighted the pin exactly—as exactly as one can with a toy gun—and squeezed the trigger while Robin watched its trajectory. It's called "fire for effect"—firing off a round to see if the aim was true. Robin told me the arrows were shooting high to the right. So I dropped the pistol down to the left after a new dart was loaded. I shot down the pin, and then two more, and won the top prize—a big stuffed pig made out of cheap, fuzzy synthetic fabric. The eyes, nose, and mouth were glued pieces of felt, and the stuffing appeared to be Styrofoam packing peanuts. It was so poorly crafted that the corner of the mouth required regluing and a seam on the leg needed mending before I could give the

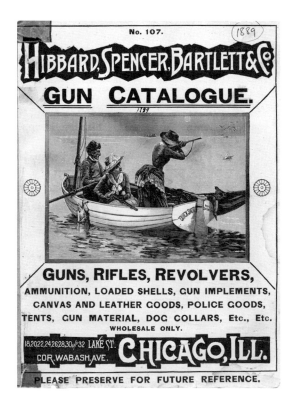

pig to my niece. But for the rest of the evening, I walked around Santa Monica Pier proudly carrying my giant packing-peanut-stuffed pig. People noticed my pig and congratulated me. I kept running the scenario over and over in my mind. This was my first shooting trophy. It wouldn't be my last.

America saw an increase in female shooters as city populations grew and outdoor leisure activities took on greater importance in the latter half of the 1800s. Some gun clubs actively encouraged women to

...........................

Hibbard, Spencer, Bartlett & Co., Firearms, Chicago, gun catalog no. 107, 1889, cover.
[Reprint courtesy of the Warshaw Collection of Business Americana-Firearms, Archives Center, National Museum of American History, Behring Center, Smithsonian Institution, Washington, D.C.]

participate, and Ladies Day at the shooting range began its legacy early on: "Ladies Day at Creedmoor: The Directors of the National Rifle Association Entertaining the Ladies," an 1878 *New York Times* headline declared. "Rifles of small bore and light recoil" were provided.[2]

The shooting range was a place for both shooting and socializing. In 1887, reporting on events in Philadelphia, a *New York Times* headline announced, "Rose Coghlan Breaks the Ladies' Record in a Ten-Bird Match."[3] "A party of ladies and gentlemen went to Andalusia this afternoon for an afternoon's sport," the article reported, "the guests of the Philadelphia Gun Club."

Articles published in newspapers and outdoor magazines indicate that girls and women were competing in the late 1800s, and a few, like Rose Coghlan, were establishing reputations as accomplished markswomen. In 1901 Rena Holmes reportedly "won many championships in contests with men in shooting clay pigeons," and a 1905 article in the *New York Times* described two women taking top honors in a shooting competition: "there were thirty-two competitors, representing five States …two women—Miss M. Waterhouse and Mrs. Leonard Tufts of Pinehurst, N.C.—have won the pistol championship of the State."[4]

According to Dick Baldwin, director of the Trapshooting Hall of Fame Museum, writing for *Trap & Field* in 2003, Etta Butts

STURDY SHOOTING SUIT

For the woman who really hunts this suit is especially designed, and is without an equal for such purposes. Coat is cut full and roomy in the skirt, especially designed as to pockets for carrying of shells, game, etc. Fitted in at waist. The breeches are of the "hunting" style, illustrated on page 154. A short skirt, buttoned up front, and which may be removed and worn as a cape, can be supplied with this suit.

Two-piece suit, coat and hunting breeches, made of imported olive drab cold stream duck.

3C7682$25.00
3C7683 Skirt of cold stream duck........$10.00
3C7684 18 oz. Forestry
Cloth coat and breeches...................$55.00

16 ABERCROMBIE & FITCH CO.,

WOMEN'S CLOTHING CUSTOM MADE.

KHAKI.

Norfolk Jacket or Long Coat........$17.50
Short Jacket15.00
Skirt10.00
Divided Ski..........................12.50
Bloomers10.00
Knickerbockers8.00
Waistcoats5.00

KERSEY.

Prices same as for Khaki.

Priestly Woolen.

BLANKETING SUITS.

Canadian Club Model With Hood.

For Snow-shoeing, skiing and tobogganing. Made of warm, soft blanket cloth, trimmed with contrasting color. Light and comfortable. White, Scarlet, Buff or Gentian Blue.

Price, $40.00.

The evolution of the clay disk (*left*) and a 1950s shooting outfit, Amateur Trapshooting Hall of Fame, Vandalia, Ohio, 1997.

[Chromogenic print. Photograph by Nancy Floyd.]

..........................

facing page, bottom: Three models in a photography studio, one with a rifle, one with a shotgun,
and one wearing ice skates, 1921. The woman pointing the firearm is holding what appears to be a Winchester
Model 12 (1912) slide-action shotgun, and the woman to her left is holding what looks to be a
Winchester Model 94 (1894) rifle. Thanks to Thomas I. Melcher for firearm identification.

[Silver gelatin print, 9 ½" × 7 ⅝".]

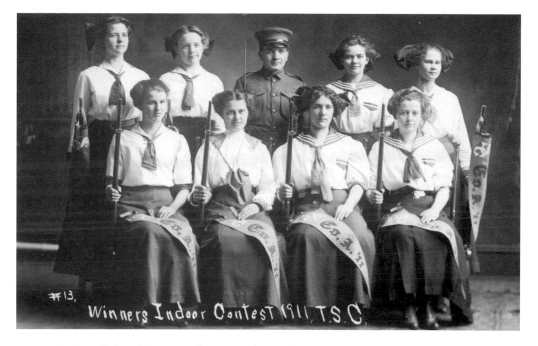

Tri-State College Women's Rifle Team with .22-caliber target rifles, Angola, Indiana, 1911.

[Real photo postcard, 3⅜" × 5½".]

· ·

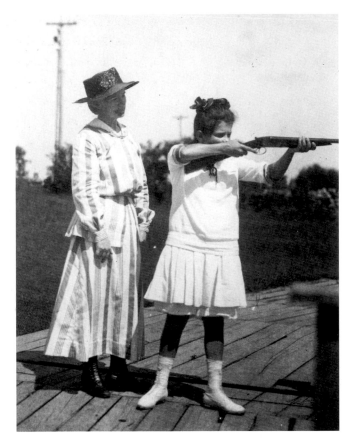

left: Annie Oakley and eleven-year-old pupil, ca. 1920. The girl is shooting Annie's L. C. Smith Trap Grade hammerless 12-gauge double-barrel shotgun.

[Sepia-toned, 3 3/8" × 5 5/8". Reprint courtesy of the Buffalo Bill Historical Center, Cody, Wyoming, image number P.69.1594. Gift of Guthrie L. Dowler and Euradean Moses Dowler, the great-niece of Annie Oakley.]

..............................

below: Annie Oakley with students, ca. 1916-21. The rifle may be a Winchester Model 1912 Trap Grade repeating shotgun.

[Sepia-toned photograph, 5" × 7". Reprint courtesy of the Buffalo Bill Historical Center, Cody, Wyoming, image number P.69.1177.]

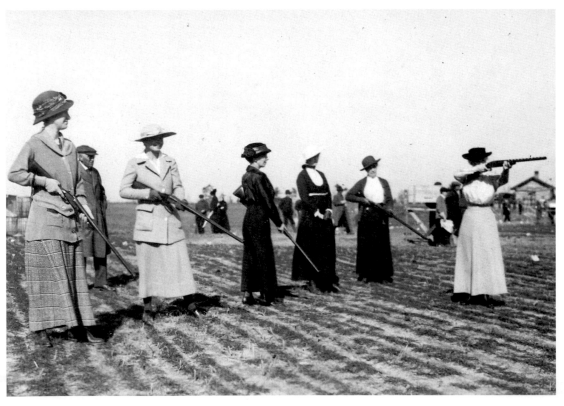

Lindsley shot trap with her husband until her death in 1902. She also published articles and wrote poetry about shooting. She shot under the name of "Wanda" so she wouldn't be confused with her husband during competition. Baldwin quotes an unknown newspaper from 1897: "Mrs. Lindsley's enthusiasm for shooting has kept pace with her ever increasing expertness. . . . Wanda, as she is known, handles her hammerless with the coolness of an old veteran and shatters the flying saucers with a neatness and dispatch that is refreshing to behold."[5]

That women participated at the range didn't mean the range was always a comfortable place for gentlewomen. Sharpshooting superstar Annie Oakley expressed her displeasure with one such range in her article "Field Sports for Women," circa 1896–1901:

> Some time ago I attended one of the largest tournaments ever held in this or any other country. What should have been the shooter's room in front of the traps, although not much larger than an army tent, had one end set off for a bar; and, although the weather was very severe, many of the gentlemen shots, as well as myself, preferred to remain outside rather than risk the tobacco smoke and smell of whisky inside.[6]

Like other top female shooters, Oakley wanted to see more women at the range. In interviews with reporters she encouraged the "weaker sex" to learn how to shoot; and in a 1916 article in the *American Shooter* she explained the popularity of her classes and the enthusiasm of her pupils at a wealthy resort in Pinehurst, North Carolina:

> On the second day I started my women pupils shooting at mark with a 22-calibre rifle, and when they quit the range each carried a card with a perfect bull's-eye. That was the beginning, and since that time my class has increased so fast that I devote two hours each morning to women pupils. Some have graduated from the rifle class and are using a shotgun. One woman, who never had held a gun before, after about five lessons was able to break five out of ten targets thrown. She became so enthusiastic that she sent in an order for a gun, and I am sure it won't be long before she will shatter ten straight.[7]

Oakley continued to compete in shooting matches until late in life. During the 1925 Grand American World Trapshooting Championship in Vandalia, Ohio, a year before her death, she broke ninety-seven out of one hundred clay

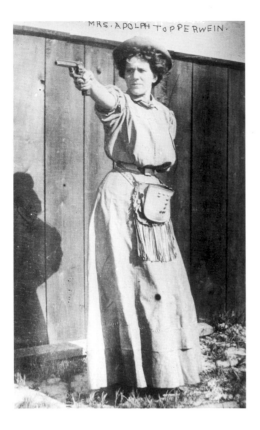
MRS. ADOLPH TOPPERWEIN.

Plinky Topperwein with a Smith & Wesson New Model No. 3 revolver, ca. 1903-10.

[Silver gelatin negative on glass, 5" × 7". Reprint courtesy of the George Grantham Bain Collection, Library of Congress, Prints and Photographs Division, Washington, D.C, image number LC-B2-2227-15.]

.............................

disks. After more than fifty years of shooting Annie Oakley remained a top shooter at age sixty-five.[8]

Plinky Topperwein, born Elizabeth Servanty (1882–1945), was another sharpshooter extraordinaire. Like Lindsley and Oakley, she accompanied her husband at the range. Plinky worked at the Winchester firearms factory in New Haven, Connecticut, and began shooting after her marriage to Ad Topperwein. In 1906 her skills caused quite a stir when she became the first woman to qualify for the National Reserve:

Mrs. Elizabeth Topperwein of San Antonio, Tex., is the only woman competitor here. She is barred from the regular military matches, but entered the national marksmen's match. The requirements are that a total of 50 out of a possible 75 shall be made at the three ranges of 200, 300, and 500 yards. Mrs. Topperwein made a total of 59 with a Winchester rifle and received one of the medals. There is an arrangement that all who make the required 50 points shall have their names sent to the War Department as members of the national reserve and the authorities are puzzled what to do in the case of Mrs. Topperwein. Having made the required score, she is a national marksman.[9]

Plinky may have been America's first female national reservist, unofficially of course.

In 2006 Dick Baldwin gained access to an old tape recording from the mid-1900s of Ad reflecting on his life with Plinky. According to Baldwin, Ad nicknamed his wife Plinky after she described the tone of a bullet hitting a tin can as a plinking sound.[10] Ad was a highly accomplished shooter with many records to his name, but Plinky was an outstanding shooter in her own right

and competed side by side with him on the Winchester Rifle Team for many years. A brochure promoting an upcoming shooting demonstration compared her skills favorably to those of her husband. "In teaming with her husband in exhibitions, Mrs. Topperwein practically duplicates the various shots in Mr. Topperwein's big bag of tricks. At some points, she even excels him. At every performance they seem to compete against each other by springing some new surprises."[11]

Plinky wrote about the changes she had witnessed over the years for the *Winchester Record* in 1920. She was optimistic about the future for women shooters and their ability to shoot as well as men:

> When I first began shooting, I was one of the few brave ones to try the clay birds at the Gun Club. Now there are hundreds of women shooting at gun clubs all over the country, and I am proud to say that a great many of them defeat their male competitors.
>
> There is no reason in the world why women can not shoot as well as men folks. . . . The love for shooting can be cultivated just as easy as the desire to play golf or tennis. . . . Not only should a woman learn

. .

Plinky Topperwein, 1915. The firearm may be a Colt New Service Improved Target Model revolver.
[Photograph by Otto M. Jones. Silver gelatin print. 6 3/8" × 10 9/16". Reprint courtesy of the Library of Congress, Prints and Photographs Division, Washington, D.C., image number LC-USZ62-99329.]

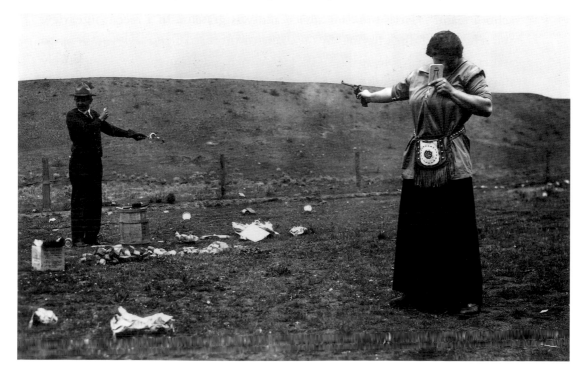

Deadeye Dick's Ectypes at G. W. U.

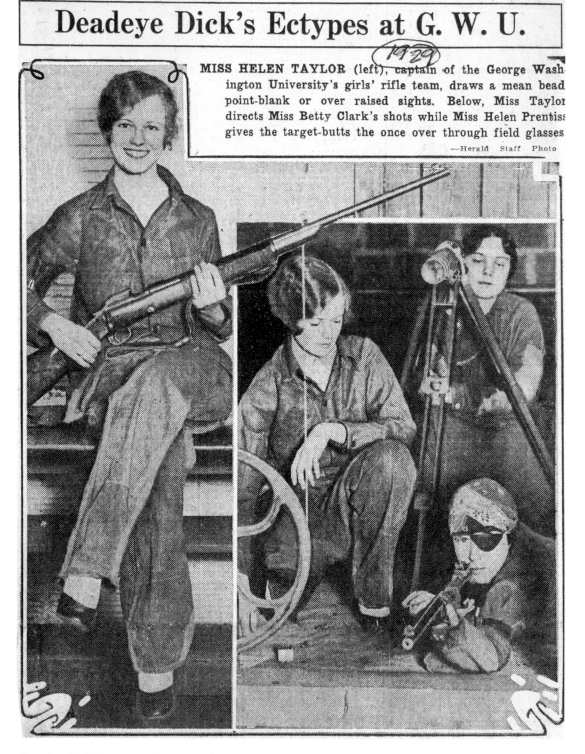

1929

MISS HELEN TAYLOR (left), captain of the George Washington University's girls' rifle team, draws a mean bead point-blank or over raised sights. Below, Miss Taylor directs Miss Betty Clark's shots while Miss Helen Prentiss gives the target-butts the once over through field glasses

—Herald Staff Photo

"Deadeye Dick's Ectypes at G.W.U." *Washington Herald*, 1929. Taylor's rifle may be a Winchester Model 52 target rifle.

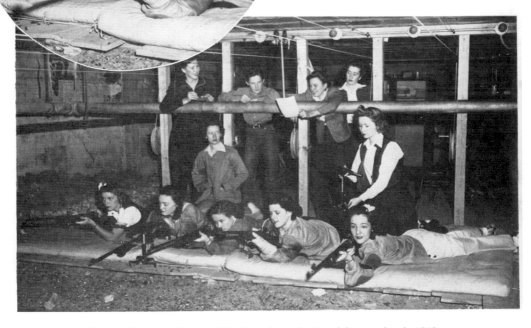

The TSCW Rifle Club
Making History

TSCW's Annie Oakleys on the beam again. Above, What those girls can't hit! Circle, Miss Grossnickle watches Gertrude Lyon make another bull's eye. Below, Load, aim, fire!

Texas State College for Women Rifle Team, from the *Daedalian* yearbook, 1943.
Some of the rifles in this image may be .22-caliber Winchester Model 52 bolt-action target rifles.
[Reprint courtesy of Texas Woman's University Special Collections, Denton, Texas.]

a brief caption about the team, including this, from 1949: "After class training, the 'Annies' have been known to out-shoot even the BEST gunmen."[19]

The TSCW rifle team competed against other collegiate teams, both male and female, and, starting in 1939, an exciting rivalry developed with Texas A&M. For the 1940 competition round, the women accepted a handicap of forty points against the all-male Texas A&M team, winning 518 to 487. Sadly, the editors of the *Daedalian* failed to note this accomplishment, instead poking fun at the team: "Point the barrel in the general direction of the target, close your eyes, pull the trigger . . . and hit the bull's eye. Or is that the way you do it, girls?"[20]

It's not known what made the team forego a handicap the following year. Perhaps close scores encouraged them. Or could it have been the denigrating comments published in their own yearbook? Regardless of the reason, in 1941 outright victory went to the women's team, by two points, 981 to Texas A&M's 979. The school newspaper described top shooter Irene Chamberlain as "Straight Shootin' Chamberlain, the girl who made the Aggie marksmen fall like they should be knitting for Britain."[21] A&M's rifle coach tried to see the bright side of the defeat in an interview with the school's reporter. "In a way I'm glad this gang beat our boys," Sergeant Richards said. "Maybe they will wake up and shoot after seeing these girls handle high scores."[22]

The TSCW rifle team continued to compete into the 1980s. It didn't always win, but the team's accomplishments were acknowledged in each issue of the yearbook, often with a reference to Annie Oakley, including this entry from 1941: "TSCW Annie Oakleys Ready! AIM!"[23]

Many nongun folks find it surprising to learn that physical training is mandatory in the more physically taxing shooting sports. While not as crucial as for a runner or a gymnast—unless she's training for a biathlon—a shooter's physical fitness is still key; to be competitive in national and international competitions, she needs a strong upper body to hold and fire the weapon, and a strong lower body to move fast or to stand or kneel in one place for fifty minutes or more. These high-level shooters keep their bodies in shape and practice often.

A strong body is not enough. Like any sport, the ability to focus—to block everything else out—is what makes a top shooter. In 1996 Jacqueline Morton, Women's Sport Pistol Collegiate National Champion, said this about her sport:

> Actually, shooting is quite simple. Once you get the technique and your mental game down, all you do is look at your front sight and do the same thing over and over. It's almost robotic. That's when you get into the groove, and that's when you're in your meditative state. If you're

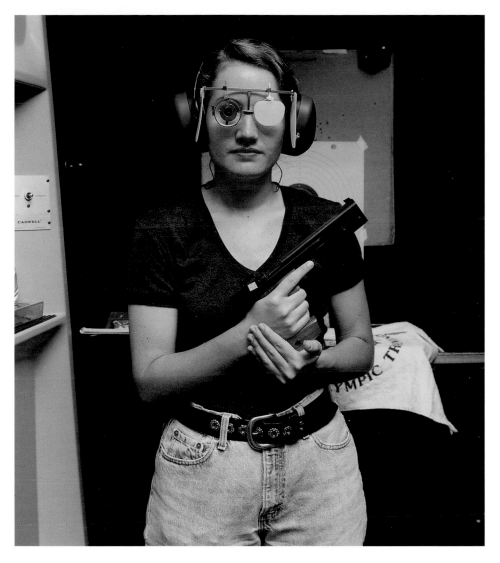

Competition Shooter Jacqueline Morton with Hammerli 208, practicing for year 2000
Olympics at the Lax Firing Range, Los Angeles, California, 1996.
[Chromogenic print. Photograph by Nancy Floyd.]

..........................

really focused, you forget you're in finals pretty much. It's just you and
the target you're shooting. That's what is really great about shooting, is
to get to that point where you're competing against yourself.[24]

Women shooters today have many sports shooting options. Some of the
traditional sports include bench rest, muzzle loading, position rifle, precision
pistol, silhouette (handgun and rifle), trapshooting, skeet, and sporting clays.

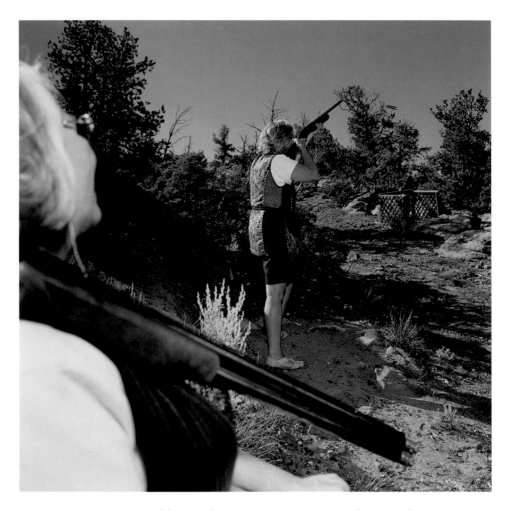

Sisters Karen Gibbons (with 12-gauge Browning 325) and Jane Sanders
(with 28-gauge Remington 1100), shooting sporting clays, Cody, Wyoming, 1998.
[Chromogenic print. Photograph by Nancy Floyd.]

............................

The newer sports include practical shooting or IPSC (International Practi-
cal Shooting Confederation, founded 1976) and cowboy action shooting pro-
moted by the SASS (Single Action Shooting Society, founded 1981).

Women first joined men in Olympic competition at the 1968 Olympic
Games. No American women entered that year. American Margaret Thompson
Murdock was the first woman to win a medal, the silver, in the 50m rifle 3
position event at the 1976 games. In 1984 separate women's events were cre-
ated, yet some events continued to allow competition between women and
men. In 1996 this all changed, and women's and men's events were separated.[25]
There are six women's events scheduled for the 2008 Olympic Games.[26]

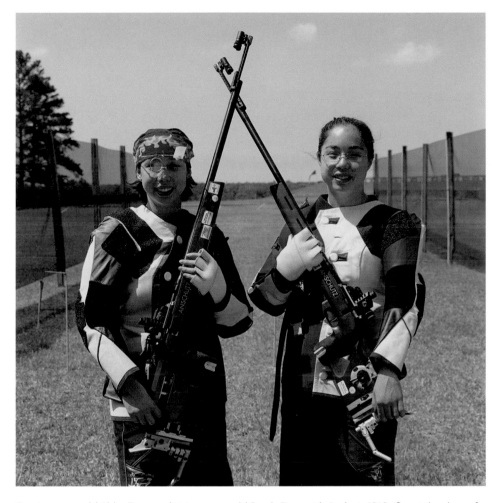

Fourteen-year-old Abby Fong and sixteen-year-old Sandy Fong with Anshutz 1913 rifles at the close of the 50m rifle 3 position competition, final Olympic selection matches, Fort Benning, Georgia, May 2004.

[Chromogenic print. Photograph by Nancy Floyd.]

....................................

The newer shooting sports, IPSC and SASS, attract various levels of female participation. Of the two, SASS encourages family activities up front. This newer sport, also known as cowboy action shooting, combines the skill of calculated shooting with the play of a Western reenactment shooting stage. The stages are described as "fantasy scenarios based on actual events from history, Western movies and Western TV series."[27] The stages and activities surrounding the major shooting events comprise a little history, a lot of Hollywood fantasy, and elements of a Wild West show, but with less dazzle and more real competition. SASS's big event is the End of Trail Wild West Jubilee and Cowboy Action Shooting World Championships.

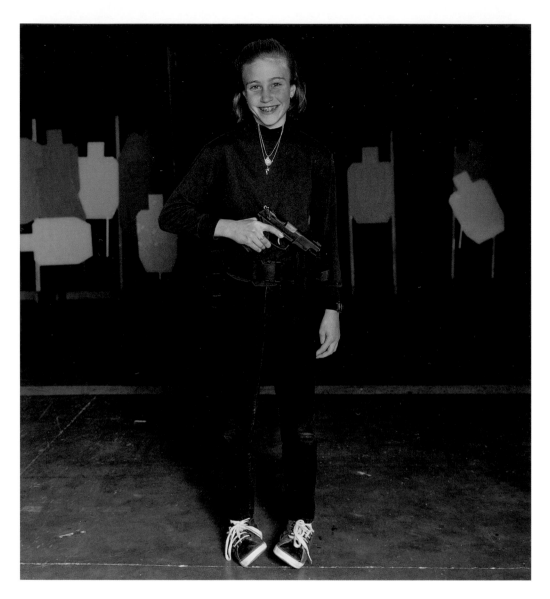

Eleven-year-old Vanessa Noble with 9mm Ruger P89 before her first practical
shooting competition, On Target Shooting Range, Laguna Niguel, California, 1996.
[Chromogenic print. Photograph by Nancy Floyd.]

Vanessa: My next IPSC match, which will be my second one, I'm going to shoot the .45. It's weird
because now it's so easy to shoot the .45 but it was, like, so hard to shoot the .22 when I first
started. IPSC gives me something to do against other people who are a lot older than me and
have more experience. Shooting is so fun because people are proud of me and they say that I'm a
good shooter. I think it's a good sport because you have to learn a lot.

 Lindsay's six and she's shooting the .22. It will probably be a couple of years before she
shoots IPSC because she's still not mature enough. She's learning a lot though, which is good.
Last week she got to shoot the .38 Diamondback, the revolver, and she said she was so excited
because, you know, it's pretty neat.

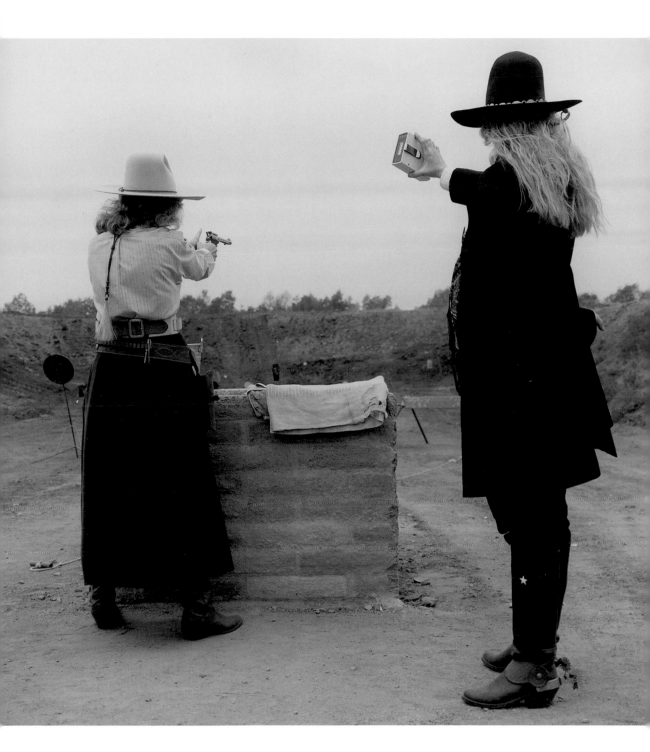

Single Action Shooting Society member Blue Eyes firing a .357 Ruger Black Hawk
while daughter Jubilee Montana times her at the 1994 End of Trail.

[Chromogenic print. Photograph by Nancy Floyd.]

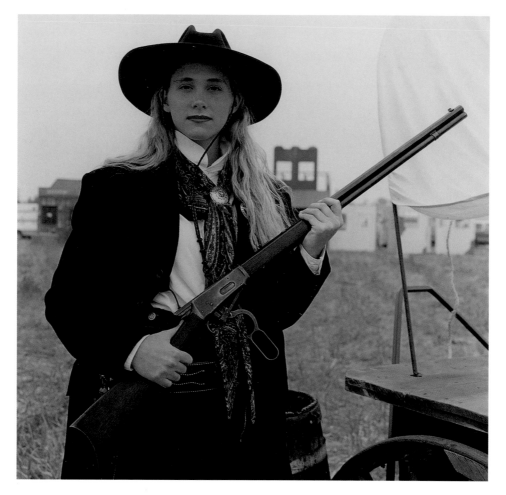

Single Action Shooting Society member Jubilee Montana with Model 1894 Winchester rifle and Montana Territorial-Centennial Diamond-Jubilee-Edition Colt .45s at the 1994 End of Trail.

[Chromogenic print. Photograph by Nancy Floyd.]

....................

Because the sport encourages family activities, children grow up attending and sometimes participating in the shooting events. Jennifer Green (a.k.a. Jubilee Montana), the twenty-year-old daughter of two SASS competitors, has an intimate knowledge of the SASS environment. Back in 1996 she told me, "First and foremost, I like the people involved in SASS. I grew up with cowboy action shooting, so I feel very close to everyone in the club, and I feel close to the sport. I mean, there is such a strong feeling of camaraderie, and people are so supportive of each other. There's a nice balance of people out there, of people who are into it strictly for the competition and those who are there just to have fun."[28]

Jumping onto a metal barrel decked out as a horse and knocking down targets again and again as the metal animal moves down the stage, or picking up a derringer in a mock saloon and shooting at balloons, might look easy to onlookers, but it isn't.[29] And while many of the competitors say they just want to play cowboy and cowgirl, it's difficult to be a really good SASS shooter, as Green attests:

> SASS is a very controlled sport. It's very precise, and what I like about it is that it requires a lot of fine-tuning, both with the firearms you use and with yourself. It's more mental than a lot of people think, because you have to be very focused while you're shooting. There's a lot of things to remember, from your stance, to your sight picture, to how you're holding the gun, to ways to improve your speed. So I guess what I really like about it is the challenge. I've certainly never won a match, but it's a really good feeling when you clean a stage, meaning you hit everything that you were aiming at, and you do it in a pretty good time.[30]

In contrast to SASS, practical shooting, or IPSC, is designed with the present-day tactical shooter in mind. IPSC, like SASS, is shot on numerous simulated stages, but the weapons are modern "race" guns. Some shooters use revolvers, but most use semiautomatic pistols. In SASS, shooters may be required to sit at a table in a simulated saloon setting, prepared to drop their card hand when a timer signals the go-ahead. At the sound of the beep they lay down their cards and quickly draw a loaded derringer from under a box on the table and shoot at balloons (stand-ins for the bad guys) on the other side of the table, about five feet away. In IPSC, competitors may be required to open a door at the sound of the beep and shoot at cardboard bad guys before running to a wooden barrier and shooting through small openings at more cardboard bad guys—the stage simulating a shootout on city streets. Both sports get the adrenaline pumping, and competitors are scored on time and accuracy. Penalties for things like shooting targets out of sequence also affect scores.

From the moment I saw Laurie Aggas enter the first stage at an indoor range in Southern California in 1994, I wanted to be just like her. Attached to her holster and across her midsection was a high-powered customized race gun with high-capacity magazines. She was dressed in blue jeans and a T-shirt, with a black leather holster, and it was clear by her demeanor that she would shoot fast and accurately.

Later, I traveled to Lake Piru, north of Los Angeles, to watch Aggas and other women compete in an outdoor competition. These women were impres-

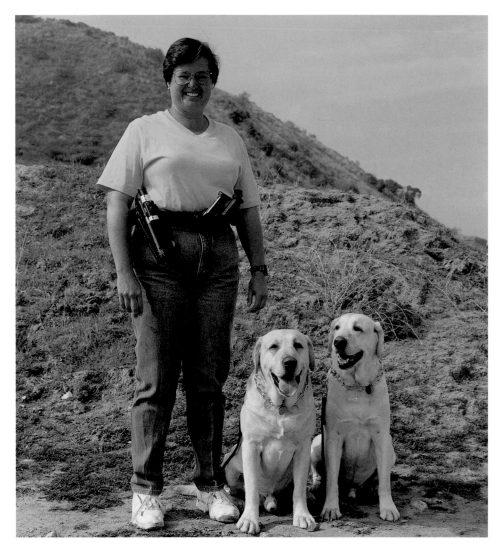

Practical Shooter Laurie Aggas (with Para-Ordnance .38 Super), Cyrus, and Alex
at the Piru Outdoor Shooting Range, Piru, California, 1994.

[Chromogenic print. Photograph by Nancy Floyd.]

..............................

sive to watch. Not only did they look good with race guns on their hips, they
shot well. The dedication and commitment, not to mention the gobs of money,
it takes to shoot at this level are impressive. Aggas explained:

> I shoot about two thousand rounds a month. Let's see, in December I
> bought twelve thousand bullets, and here we are at the end of June, and
> I'm out. I have a really nice loader and can load two or three weeks'
> worth of ammo in an hour and a half.

In the last six months I've gotten really serious about shooting, so I make sure to handle the gun every day. Every night at home, I practice for ten to fifteen minutes. I have little targets set up in my living room so I can sit on my couch and dry fire and practice reloading while I'm watching television. If I have time, or there's something I really want to work on, I'll practice at the range once or twice during the week. Then I shoot matches every Saturday and Sunday.[31]

I'll never be as good as Aggas—I certainly don't have her commitment or drive for shooting. But I did win a "real" shooting trophy. It sits in a place of honor on a bookshelf in my office, next to my one tennis trophy. I received the award at the Ladies Charity Classic, sponsored by the Women's Shooting Sports Foundation, in Southern California in 1995. This was my first foray into competition shooting and I entered for the opportunity to meet other women shooters and to shoot a variety of handguns. Plus, they offered prizes. The Classic was similar to the penny arcade at Santa Monica Pier—I slapped down some money and received equipment to go through several preplanned courses. The Classic's equipment was much better than the arcade's, of course. Individual shooting stages, each with a different style of handgun and target setup, were waiting for me. I shot .22- and .38-caliber revolvers and semiautomatic pistols, with different style grips and barrel lengths. Our skill levels ranged widely, from the accomplished markswoman to the first-time shooter.

My shooting came together at the second-to-last stage. I'd already cleaned most of the stages, but the experience at this stage was different. Orange clay disks were attached to a fence-like contraption ten to fifteen feet away. I was handed a Smith & Wesson .357 revolver with a six-inch barrel, loaded with .38 Special ammo. It fit perfectly and solidly in my hands. I was using a modified Weaver stance at the time, a two-handed grip where the shooting arm (strong arm) pushes out on the grip while the other arm pulls back and bends down at the elbow to control muzzle lift. There's more to the stance than this, but what I remember was the way my grip came together with that Smith & Wesson. The push/pull seemed so natural. I began shooting, breaking the first disk, then another, and another, and all of a sudden I realized I wouldn't miss. My body felt calibrated and knew exactly where to aim. My upper torso rotated from disk to disk, squeezing the trigger, moving on, reloading and shooting again. The range officer at one point said, "There's no hurry, you can slow down," but I didn't feel like I was rushing—I was in a rhythm. I

moved solidly from clay to clay. I wouldn't, couldn't miss. A quality handgun, placed snuggly in my hands, was now an extension of my body, making my bullet placement perfect. A second-place trophy in the women's "A" division was mine.

With a stuffed pig and a "real" trophy under my belt, I was hooked. So I began shooting IPSC (pronounced "Ip Sic") in 1995. At the time, the only gun I owned was my revolver, and while some shooters used revolvers, I was ready for a semiauto with high-capacity magazines. I wasn't ready to buy a gun, however—I needed to make sure I had a passion for this type of shooting—so I borrowed Robin's .45-caliber Ruger and one of his old leather belts and went to a gun show to purchase an inexpensive holster, extra magazines, and holders for the magazines.

Here's how IPSC generally works: I wear a gun and holster. My magazines (three if I'm shooting the handgun I purchased in 1997) are filled with ammo and loaded on my belt. When it's my turn, I walk to the stage and wait in the starting position. A range officer with a timer in hand yells, "The range is hot," meaning that everyone else needs to stay back behind the shooting line now. Then the RO gives me the okay to proceed. I load the magazine, rack the slide, engage the safety, and return the gun to my holster. I drop my hands to my sides, or do something else with them if instructed. I may be asked to start in a sitting position or with my back to the stage. The RO asks, "Is the shooter ready?" and I nod. Then there's a beep from the timer in the RO's hand. The timer tracks how long it takes me to shoot the stage; it's sensitive to gunshots and is calibrated for a specified number of rounds. I draw my gun, release the safety, and start to move through the stage. I can shoot anywhere from eight to twenty-eight shots, depending on the course. Usually we're required to put two bullets in each target. The targets are set apart, so after shooting at one target I must move to the next one. When it's time to eject a magazine and replace it with a full one, I let the used one drop to the ground (can't waste time in this sport) and quickly insert another.

IPSC is best shot outdoors. Most indoor ranges allow for only one to three shooting stages owing to limited space, and the targets are all paper and cardboard. Outdoors I've shot four to six stage courses, and cardboard is not the only target material. I personally like the steel silhouettes that clang as they fall over when struck.

Outdoor stages can take up a lot more space and are generally more sophisticated in design, allowing for some crazy courses. I've shot through barrels and

mock windows and doors, and contorted my body to shoot around corners or over barriers. Sometimes I'm down on my belly and sometimes the targets move.

If it's been raining, things will get muddy. If it's a hundred degrees, we're sweaty. IPSC is shot in all types of weather, as long as it's safe.

The timer stops when it detects my last shot. The RO with the timer walks over to me. I drop out my magazine and rack the slide, ejecting the live cartridge if there is one. The RO wants to see an empty gun. I holster my unloaded gun and the RO yells, "All clear." I pause momentarily, letting the euphoric feeling flow through my body, and then I follow the RO over to the targets where my score is being tallied. I'm super slow, so I'm pretty accurate. Time plus accuracy is the goal. While I'm listening to my target scores, my shooting buddies are working for me. As I went through the stage, I left a mess behind me. My comrades hand me my dropped magazines and as many of the spent cartridges from my gun as they can find. Spent cartridges are like money in the bank—some shooters load their own ammo, reusing their cartridges; some, like me, will turn them in for a credit on my next purchase. My pals are also taping over the bullet holes I created in the cardboard targets, after the scores are tallied. They do what I will do when I'm not shooting or reloading my magazines for the next stage. Everyone pitches in, preparing for the next shooter. It shortens the time between shooters, and it also builds camaraderie.

A year after moving to Georgia I bought my .40-caliber Para-Ordnance. I immediately gave it to a gunsmith to customize—to fit my hand. He shortened the distance between the trigger and the grip, lightened the trigger's resistance, and added an ambidextrous safety—I'm left-handed. After purchasing a small protective case for the gun, two additional high-capacity magazines, a quality leather holster, cleaning brushes, a shooting bag large enough for carrying lots of stuff, a thousand rounds of reload ammo, and a membership to the United States Practical Shooting Association (the U.S. affiliate of IPSC), I was set. Practical shooting is not cheap.

Preparing for an outdoor event takes time, getting to the range takes time, and the event itself takes time—it lasts all day. Before shooting a stage I memorize the layout and shooting requirements and plan my strategy—I plan by asking other shooters what they're going to do, since I'm a novice. Throughout the day I pick up a lot of magazines and cartridges for other shooters, and at the end of the day I help tear down stages. I'm surrounded by a bunch of people who are just as nuts about IPSC as I am, or even more so.

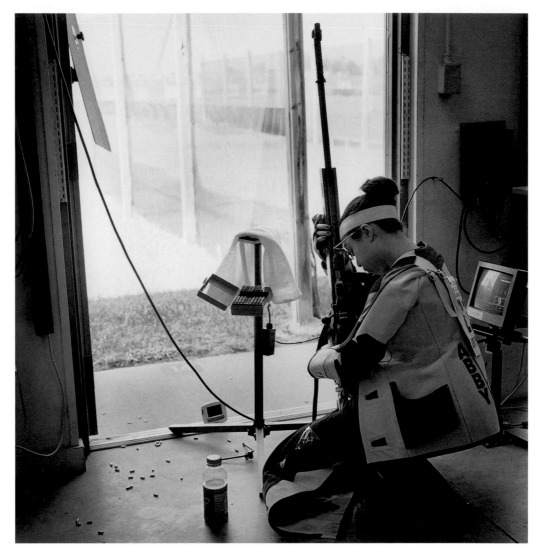

Sixteen-year-old Sandy Fong with Anshutz 1913 rifle during the 50m rifle 3 position competition, final Olympic selection matches, Fort Benning, Georgia, May 2004.

[Chromogenic print. Photograph by Nancy Floyd.]

..........................

I love the altered reality of the match: walking around with a gun on my hip all day long, hanging around and learning shooting tips from experienced gun people, and moving through a stage with multiple levels of shooting difficulty. For the entire day the only thing that matters is guns and shooting. IPSC is a performance involving mind and body control while discharging a deadly weapon. It is far removed from anything I do in my day-to-day life as a teacher, colleague, sister, daughter, friend, or neighbor.

I'm totally focused—engaged in the moment. By immersing myself fully in the event, I cleanse my body and mind of life's muddled responsibilities. I am utterly happy.

Top female competitors may be outnumbered by men, but they are not ignored by other shooters—the American Trapshooting Association (ATA), IPSC, and SASS all carry information about women shooters on their websites and in their publications. Unfortunately, or not, depending on your opinion, some of the shooting sports are segregated by sex, with women in their own division.

Some styles of competition even have different rules for the same kind of shooting. In 1984, eight years after American Margaret Thompson Murdock won a silver medal at the Olympics while competing with men in the 50m rifle 3 position event, women and men were segregated and the rules of the game changed, thus making it impossible to compare male and female abilities in this event.[32] A few Olympic competitors have told me they believe the change was done exactly for this reason—some men didn't like the idea of women outshooting them. According to a spokesperson for the International Shooting Sports Foundation, the goal was simply to give women their own events.[33] I have met a few female shooters who have told me they like segregated shooting, feeling they have a better chance of winning in a separate division.

In contrast to the Olympic Games, IPSC, SASS, and the ATA do not have segregated shooting competitions, although they may have special categories. For example, top-scoring female IPSC shooters, juniors, seniors, and super-seniors are acknowledged in separate charts, but there's only one set of scores and one top shooter. According to Lamar Shelnutt, national programs director for SASS, they have a "protected category" for women in their sport, but all other categories are open to either sex.[34] According to Shelnutt (a.k.a. Coyote Calhoun), one of SASS's top female shooters, Randi Rogers (a.k.a. Holy Terror), has won overall state and regional championships, and she's been in the top ten at the End of Trail World Championship. Respectful of her skills, he explained, "SASS Cowboy Action Shooting is a very demanding gun sport. It requires mastering not only pistols, but also rifles and shotguns. You ask how Holy Terror competes with the men, I think on any given day she can beat most anyone in the sport."[35]

Bottom line: even though women have fewer female role models than men have male ones, receive little attention for their accomplishments outside their own community, and are often the only female competitor at local shooting

Women & Guns, January-February 1999.
[Reprint courtesy of *Women & Guns* magazine.]

...........................

ranges, or one of a few, gun women continue to do as they always have—they take great pleasure in shooting well, and they love the competition.[36]

Annie Oakley spoke often about the pleasures of shooting well. She spent her adult life as an exhibition shooter and shooting instructor, explaining to women and men just how much fun shooting together could be. But she was a product of her generation, and while she encouraged women to take up the shooting sports, she also made it clear that shooting should not interfere with domestic responsibilities. "I do not mean that a woman should neglect her home duties," she wrote, "that is furthest from my intention. But there is

a time for work and rest, and you know the old saying about all work and no play, etc."[37]

Oakley's demure posturing at the turn of the century probably helped placate her critics. In contrast to the highly successful and financially rewarded Oakley, her contemporary, Calamity Jane, also spoke of the pleasures of shooting in 1896, but domesticity was never mentioned. This famous Western gun woman preferred adventure:

> During the month of June I acted as a pony express rider carrying the U.S. mail between Deadwood and Custer, a distance of fifty miles, over one of the roughest trails in the Black Hills country. . . . It was considered the most dangerous route in the Hills, but as my reputation as a rider and quick shot was well known, I was molested very little, for the toll gatherers looked on me as being a good fellow, and they knew that I never missed my mark.[38]

Because of Oakley's fame as a sharpshooter in Wild West shows, Jane's fame as a Wild West character in dime novels, and a ravenous press that covered their nontraditional lives (both accurately and inaccurately) from the 1870s to the 1920s, they became twentieth-century gun women icons. Chapter 3 looks at these two famous women and shows how their distinct behaviors contributed to the myths and legends that survive them to this day.

Teenage girls competing for the 1997 title of Miss Annie Oakley with a Daisy Model 880 Powerline air rifle. Annual Miss Annie Oakley Shooting Competition, Greenville, Ohio. Chromogenic print.

[Chromogenic prints. Photographs by Nancy Floyd.]

SHOOTING STARS:
CALAMITY JANE AND
ANNIE OAKLEY

..........................

I frequently have wondered, after some person asked me the question, how many shells I have fired in more than thirty years of shooting. I really have not the slightest idea. Possibly I have fired more than any other living woman, and I do not know that any man can beat me so very much. I know that in one year I used more than 40,000 shells. Also several thousand ball cartridges. In the course of one of my exhibitions in Continental Europe I gave two exhibitions daily, including Sundays, for 17 months. I am quite certain that I have fired more than 1,000,000 shells.

—Annie Oakley, 1916[1]

Was in Arizona up to the winter of 1871 and during that time I had a great many adventures with the Indians, for as a scout I had a great many dangerous missions to perform and while I was in many close places always succeeded in getting away safely for by this time I was considered the most reckless and daring rider and one of the best shots in the western country.

—Calamity Jane, 1896[2]

merican gun women Annie Oakley and Calamity Jane lived in an era when women had few legal rights (circa 1850–1920) and suffragists argued unsuccessfully for gender equality (though Oakley was still alive when the Nineteenth Amendment to the U.S. Constitution took effect, granting women the right to vote). Oakley and Jane participated in the male province of shooting and hunting, but they did so in different ways and for different reasons. They

Deadwood Dick in Leadville, or, a Strange Stroke for Liberty, Deadwood Dick Library no. 23

[Cleveland: Westbrook Co., 1899]. 5 ¼" × 7 ⁹/₁₆". Reprint courtesy of the Warshaw Collection of Business Americana-Firearms, Archives Center, National Museum of American History, Behring Center, Smithsonian Institution, Washington, D.C.]

both stood out because they were known to be skilled gun women, and Jane stood out because of the way she looked and acted. I write about these two women not only because I just plain like them, but also because their behavior invites discussion about what it meant to be gun women in late nineteenth- and early twentieth-century America.

America's sharpshooting sweetheart was, and remains, Annie Oakley (1860–1926), born Phoebe Ann Mosey. By the late 1880s Oakley had established herself as a superb markswoman and hunter, entertaining audiences both here and abroad. After a lucrative career in Wild West shows she continued her passion for sports shooting and hunting, and on occasion she participated in shooting exhibitions. Throughout her adult life she encouraged and taught women how to shoot, and by the time of her death at age sixty-six, her influence was substantial. Her old-fashioned ways may seem quaint by today's standards, but her impact still resonates in the gun world and popular media.

Although Oakley rose to fame as a shooting superstar and died a wealthy woman, her early years were full of hardship. She was born into poverty on a farm in Darke County, Ohio, in 1860. When she was six, her father died, leaving seven children and a wife to struggle for many years. Although Oakley's Quaker mother initially forbade her to use her father's rifle, Oakley eventually prevailed, and she used the weapon to kill game for the large family. Still, her contribution was not sufficient, and Oakley was moved to the Darke County Infirmary

Annie Oakley, Buffalo Bill's Wild West poster, 1898.

[Approx. 42" × 28" (paper size). Reprint courtesy of Circus World Museum, Baraboo, Wisconsin, image number BBWW-NL200-98-1U-1.]

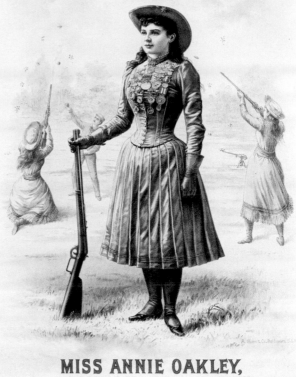

BUFFALO BILL'S WILD WEST·
CONGRESS, ROUGH RIDERS OF THE WORLD.

MISS ANNIE OAKLEY,
THE PEERLESS LADY WING-SHOT.

at the age of eight or nine so that her mother had one fewer mouth to feed. There she was taught to sew, knit, and embroider.[3] She was then farmed out to an abusive couple; after two years she escaped and returned to her mother, and then went back to the infirmary. She eventually moved back home and took up trapping and hunting again. This time she helped feed the family successfully, and after becoming a skilled trapper and hunter, she made money on the game she sold to a Greenville, Ohio, shopkeeper, who shipped it to city hotels. When Oakley was almost fifteen, the shopkeeper arranged for her to compete in a shooting match with Frank Butler, an accomplished shooter and stage performer. During the competition, he missed his last shot. Oakley didn't. They eventually fell in love and married, and for a few years Butler supported her by performing in circus and in stage acts. When Butler's performing partner became ill, Oakley joined her husband onstage. The rest, as they say, is history. Phoebe Ann Butler took the stage name Annie Oakley, and in 1885 the Butlers joined Buffalo Bill's Wild West, where Annie Oakley became a star performer and was touted as "A Peerless Lady Wing-Shot."[4]

Oakley shot many firearms over the course of her career. Some were purchased; many others were gifts. Yet, according to Glenda Riley, author of the 1994 book *The Life and Legacy of Annie Oakley,* she refused to endorse any one gun. She did, however, have preferences. Early in her career Oakley was fond of a Parker Model 1883, G Grade, 16-gauge double-barrel hammer shotgun, and one of Oakley's favorite rifles was a Stevens 32/20 repeating rifle.[5]

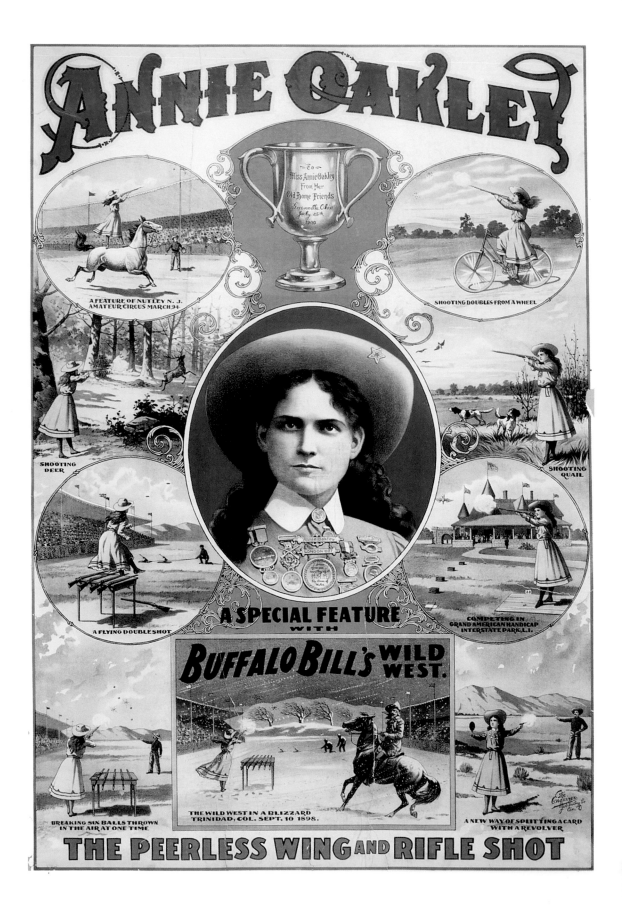

...........................

Oakley charmed audiences with her spectacular shooting skills and athletic prowess. She was one of the best shots in the country, consistently demonstrating great accuracy and skill with shotguns, rifles, and handguns. In the next chapter we'll see just how amazing her shooting skills were. For now, I wish to focus on Oakley's behavior and personality.

Oakley had a strong sense of who she was, and she adhered to Quaker ethics and values throughout her life. She always wore the proper attire for a nineteenth-century lady, refusing to wear modern clothing that allowed a woman to straddle a horse, opting instead to ride sidesaddle in a modest outfit that always covered her legs and rose to her neck.

Oakley shied away from all forms of masculine display except shooting. Her traditional womanliness was made clear, and she was well known for her domestic pursuits, including making her own dresses and knitting while on the road with Wild West shows. Little Sure Shot, another of her nicknames, had no known vices—no drinking, smoking, cursing, or gambling—and a strong work ethic.[6] She espoused an early-to-bed, early-to-rise routine and was a proponent of fresh air and daily physical activity for good health. She was also openly patriotic and volunteered her services to train women to protect the home front during times of war. She even performed shooting exhibitions for the troops at her own expense in 1918.[7] To those who knew her she remained a lady with a passion for guns.

Although her earnings supported her and her husband, Frank Butler was in charge of the business: he was her manager, he wrote articles in her defense when she was personally attacked, and he augmented their income as a representative for the Union Metallic Cartridge Company and the Remington Arms Company.

In the public eye she didn't make waves, she didn't talk politics, and she didn't support the suffragist movement. She also distanced herself from scandal except when she needed to defend her honor. For example, when the *Chicago American* and the *Chicago Examiner* wrote false stories in 1903 about Oakley being jailed for stealing "a negro's trousers to get money with which to purchase cocaine," she was mortified.[8] Apparently the arrested woman had given Oakley's name to her jailors, and without checking the facts, a reporter gave the story to his newspaper. In turn, more than fifty newspapers around the

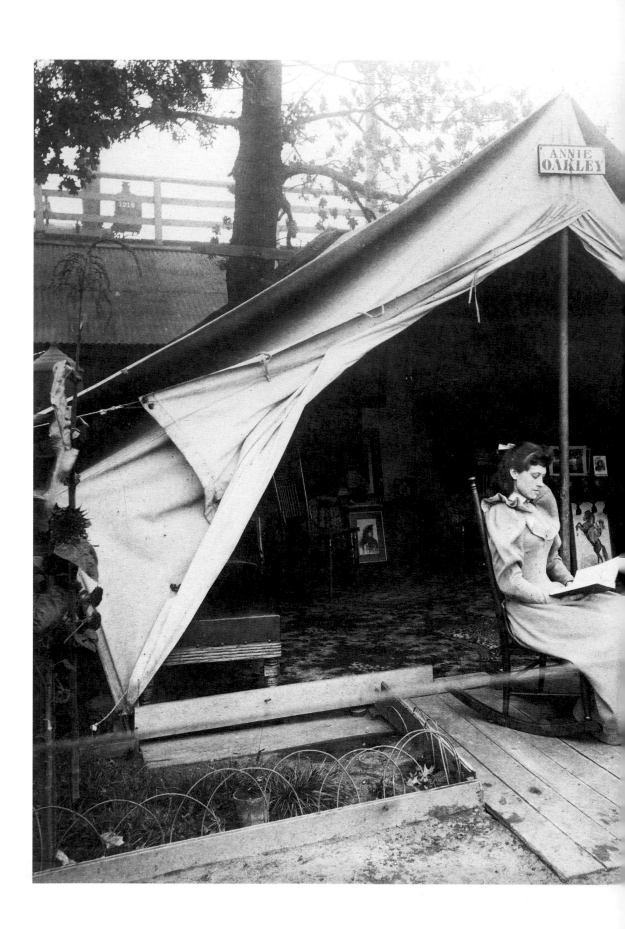

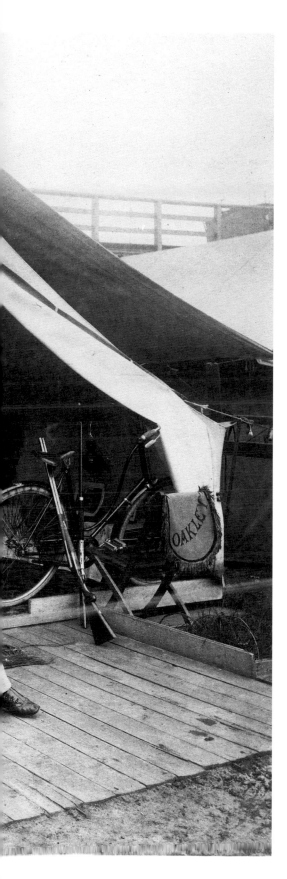

country quickly picked it up. According to Glenda Riley, Oakley practically put her career on hold from 1904 to 1910 while she traveled the country suing every paper that ran the story.[9] Various papers attempted to find scandalous details about her past to help their case in court, but she was evidently above reproach. More than a generation later, Dorothy Fields, co-author of the musical *Annie Get Your Gun,* would make the same claim in a less flattering way: in the 1940s, she and her partner attempted to incorporate entertaining facts about Oakley into their musical. They failed. There was nothing in Oakley's life or behavior sensational enough to tarnish her ladylike image. "We did a lot of research on Annie Oakley and Frank Butler . . . and both of them apparently were about the dullest people in the world. Annie Oakley in real life used to sit in her tent and *knit,* for God's sake."[10]

There was good reason for Oakley to be concerned with what genteel society thought of her. Female entertainers were generally believed to be sexually promiscuous; unconventionality could bring on scandalous publicity and possibly financial ruin. A female shooting star needed to maintain a stellar reputation if her chosen fan base was middle-

..........................

Annie Oakley at the Chicago World's Fair, 1893.

[Sepia-toned photograph, 7 5/8" × 9 1/2". Reprint courtesy of the Buffalo Bill Historical Center, Cody, Wyoming, image number P.69.73.]

and upper-class families. Financially as well as personally, it was prudent for a lady to fight actively to clear her name.

Oakley worked the Wild West circuit, off and on, until 1913. For years after her retirement, she and her husband traveled to wealthy resorts for relaxation, finding comfort in places where they could socialize with others as well as participate in the activities they both enjoyed, such as hunting, horseback riding, taking long walks, and sports shooting. Oakley also enjoyed offering free shooting lessons to women, and her classes were quite popular. Given her fame, her presence and lessons were viewed as a great honor by the women and girls whom she met.

Oakley ardently encouraged women to take up shooting, telling them they could excel in the sport if they so desired. She was instrumental in defining the gun woman of her generation; and while she had critics, women and girls who aspired to be like her learned that becoming an accomplished markswoman took hard work and discipline. "From many years of experience," she wrote in 1920, "I have come to the conclusion that, except in some extreme cases, it is largely a matter of determination and practice that make good marksmen and women."[11]

Oakley's life and the myths surrounding her still resonate with many Americans. The musical *Annie Get Your Gun* has been extremely successful since it was first staged in 1946 and has played many times over in theaters in America and abroad. It was made into a movie in 1949, and in 1999 the musical returned to Broadway (albeit somewhat revised, in part, because of racist scenes in the original script), and many famous actors and singers have since played Oakley's part. Since her death in 1926, Oakley has appeared countless times as a character in magazines and books. In the 1950s a television series, complete with merchandising (toys, comics, clothing) celebrated her image and her life. A few years ago, the Annie Oakley TV series was released on DVD. Oakley was inducted into the National Women's Hall of Fame in Seneca Falls, New York, in 1993, and the Annie Oakley Foundation in Oakley's hometown area of Greenville, Ohio, states that Oakley "has become a role model for students and foundation members ranging in age from nine to ninety."[12] The foundation is raising money for a proposed Annie Oakley Cultural and Activity Center to honor her life and legacy.

Photographs and illustrations of a physically fit Oakley show her in feminine or ladylike poses, looking dainty even while leaping over obstacles before grabbing her gun or shooting from the back of a galloping horse. The petite Oakley looks like a girl in many of her studio portraits, and her form-fitting

dresses emphasize this. Shooting medals appear in many of the photographs, fastened to the front of her blouse or affixed to a cloth inscribed with "Oakley" and draped over the edge of a table. She often wore a hat with a star on the brim. With the exception of her hands, her outfits cover her from neck to toe. Snapshots of Oakley show her teaching women and girls to shoot, reading outside her tent, and giving shooting performances.

In films of her performances, Annie Oakley seems to move effortlessly, shooting over and over at objects tossed into the air. What a thrill it must have been to take shooting lessons from her! I wouldn't want to shoot targets while standing atop a moving horse, or apples off a dog's head, or playing cards out of Frank Butler's hand, but I'd like to learn how to shoot six balls out of the air before any of them hit the ground. I'd try to find out if her ladylike manner was true to her character at all times. Although it's possible she believed in the social customs and manners she publicly displayed, as many researchers of her life suggest, she compensated for any negative publicity by going to extremes (e.g., suing newspapers for libel even after they retracted the story about cocaine use). To me, this behavior seems obsessive, perhaps a bit paranoid, given that her good name was reinstated when the newspapers issued retractions. But I speak as a twenty-first-century woman—possibly Oakley's actions made sense at the time: she wanted society's approval for her excellence with guns, and she knew that even a slight impropriety could prove disastrous. So Oakley never drifted far in public. She was indeed a shrewd, complicated woman who kept her private life private and her public life free from scandal—she was an astute businesswoman who worked the system to her advantage, performing within the proper social codes of her time, and became a highly respected and successful shooting superstar.

Calamity Jane (1856–1903), born Martha Jane Canary, was the antithesis of Oakley. After her death in 1903, she was remembered by the *Bozeman Avant Courier* as a woman with "a man's will and a man's nerve always, but she had acquired a masculine appearance and, I am sorry to say, some of the masculine vices."[13]

Calamity Jane's life does not read like Oakley's real-life fairy tale. It's also more difficult to separate fact from fiction in Jane's life, because of the many tall tales told about her and the lack of documents to repudiate or substantiate them. James D. McLaird's 2005 book, *Calamity Jane: The Woman and the Legend,* does an excellent job of separating some of the facts from some of the fiction. Yet even with his extensive research, McLaird acknowledges that many questions about her life remain unanswered: "there are still leads to follow

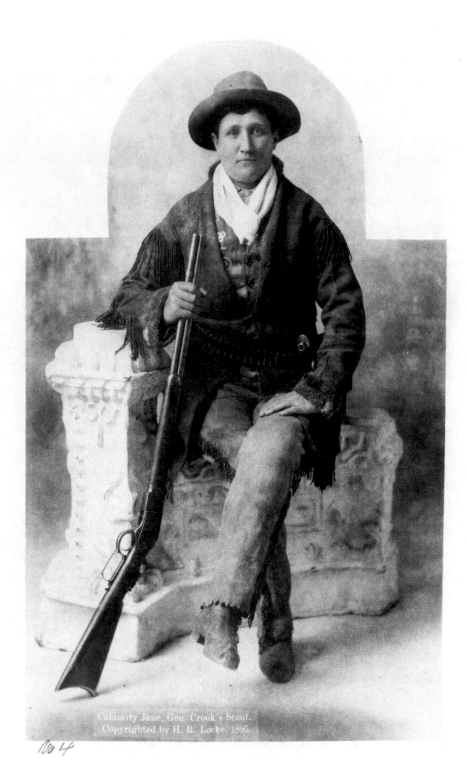

No 4

Calamity Jane, age thirty-nine, 1895. The long gun is a Winchester Model 1873 lever-action rifle. The revolver appears to be a Webley Model 1872 Royal Irish Constabulary double-action revolver.

and bits of information in my files that need to be connected."[14] Jane herself contributed mightily to these tall tales. In her 1896 autobiography, *The Life and Adventures of Calamity Jane,* she claimed that she was born in Missouri in 1852 and that her family migrated west. She and her siblings had to survive on their own at an early age because their parents either died or abandoned them. Any young girl alone in a mining town in the 1850s and 1860s would have had her share of bad influences. Most sources agree that Jane was a bullwhacker[15] on occasion, perhaps tried her hand at staking claims, worked in saloons, restaurants, and laundries, and was a prostitute. She married at least once, had a child, and was an alcoholic.[16] Some acknowledge that although she lacked domestic charms, she did display compassion and kindness for the ill and destitute, caring for those who needed help. But staff at the Adams Museum in Deadwood, South Dakota, are more blunt: she was a drunk, abandoned her child, and died alone. They have no plans to build a museum or center to honor her life and legacy.

Jane led a hard life, preferring boomtowns to cities and saloons to domestic life. She claimed to be a scout, hunter, and expert horsewoman, and in the first two paragraphs of the booklet she is said to have written in 1896, she tells how she preferred to be remembered:

As a child I always had a fondness for adventure and out-door exercise and especial fondness for horses which I began to ride at an early age and continued to do so until I became an expert rider being able to ride the most vicious and stubborn of horses, in fact the greater portion of my life in early times was spent in this manner.

In 1865 we emigrated from our homes in Missourri [*sic*] by the overland route to Virginia City, Montana, taking five months to make the journey. While on the way the greater portion of my time was spent in hunting along with the men and hunters of the party, in fact I was at all times with the men when there was excitement and adventures to be had. By the time we reached Virginia City I was considered a remarkable good shot and a fearless rider for a girl of my age [fourteen].[17]

This small pamphlet was published late in her life—long after she had been made famous in dime novels and adventure stories for boys and young men. While many questioned the details of her tale, it's true that Calamity Jane was an armed, coarse woman who led an unconventional life. In 1896 the *Helena (Mont.) Daily Independent* expanded on her behavior:

Calamity Jane belongs to a type that, though once familiar in all western towns, is now fast dying out. The best portion of her life was spent on the plains and in the mountains at a time when dangers abounded. She endured all the hardships, privations and dangers of a life on the frontier with a sturdiness that won her the admiration of all the rough element with which she was thrown in contact. She possessed an adventurous spirit and was never so happy as when engaged in some perilous undertaking. She might, perhaps, have escaped many of the dangers incident to border life had she tried, but she lived in an atmosphere of adventure and the more she breathed of it the more she liked it.[18]

Her manner and occasional dress in men's clothing made Jane a novelty and a "freak" by the standards of the day. In her younger years, newspapers had played up her cross-dressing, as the *Denver Daily Rocky Mountain News* did in 1877:

As she sits astride her horse there is nothing in her stare to distinguish her sex save her small, neat fitting gaiters and sweeping raven locks. She wears buckskin clothes, gaily beaded and fringed, and a broad-brimmed Spanish hat. . . . Donning male attire in the mining regions, where no restraints were imposed for such freaks, she "took the road" and has ever since been nomadic in her habits—now one of a hunting party, then in a mining stampede, again moving with a freight train and it is said that she had rendered services as a scout. She has had experience as a stage driver, and can draw the reins over six horses, and handles the revolver with dexterity, and fires it as accurately as a ranger. She is still in early womanhood, and her rough and dissipated career has not altogether "swept away the lines where beauty lingers."[19]

According to Roberta Beed Sollid, it's not always clear from newspaper accounts when a reporter was describing Martha Jane Canary and when he was discussing some other woman claiming to be Calamity Jane.[20] Some women, admiring her notoriety, pretended to her identity. It was also not uncommon for a woman with one or more of Canary's habits to be called Calamity.

Jane was happy to pose for photographs but distrusted reporters. A number of reports agree that she had a mouth like a toilet, preferred the company of men, and drank excessively. Her out-of-control drinking would eventually kill her. Less than a year before her death, in 1902, the *Billings (Mont.) Gazette* reported that she had been jailed for threatening a young woman: "Without any apparent

PLEASURE: SPORTS SHOOTING, ENTERTAINMENT, FICTION

reason, save that suggested by a mind more or less disordered by too free indulgence in her favorite tipple, Jane armed herself with a hatchet and invaded Yegen Bros. Store and attempted to put an end to the existence of one of the young ladies employed in the drygoods department."[21] According to many reports, and echoed by William F. Cody (Buffalo Bill Cody) at the time of Jane's death, a Captain Egan had given Jane the name Calamity after she saved his life. Cody also claimed she had been a scout in the U.S. Army, was courageous, and had saved many lives. According to Richard Slotkin, however, author of *Gunfighter Nation: The Myth of the Frontier in Twentieth-Century America*, many of Buffalo Bill's claims are suspect; he was one of the key players in the creation of the mythical West, so he had a vested interest in touching up the story of Jane's life.[22]

Her notoriety, much exaggerated by everyone, did not sit well with all reporters. Some, like this reporter from the *Yankton (S.D.) Daily Press and Dakotian* (1877), grew tired of the attention she garnered:

> It is a fact that cannot be successfully contradicted, that newspapers make presidents, senators, generals, politicians and "sons of guns." The best specimen in substantiation of this assertion is Calamity Jane. So far as real solid merit is involved, she is a fraud, a dead give away. . . . Suppose she strikes out and lays around with a lot of road agents on the prairies—what of it? A squaw does the same thing. Why, then is she entitled to more consideration than a squaw? Yet, she is. . . . Everybody who has been in the Hills knows Calamity; simply because the newspapers have thrown her up on the surface of public notice, like a volcano throws up the bowels of the earth. She is nothing in the aggregate of nature. The old madam was not generous with her when she cast the die that molded her. Her form and features are not only indifferent, but repulsive. It makes us tired to see so much written about her, and, to be honest, this item makes us sick, too.[23]

Despite such criticism, or perhaps because of it, the persona of Calamity Jane continued to interest the public. Jane preferred the freedom of the West, perhaps because there she could ignore most female conventions and do as she pleased. Late in her life, in 1896, Jane was hired by Kohl and Middleton's museum in Chicago to make appearances and tell her tall tales, and the *Chicago Daily Inter Ocean* repeated many of her legendary gun-toting myths as facts: "As a marksman she had no peer, and in riding the uncultured mustang she held her own in with the most reckless men. With her rifle she won the respect of everybody—even the Indians. In the early days of Deadwood she served on the

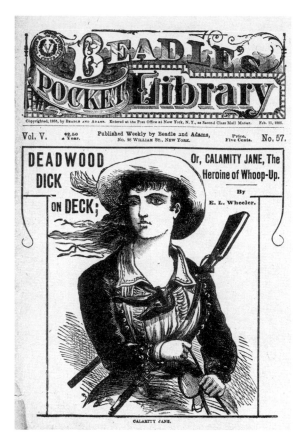

Deadwood Dick on Deck, or, Calamity Jane, the Heroine of Whoop-Up: A Story of Dakota
[New York: Beadle and Adams, 1885. 5 9/16" × 8 5/16".]

vigilance committee and participated in all of the lynching bees."[24] Indeed, Jane remained well known even late in life, initially because of a generation of boys who had grown into men reading the early dime novels, then later because of the public's fascination with all things "Western."[25] Buffalo Bill Cody, whose firsthand knowledge of Jane was minimal, and whose commitment to the romanticizing of the Wild West was absolute, reminisced to reporters at the time of her death in 1903, "Calamity was a character—an odd one. She always was different from any woman I ever knew, and it has been my fortune to meet many different kinds of women. None of us on the frontier ever met any one like her. She belongs to a time and a class that are fast disappearing."[26]

Calamity Jane was a popular subject of newspaper articles from the 1870s until her death, and she reinforced her popular image by publishing an autobiography in 1896. Stories about her continue to be published today, along with the images of her posing in a buckskin outfit with a rifle and handgun. Characters based on her appeared in fiction and silent films through the 1920s, and after sound was introduced she was featured in a variety of movies and television programs; Doris Day's performance as Calamity Jane in the 1950s film of the same name is perhaps the best known. Jane's character even made a brief comeback in a Saturday morning cartoon show, *The Legend of Calamity Jane* (1997–98); and the latest reincarnation is a very hard-edged Calamity Jane character in the HBO television series *Deadwood* (2004 to present).

In most of Jane's gun-toting studio portraits, her posture is straightforward and the studio set is spare. A photograph taken around 1876, when she was approximately twenty years old, shows a disheveled Jane wearing a buckskin jacket that hangs slightly askance on her right shoulder—it isn't even buttoned

properly for a formal portrait. Her pants drag on the ground. Her hat is tilted and her weight is shifted to her left leg. She stares at the camera blankly. Her revolver is holstered on her right side with the grip pointing toward her left side. Her rifle, according to Warren Newman, curatorial assistant at the Cody Firearms Museum, is a Stevens Hunter's Pet Pocket Rifle No. 34.[27] Interestingly, not only does the style of handgun and rifle change over the years, the handgun's placement changes, too.

Jane's life as we know it is a combination of fact and myth. The majority of photographs published for tourists today show her with guns and dressed in men's clothing; yet in most photographs taken outside the studio, Jane wears a dress, not britches. The buckskin outfits in the posed tourist photographs, which she may or may not have owned, were worn primarily to reinforce the myths created by dime novels and false newspaper reports.

Jane used her guns to rebel against traditional roles for women. If I could meet Jane, I'd want to know how she really felt about her difference. How much she worked the system once she was celebrated in the press and dime novels and how much of her behavior was genuine is anyone's guess. She was sought after and occasionally employed for her rough, tough, unfeminine ways; with rebellion came tourists, and she was able to hawk more photographs and copies of her autobiography. She died a pauper, but perhaps even with all the drinking, she led the life she preferred.

Drinking a couple of beers, riding horses through the Black Hills, and carousing with Calamity Jane would be fun. I might even go on a bullwhacking trip with her. I'd like to shoot tin cans with her to see how she handles a pistol and rifle. There's no evidence that she had the expert shooting skills of Oakley, but I'd like to think Jane was good enough. I'd like to meet her before the 1880s, however, in the hope that I might hang out with her before her drinking became all consuming.

Advances in media in the second half of the nineteenth century were instrumental in making celebrities of Jane and Oakley. Jane wrote a short autobiography; Oakley published articles about shooting in newspapers and magazines. For both, the press played a significant role in building their fame during their lifetimes. Photography also contributed to their fame. They appeared in portraits in their shooting outfits, holding firearms. Oakley would also be captured on film in the late 1890s, shooting at glass balls, and later at a shooting exhibition in 1910.

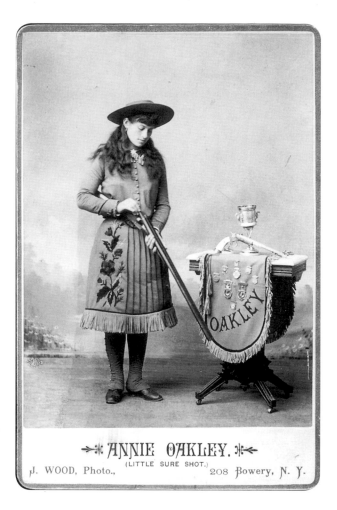

ANNIE OAKLEY.
(LITTLE SURE SHOT.)
J. WOOD, Photo., 208 Bowery, N. Y.

Annie Oakley, ca. 1885. Oakley may be posing with her favorite shotgun at the time, a Parker Model 1883, G Grade, 16-gauge double barrel hammer shotgun. The handgun is a Stevens-Lord No. 36 single-shot pistol.

[Sepia-toned photograph, 6⅜" × 4¼". Photograph by J. Wood. Reprint courtesy of the Buffalo Bill Historical Center, Cody, Wyoming, image number P.69.1177]

The myths that surround Oakley and Jane were reinforced by these commercial photographs. This is what they wanted us to know about them, or at least this is how the photographer instructed them to pose, and they complied. In most of Oakley's photographs her body turns away from the camera. She's loading her shotgun, reading a book, or posing with her chest covered with shooting medals as she looks out past the camera at some distant object. In most of Jane's photographs, her body is straightforward, her eyes meet ours. She stands or sits wearing a buckskin jacket and trousers, and is armed with a rifle and handgun. Simply put, in commercial photographs Oakley is photographed like a woman; Jane is photographed like a man.[28]

Oakley told us over and over, in photographs, letters, interviews, and the articles she wrote, how she wanted to be remembered. Jane's life is more difficult to assess. Most photographs of Jane outdoors, with the exception of one in which she sits atop a horse at a fairground, show her in dark dresses, not buckskin.[29] There seem to be no photographs of her as a bullwhacker, scout, or any other of the adventurous occupations she claimed. Both James McLaird's and Roberta Sollid's research suggests that Jane was mostly a camp follower and not an active player in bullwhacking or scouting. It's not even clear that she owned her guns. As stated earlier, the handguns and rifles in photographs of her changed over the years; and James McLaird told me that he suspects that the firearms for photo

shoots were borrowed, explaining that even if she owned a firearm, she probably wouldn't have kept it for long—apparently she often sold her belongings for alcohol.[30] This may explain why the position of Jane's holster changes: sometimes it's on the right, sometimes on the left. Perhaps she was ambidextrous, or perhaps the handguns, like many of the tales about her, weren't always hers.[31]

For the most part, Annie Oakley complied with social expectations, and she was rewarded with an untarnished reputation. This didn't mean she was like other ladies of her generation, however. While shooting and hunting were acceptable pastimes for women—pastime being the operative word here—for Oakley they were her passion and her career. By adopting a traditional demeanor in public she was able to make statements and give opinions about women and shooting. In essence, she made it look natural for a lady to be good with a gun. Unlike Oakley, who infiltrated the male world of shooting and hunting and was a role model for women and girls, Calamity Jane remained an outcast to most citizens who knew her, and a curiosity to tourists. Jane did not play along with social expectations, and many who knew her considered her a slattern. This means that two of the most visible and popularized gun women of nineteenth-century America were viewed as variations of the virgin/whore dichotomy common since biblical days—a dichotomy that's been played out in myths and legends ad nauseam, making it difficult for real women to break out of traditionally feminine roles.

Calamity Jane had many critics during her lifetime because of her behavior while drunk and her exaggeration of

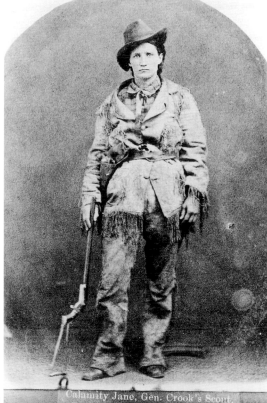

.............................

Calamity Jane, age twenty or twenty-one, ca. 1876-77. The rifle is a Stevens Hunter's Pet Pocket Rifle No. 34 with a heavy-frame detachable shoulder stock. The holstered pistol is a Colt single-action army revolver, and the small pistol resembles a Smith & Wesson Model No. 1 third-issue revolver.

[Photograph by H. R. Locke. Silver gelatin print, 5 5/8" × 4". Reprint courtesy of the Library of Congress, Prints and Photographs Division, Washington, D.C., image number LC-US262-17514.]

Annie Oakley Room, Garst Museum, Greenville, Ohio, 1997.

[Chromogenic print. Photograph by Nancy Floyd.]

..........................

the truth. She was also criticized for the actions she didn't perform but that were part of contemporary publicity. The dime novels that made her famous, and many stories about her to this day, reinforced the myths. Most of the stories were totally fabricated, her character adventurous and sexualized for the male reader—she was transformed into a male fantasy.[32] In contrast, Annie Oakley became a gun woman superstar because of her shooting skills, her affiliation with Wild West shows, and her knack (with help from her husband) for self-promotion. Her prim behavior and avoidance of controversy also helped her overcome the reputation of many female performers. As a result of marketing, Jane's character was popular with boys and young men, and Oakley's character was popular with families.

Gender roles have evolved since 1850, and standards of behavior for women are dramatically different today, yet cultural myths concerning women's roles remain hard to shed. Women with guns and those who support them mostly

Two girls writing about Annie Oakley, National Women's Hall of Fame, Seneca, New York, 1998.
[Chromogenic print. Photograph by Nancy Floyd.]

endeavor to distance the armed female from the masculine female by emphasizing feminine qualities whenever possible. Mainstream America, then and now, approves of girl sharpshooters, can put up with tomboys, and tries to ignore outspoken masculine gun women.

Male and female narratives in popular culture have been conventionally demarcated along gender lines, thereby reinforcing and rarely challenging the way Americans look at masculinity and femininity. It's within this popular culture that female shooters first become visible. Live performances and female action figures in books, comics, film, and on television have entertained us for more than 130 years with their outstanding shooting skills and dramatic tales of high adventure. In the next chapter, I look at Jane and Oakley again, this time as media concoctions, alongside other gun-toting female performers. I explore how women with guns have been represented and promoted in the entertainment industry, what has changed, and what hasn't.

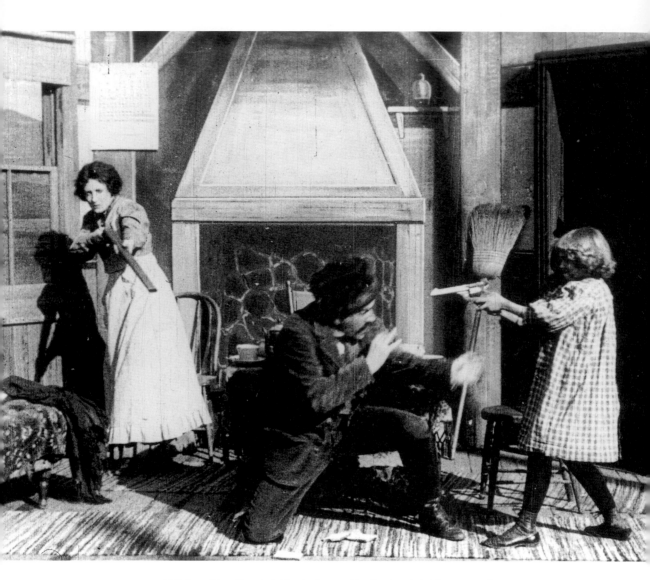

Still from *Ventriloquist's Trunk*, directed by Frederick A. Thomson, 1911.

A lecherous landlord attempts to take advantage of a woman in her apartment. His advances aren't welcome and a scuffle ensues. The woman's daughter runs into the room, jumps atop a table, and hits the unsuspecting landlord with a rolling pin, knocking him to the floor. The daughter grabs his handgun as her mother grabs a shotgun from the corner of the room. Barrels pointed, they make the landlord leave.

. .

LOOK OUT!
SHE'S GOT A GUN!

4

.........................

The 101 Ranch cowgirl. The sauciest, happiest, loveliest assemblage
of femininity that ever galloped gleefully around an arena or
appeared in a street parade. . . . The real cowgirl may be an element
of society new to this city, but she is a welcome comer. She is a
development of the stock-raising West comparing with the bachelor
girl and the independent woman of the East. She is not of the new
woman class—not of the sort that discards her feminine attributes
and tries to ape the man, simply a lively, athletic young woman
with a superfluity of nerve and animal spirits, with a realization
that in affairs where skill is the chief qualification she has an equal
chance with her brothers. . . . They can "rope" with horse running
at top speed, swing gracefully from the saddle and pick a fallen
handkerchief from the ground, mount and subdue "bucking" horses,
and use gun or pistol with the nonchalance and proficiency of the
most expert cowpuncher.

—*Miller Brothers and Arlington 101 Ranch Real Wild West*
(1915 brochure)[1]

Women with guns in fiction and live performances have
captured America's imagination since at least the post–
Civil War era. However, only a few really "owned" their
shooting capabilities—their guns fitting, literally as well
as metaphorically, snuggly in their hands. These armed
female action figures took control of their own destinies and went after their
own needs and desires. Some tried to fit in, not to make waves or challenge
masculinity (too much) with their guns. Others were edgy: they either tried to
fit in but couldn't manage it, or they left the straight and narrow to get what
they wanted or needed to survive. These women were superstars and superhe-
roes. They claimed their right to play with guns.

I focus in this chapter on fictional narratives in which women are given top, not equal, billing with men. If she's part of a mixed-gender team, is ambivalent about her role, or uses her gun as a handy tool only occasionally, I'm not likely to discuss her here. Apologies to those who feel I've missed their favorite gun woman—it's inevitable, given the number of women with guns out there in fiction land. I look at popular spectacles and narratives, primarily Wild West shows, novels, movies, and television, focusing on sharpshooters who entertain audiences with their shooting prowess and fictional female action figures who save the day.

It's not necessary for the female action hero to undergo complex character development for her to be included here. I don't distinguish between what would be considered good or bad fiction. For example, dime novels and silent Western melodramas are predictable and at times, frankly, corny. However, if I believe the heroine's behavior is true to her character after the bad guy yells, "Look out! She's got a gun!" and she fits the criteria I've set up for this chapter, then she's someone I'm going to discuss.

..........................

top: Studio photograph of Jennie surrendering to Julia, ca. 1907-18. [Real photo postcard, 3 ¼" × 5".]

left: Studio photograph of a woman dressed in a cowgirl costume pointing what may be a derringer at a second woman, dressed in a Native American costume. [Real photo postcard, 3 ⅜" × 5 ⅜".]

If you're looking for role models for women's equality, black resistance, or lesbian revolution, you won't find them in most female action hero narratives—guns never bring about *that* kind of equality. But if you like wiping Alien slime off your face, figuratively destroying rapists and homophobes, and standing up to a bunch of bad guys with a sawed-off shotgun and no backup, saddle up your horse or start up your sports car or starship, and I'll take you on a journey past shooting superstars and female action figures. You can kill as many bad guys—and, later on, bad gals—as you want, or you can hold them at bay until help arrives.

The earliest widely distributed tales of female gunslingers were produced by the publishing house of Beadle and Adams (originally Irwin P. Beadle & Company), which printed the first dime novels in 1860. These inexpensive booklets, full of action and high drama, were primarily read by boys and young men. In dime novels about the West, descriptions of a character's dress and demeanor told the reader what to think of the individual. Bad guys were weak and good guys were strong. Extreme stereotypes were used to keep action moving quickly. Firearms were central to rites of passage for men; weapons were natural accessories. The rare woman or girl who rode, shot, and performed acts of bravery in dime novels did so for different reasons. She was armed not because she desired the gun and was born a good markswoman but because of some tragic event from which no man could save her. This cataclysmic event, be it rape, deception, or the murder of loved ones, made her shift in behavior acceptable, understandable. In *Buffalo Bill Border Stories,* for example, published in 1908, Dell explains her reason for arming herself:

> "They're sawed off 38s," said the girl promptly, jerking one of the weapons into view. "I can take your sizing, all right, Nomad. You think I'm too much of a spectacle to make good in a fight. I'll admit to you that I don't like rowdiness. I try to be a lady both at home on the ranch and when I'm abroad in the hills. But I don't think any the less of a lady because she's able to take care of herself. Do you?"
>
> "Nary, I don't," said Nomad.
>
> "I'm no second edition of Rowdy Kate or Calamity Jane; but when my father died"—the girl's voice trembled, and a mist came into her fine eyes—"and left no one but me to look after mother and take care of the ranch, it was up to Dell of the Double D to show her hand. In self-defense I was obliged to learn the ways of the frontier. How well I have learned them, Nomad, any one in these parts can tell you."[2]

..........................

The reader is meant to feel sorry for Dell and her mother. The tragedy justifies the female hero's actions. Depending on the story, the transformation can range from becoming an expert shot in order to survive, like Dell, to a complete gender switch, in which the heroine rejects womanly ways and seeks instead manly revenge, as Hurricane Nell does in the 1899 dime novel *Bob Woolf, the Border Ruffian, or, The Girl Deadshot*:

"No! that ye're mistaken. A purer, prettier, braver girl never breathed, sir. I've known Hurricane Nell since her escape from the great prairie fire five years ago, an' could swear that her honor is as bright as ever was the honor of a saint. She's an odd one, though. Her whole life is devoted to the one terrible object, revenge. She roams through the wilderness in various disguises, and every few weeks someone finds a dead outlaw, wi' her death-mark upon him.[3]

Like Hurricane Nell, the fictional version of Calamity Jane was admired for her bravery as well as her beauty, as a dashing young woman hidden behind manly dress and behavior. Calamity Jane was the bad girl in a sexually attractive way: a sharpshooting wild woman. In the 1899 dime novel *Deadwood Dick in Leadville, or, A Strange Stroke for Liberty,* Calamity

was attired in a costume consisting of fancifully ornamented buckskin breeches, and a hunting-frock reaching nearly to the tops of a pair of patent-leather knee boots. A jaunty slouch hat boasting of a wild eagle's feather, she wore back upon her head; a belt upon her waist contained a pair of handsome revolvers.

These were the principal items of her make-up, except that she was even more handsome than when we saw her last, with her eyes grown brighter, her checks more tinted, and her form just a trifle more robust.[4]

A creature like no other, in the 1887 novel *Calamity Jane: A Story of the Black Hills,* she is noted for her kindness as well as her strength by the men with whom she gambles and drinks:

"She's a wild 'un! Man or ooman? Who ken tell? Wi' the face o' a girl, an' the strength o' a man, an' more darin' than both on 'em tergither. But no badness in her, no meanness. That's Calamity! Here's one fer her!" So agreed the men, and being in the mood for cheers, they gave her one, good and hearty.[5]

Like most heroines of adventure fiction, Calamity's manner and behavior are blamed on bad experiences. Without a man and hardened by life, she sometimes takes the law into her own hands. In the 1885 dime novel *Deadwood Dick on Deck, or, Calamity Jane, the Heroine of Whoop-Up: A Story of Dakota,* she shoots a man for insulting her: "His sentence was finished in a ringing shriek, for Calamity had drawn a revolver and shot him, even while his sarcastic words left his lips, and he fell to the ground, wounded through the breast."[6] It is clear to Calamity, however, and to the reader, that her actions, while extreme, are justified, given the circumstances.

Like other dime novel heroines, Calamity may marry at the end of the story, but by the next tale she is single again. Her handsome—as opposed to feminine—beauty and her zest for adventure presumably made her sexually

attractive to the boys and young men who read many of the stories featuring her in dime novels and, later, Western comics.

Being attractive and adventurous is not enough for a dime novel heroine, however. She must display the same qualities admired in male heroes, and her athletic prowess with firearms and animals must border on the superhuman. Above all else, Calamity is what is considered in dime novels to be a good pard—an exceptionally good friend, someone who is honest and trustworthy to the very end, and who is willing to take a bullet for you. Good always triumphs over evil in a dime novel. Just like male heroes, Calamity Jane is in the right place at the right time to save the day using her seemingly superhuman abilities. She is the best, the smartest, and the most powerful character, and the bad guys don't have a chance. While dime novels were written for boys, I imagine that at least a few nineteenth-century girls secretly read their brothers' stories and were entertained by Calamity's adventures.

In contrast to the unbridled wildness of the Calamity Jane character, the gun women of Wild West shows and of early film and television were promoted as ladies with extraordinary skills. Annie Oakley, Lillian Smith, and other women performed fantastic feats of skill with their guns in Wild West shows. In early film and television, heroines performed death-defying acts while protecting themselves and loved ones from the bad guys. Action and melodrama were highly desired elements, both in Wild West shows and in early film and TV. The armed female conformed to certain early twentieth-century gender-based roles, and scenes in which she shot at targets while riding a bicycle or a horse or jumping on a train entertained female and male viewers alike. Female action figures in film were athletic, honest, ethical, and principled ladies. They knew the difference between right and wrong and were usually cool under pressure. Most of these characters remained within accepted female roles, and by the end of the film they were usually in the arms of the handsome male lead.[7]

The real Annie Oakley was a traveling Wild West show entertainer. Wild West shows, popular from the 1880s to the 1920s, were large production companies that traveled around the country like circuses. The programs expanded on Western myths created in late nineteenth-century dime novels and created new ones. Buffalo Bill's Wild West, Pawnee Bill's Wild West, and the 101 Ranch Real Wild West produced nationalistic displays designed for white, mainstream audiences.[8] Famous military battles, spectacular athletic feats with animals and guns, and Western history lessons were all part of their narratives.

Armed with a variety of handguns, shotguns, and rifles, Annie Oakley was the Wild West show's quintessential female sharpshooter. A few females rivaled her skills, but Oakley's fame gave her top billing in myth and legend. She never performed in simulated battles with Indians or bad guys; she was featured for her shooting skills alone. In an 1894 Wild West program where other featured acts were described as "Attack on the Deadwood Mill Coach by Indians" and "Attack on Settlers' Cabin," Oakley's act was described simply as "Miss Annie Oakley, Celebrated Shot, who will illustrate her dexterity in the use of firearms. . . . an accomplished equestrienne . . . her success with the public has been greatly enhanced by the fact that in dress, style and execution she is as original as she is attractive."[9]

After retiring from Wild West shows, Oakley continued her shooting performances and even tried her hand at acting. But while the reputations of most women entertainers in Wild West shows were tarnished by the affiliation, Oakley overcame this negative stigma. She boasted an impressive stature as an accomplished sharpshooter and was billed favorably in

. .

top: Jeanette Bruno, rodeo trick rider, ca. 1910–20. Bruno (ca. 1896-1960) was a full-blooded Wasco Indian. She worked as a rodeo trick rider in the early 1900s.
[Reprint courtesy of Pamela Louis, granddaughter of Bruno.]

right: Cowgirl and friend, ca. 1907-18. The girl on the right may be a younger Jeanette Bruno.
[Real photo postcard, 3⁷/₁₆" × 5⁷/₈".]

program guides. Credit must also be given to shrewd public relations. Oakley was always described as a lady:[10]

> Miss Annie Oakley comes to the Majestic Theater next Monday and Tuesday, with a matinee each day, in a comedy-drama by Langdon McCormick, author of "The Tollgate Inn," entitled "The Western Girl." Miss Oakley has an enviable reputation as champion lady rifle shot of the world, and was for years the star feature of Buffalo Bill's Wild West. Unlike the usual western dramas commonly produced nowadays, this play has little of the wild and wooly to recommend it, and rather appeals to the better class of theater-goers because of its real merits as dramatic creation. True, there is some shooting; the star uses her rifle at critical moments to the discomfiture of the villain, and incidentally to break a few glass balls, just to show her old time skill; but instead of a lurid Jesse James play, the audience will enjoy a beautiful story of western life entreatingly told and magnificently mounted.[11]

No other woman sharpshooter achieved the lasting fame of Annie Oakley, but other female shooting stars in Wild West shows were arguably as good, if not better, with a firearm. Lillian Francis Smith, later known as Princess Wenona, rivaled Annie Oakley and set her own sharpshooting records, earning special billing for her shooting skills.

Smith beat many top shooters and became famous, at the age of fifteen, while performing in Buffalo Bill's Wild West. One Wild West program claimed that Smith's interest in shooting began at a young age: "At seven [Smith] expressed herself as dissatisfied with 'dolls' and wanted a 'little rifle.'" The program goes on to describe Smith's first outing with a Ballard .22-caliber rifle, given to her by her father when she was nine: "after a little practice and instruction, she, on her first foray, mounted on her pony, bagged two cottontails, three jack-rabbits, and two quail."[12]

Although Smith's skills rivaled Oakley's, the two never competed in a match. According to Michael Wallis, author of *The Real Wild West,* many at the time considered Smith's skills superior to Oakley's.[13]

While touring with Buffalo Bill's Wild West, Smith was touted as a young lady who outshot everyone, making local shooting competitions unfair. In 1887 she "killed so many turkeys she was set back to 200 yards, but her dexterity at that distance being equally destructive, the managers arranged with her 'to drop out and give the boys a chance at the turkeys, too.'"[14]

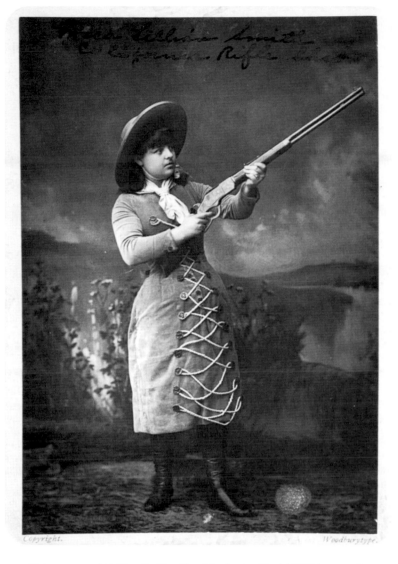

Sixteen-year-old Lillian Smith with a Winchester Model 1873 lever-action
repeating rifle, .22 rim fire caliber, ca. 1887.

[Sepia-toned Woodbury-type, 4 ¼" × 5 ³¹/₃₂". Reprint courtesy of
the Buffalo Bill Historical Center, Cody, Wyoming, image number P.69.1588.]

. .

 Smith eventually left Buffalo Bill's Wild West but continued to perform
throughout her life in other Wild West shows and in private shooting exhibi-
tions, such as those held at shooting clubs. By the end of her career she was
with the Millers' 101 Ranch Real Wild West and had changed her name to
Princess Wenona (many accounts listed her as a Sioux tribe member), and in
newspaper articles she was still heralded for her shooting skills. Smith died in

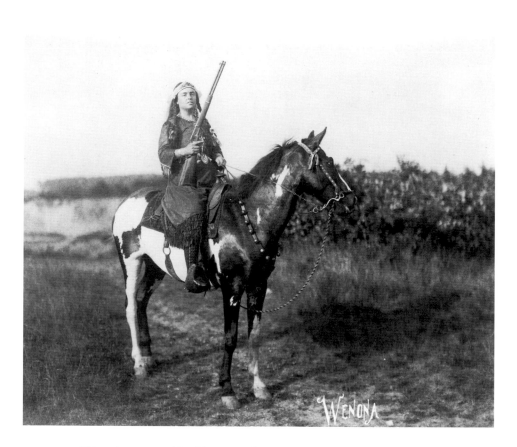

Thirty-three-year-old Wild West performer Princess Wenona (Lillian Smith)
with a Winchester Model 1892 lever-action carbine, 1904.
[Photograph by Fred Glasier. Silver gelatin print, 6" × 8". Reprint courtesy of the Library of Congress,
Prints and Photographs Division, Washington, D.C.]

.........................

1930. She requested that her tombstone read *Lillian Francis Smith* but stated, "I
wish to be buried in my Indian clothes."[15] In 1999 the people of Ponca City,
Oklahoma, erected a black granite marker at her gravesite, and the mayor pro-
claimed 21 August Princess Wenona Day. The marker includes a list of "unbro-
ken records" Smith achieved while shooting glass balls thrown in the air with
a .22 rifle. Achievements include breaking 495 of five hundred balls, breaking
one hundred balls in eighty seconds, and hitting twenty-four of twenty-five
eight-inch bull's-eyes at two hundred yards.[16]

Wild West shows began declining in popularity at around the same time
that moving pictures were becoming popular. As the twentieth century began
and film technology advanced, some storeowners began showcasing short films
of live and staged performances in their establishments. Mostly ignored by the
wealthy and middle classes but popular with the working class, these nickelode-

ons, as they came to be known, acquired a sordid reputation as dark places where anything might happen unobserved.[17] By the 1910s, however, their popularity was already waning, as they began to be replaced by elegant theaters. With the production of more ambitious films and advertising targeting the middle class, a more respectable clientele (i.e., women and children) began to attend. To make the shift to respectable theaters, management had to actively court women—they gave away free passes, held raffles, and offered reduced rates for matinees. The working-class audience did not disappear; it, too, preferred the upscale look of the new theaters and less seedy company. But something more than gimmicks was needed to continue to draw female audiences. For women to go to the movies, movies had to be made for them.

The narrative conventions of serial dime novels and magazine stories were easily transferred to serial films. One of the best-known serial-film heroines was Helen of the *Hazards of Helen* series (1914–17). Helen Holmes played the role from 1914 to 1915 and Helen Gibson took over from 1915 to 1917. Helen might swoon, faint, or need to be rescued, but she also jumped onto a moving train from the back of a galloping horse. The athletic Helen dangled from a bridge until a train passed beneath and then dropped onto its roof. And she was skilled at catching bad guys and holding them at gunpoint until the good guys arrived as backup.

Another serial-film heroine was actor Marie Walcamp, who had a long career in film playing roles similar to those of Holmes and Gibson. Walcamp's characters were highly skilled with both guns and animals. In *The Red Glove* (1919), for example, Billie was adept at using both her horse and gun because she was brought up in "true Western fashion." She was likened more to a son than a daughter.

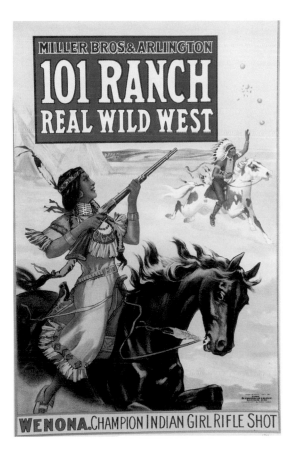

............................

Princess Wenona, 101 Ranch Real Wild West, 1911.

[Poster, approx. 28" × 21". Reprint courtesy of Circus World Museum, Baraboo, Wisconsin, image number M101-NL22-11-½U-2.]

Marie Walcamp as Billie. Movie advertisement for *The Red Glove*, directed by J. P. McGowan, 1919. Slides like this were projected in theaters, advertising upcoming movies. The blank space at the bottom allowed the projectionist to add the date of the film's screening.

[Glass slide, 3½" × 4".]

She was an expert with any kind of firearm and could shoot from the hip as well as any bad man in the West. If it was a question of disarming a villain her unerring aim planted a bullet in his gun hand often before his gun was out of the holster. And how Billie could ride! Nothing on four feet had any terrors for her, whether they were inclined to buck or single foot. She was master of them all, and her spotted calico pony, once a devil with a pair of watch eyes, was as easy for her to handle as any lady's pacing palfry [*sic*].[18]

Marie Walcamp's fans were led to believe that she embodied the virtues of the characters she played—bravery, resourcefulness, skill, and strength. She

didn't kill her adversary unless forced to, even though she might plant "a bullet in his gun hand" or hold him at bay until help arrived. If shot at, she shot back. But, although she was a deadeye, when face to face with an enemy she might falter, as she did in the sixth episode of *The Red Ace Serial,* "Fighting Blood" (1917):

> Hanging to the guide rope of the bridge, Virginia holds on by one hand and reaches for her gun with the other. As one of her pursuers is about to cut the rope with a hatchet, she fires at him and he falls over into the canyon. Then hand over hand, Virginia climbs up the rope until she gets to a tree, where she swings from branch to branch, and finally reaches the bottom and hides in the rocks, firing at "Steele" Heffern and his bunch, who return the fire. But one of the men scales the wall in the rear of Virginia and is dumbfounded to see that she is a woman, for they had thought her to be Winthrop. He openly dares her to shoot him, but she hasn't sufficient nerve, and allows herself to be taken prisoner.[19]

Walcamp's characters as a whole displayed a lot of pluck, independence, and the skills necessary for the adventure. Although at the end of each series she married, soon a new series began, with a new heroine, ready for adventure.

Early Western adventure movies were popular, and, like dime novels, they represented the West as a dangerous place for men. It took a really tough, resilient woman to survive the scoundrels she came across, especially if she owned a ranch or a saloon or was hired to oversee someone else's ranch. The formula for most female heroes of this era was to flirt with adventurous behavior before giving up the adventure to marry and settle down, like some of the characters Walcamp played.

However, at least one actor stood out in the early days of cinema. Like other serial heroines, Texas Guinan's characters were athletic, courageous, good-hearted, and, at the end of the film, usually in the arms of the male hero. In contrast to Walcamp's and the *Hazards of Helen* characters, some of Guinan's characters were independent and avenged wrongs by killing men. Guinan was touted as the female equivalent to Bill Hart, the famous cowboy actor of the time, and some of the characters she played resembled the persona of the dime novel heroine Calamity Jane.

William L. Sherrill, president of the Frohman Amusement Corporation, explained to a reporter why Guinan was chosen for his films in 1919:

It has taken me three months to pick out the person who by environment and experience can portray the spirit of the west. . . . When I saw her work in The Gun Woman, I made up my mind that here was the female Bill Hart of the screen. Miss Guinan can handle a gun, roll a cigarette and boss a mob of cowboys all at one fell swoop. To me, the idea of a woman Western character, no less brave or daring than a man and at the same time portraying her womanly side, is indeed a welcome addition to the motion picture art.[20]

Guinan personified many of the characteristics admired in male actors, including expertise with a gun: "He thought she couldn't shoot, but she beat him three to two."[21] She was also dangerous: "The tougher they are, the softer they get, and the Tigress sure was tough. Never jilt a woman who can shoot."[22]

In real life, Guinan was confident in her abilities and bragged about them. She played up her hard-edged persona, pretending to have lived the life she portrayed on the screen.[23] She acknowledged, and embraced, her persona's assertive manners, explaining that life was hard for spirited Western women. "You know now that I was a tomboy," she said in a 1929 interview. "You may say I was a roughneck. But give me a break, because it's hard for a girl to be gentle and ladylike out there in the great wide-open spaces where men are men and women are safe—in books."[24]

Texas Guinan began her notorious career in New York City in 1906, working first in vaudeville and then in the movies. In the 1920s she became a performer and hostess in speakeasies, greeting customers with the phrase, "Hello Sucker!" She was well known during this period, made a lot of money, and was charged more than once with selling liquor during Prohibition. Guinan's personality was larger than life—much like the characters she portrayed on screen. Her characters showed that a woman could do practically anything a man could. In *The Gun Woman* (1918), her self-confident, self-assured character, Texas Tigress, owns her own saloon. It's not clear how Texas came to live in the rough town portrayed in the film or how she became the owner, but she's alone, with no one to lean on. She isn't described as beautiful, or even feminine, by the trade magazine *Variety*: "[Texas] lends a hardness to her facial expressions one expects from a woman in such a station. Hers has been a hard sort of existence and free from the tenderer things in womankind."[25] Eventually Texas falls in love with a man called the Gent. Unbeknownst to her, he's a notorious road agent (a bandit who robs travelers on a road). Even the astute Texas is blind to love; she falls hard for the Gent—hard enough to

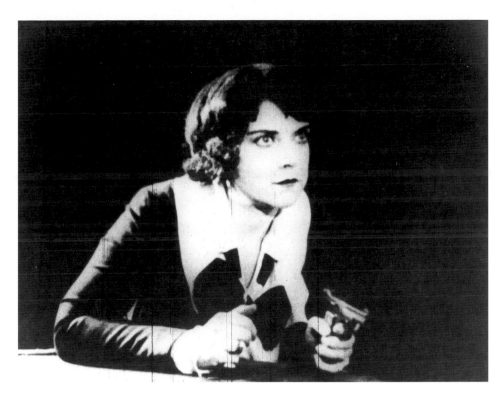

Texas Guinan as Texas Tigress. Texas Tigress points a gun at the man who stole her heart and then deceived her. Still from *The Gun Woman*, directed by Frank Borzage, 1918.
[Reprint courtesy of the Library of Congress, Motion Picture and Television Reading Room, Washington, D.C., image number FLA 0619-0620.]

trust him with her money. The audience knows the Gent is a snake, but all we can do is watch.

> HE: If I just had the money I could talk different.
>
> SHE: But I have plenty of money, and—
>
> HE: I hate to have you live in a town like La Mesa alone and unprotected.
>
> SHE: A woman does get tired of doing her own protecting—even a woman like me.

The Gent takes her money and leaves town, promising to return once he establishes a new home for them. Later, learning of his deceit, Texas considers shooting him but decides to give him a month to return her money. When he doesn't deliver, however, she enters the saloon he purchased with her money and kills him with her .45. A man called the Bostonian is in love with Texas,

and at the end of the film he asks for her hand in marriage. She replies, "I do love you as a friend—but my heart's back there." Going against typical Western film formula, Texas, who took care of herself in the beginning, takes care of herself in the end.[26]

Theater managers were encouraged to create publicity for this film, but instead of suggesting a raffle or free movie passes, *Moving Picture World* magazine gave the following advice on promoting *The Gun Woman*: "If there is a nearby rifle range offer a month's pass to the woman who makes the best revolver score. Display the targets in the lobby and try and get some well known women to give you the first targets to set the example." Theaters were also encouraged to involve other businesses in the promotion of *The Gun Woman*. "Get the Hardware stores to display pearl-handled revolvers alongside the real guns with a sign, 'The Gun Woman did not pack a pair of toys. She took a chance with the men and used man-sized guns. We have revolvers to suit all tastes.'"[27]

Texas Tigress doesn't shoot the gun out of her ex-lover's hand with her .45 and turn him in to authorities. She is a woman scorned by the man she loves, so she takes back what has been stolen from her and then kills her betrayer. On a similar note, in the 1920 film *Letters of Fire,* Texas Bell doesn't follow the formulaic "hold the bad guy at bay until the posse arrives" scenario. She turns bad guy El Tigre over for arrest, but not before taking revenge. In an earlier scene from the film, El Tigre brands his letters on Texas Bell's chest for, among other things, disrupting his bullying a boy on the street. In the end, she avenges this wrong by using his branding iron on him.

Many of Texas Guinan's films have been lost, so it's not clear how many were like these two. Her image before the release of *Letters of Fire,* as this 1919 *Exhibitor's Trade Review* suggests, had apparently been too masculine for some critics:

> She rides well, handles a gun in business-like fashion and demonstrates that the west is a wonderful place to promote nerve, resourcefulness and physical capability. The spark of femininity that was lacking in her first releases has been kindled to a tiny degree in these latest pictures and the result is ever so satisfactory. She now appears as a human, wholesome sort of out-door person who isn't above weaknesses and emotions, and best of all romance. Fans will find her much more likeable.[28]

But Guinan offered no apologies. In a 1929 interview she noted, "*The Gun Woman* was my first film, and of all the blood-curdling, whoopee strips ever

Texas Guinan as Texas Bell. Seeking revenge, Texas Bell returns the favor and brands evil El Tigre with his own branding iron. Still from *Letters of Fire*, 1920.
[Reprint courtesy of the Library of Congress, Motion Picture and Television Reading Room, Washington, D.C., image number FEA 6977.]

shot on a movie lot, that was the winnah, folks, the winnah. I raided towns single-handed, shot up and burned saloons, held up faro games and raised merry hell all over the place through as many reels as the bosses could stand for."[29]

Like the real Annie Oakley, Guinan understood publicity and was a shrewd businesswoman. She used her bad-woman reputation to make a living in the speakeasies and in the movies. She bragged about her accomplishments and didn't apologize for her vices. Her fictional autobiography was full of drama and adventure. Many of her characters were similar to the dime novel heroines who exhibited recognizable Calamity Jane qualities. Unlike other silent-film heroines, Texas Guinan's characters were edgy, kicked butt, and then saved the day.

Movies evolved. the serials ended and sound was introduced. The 1930s and 1940s saw women characters in a variety of action roles. Two films and a play loosely based on the life of Annie Oakley were created between 1935 and 1950, beginning with the movie *Annie Oakley,* starring Barbara Stanwyck, in

Barbara Stanwyck as Annie Oakley, with pump shotgun. Farm girl Annie
loses to her love interest, Toby Walker, explaining to her shocked neighbors that she threw the
last shot because she "didn't have the heart to [beat him] . . . he was just too pretty."
[Still from *Annie Oakley*, directed by George Stevens, Warner, 1935.]

1935. In 1946 the stage musical *Annie Get Your Gun* opened on Broadway, star-
ring Ethyl Merman, and in 1950 a movie based on the musical was released,
starring Betty Hutton. Only Stanwyck's Annie owned her gun, however. In the
musical and film of the same name, Annie intentionally loses a match to the
man she loves, Frank, because he cannot acknowledge her superior skills. For a
happy ending, Annie must choose marriage over professional achievement.

Calamity Jane, starring Doris Day, was released in 1953. In contrast to
the Annie Oakley films and musical, Day's Calamity lives in the West
and keeps everyone safe: she is armed with a revolver and, while rid-
ing shotgun on the stagecoach, a rifle. She repeatedly saves the day, including
rescuing an army lieutenant from a band of Indians. Like Annie, Calamity starts
out unrefined, but by the end of the film her feminine qualities emerge and
she gets her man.

Like Day's Calamity, Vienna, the protagonist in Nicholas Ray's *Johnny Guitar* (1954), shoots well and wears pants, but the similarities end there. *Johnny Guitar* is not a typical Western, as reviewers at the time pointed out. Vienna, played by Joan Crawford, is an independent woman who owns her own business. She was once a lady of the night, carefully saving money for a grubstake. This meant that she put up with the disrespect of the community in order to survive. Vienna, the shrewd businesswoman, uses her earnings to buy land and build a saloon, knowing that the railroad is coming and her business will thrive. The self-assured Vienna, with her trousers and revolver, is decidedly butch in appearance, and she was attacked by the *New York Times* for it. "No more femininity comes from her than from the rugged Mr. Heflin in '*Shane*.' For the lady, as usual, is as sexless as the lions on the public library steps and as sharp and romantically forbidding as a package of unwrapped razor blades."[30] Even the characters in the movie acknowledge her manly behavior. In an early scene, Sam the card dealer tells Tom the cook, "I've never seen a woman who was more a man. She thinks like one, acts like one, and sometimes makes me feel like I'm not one."

. .

Doris Day as Calamity Jane, with a Hollywood version of a Colt Single-Action Army Revolver. Opening scene with Calamity singing "The Deadwood Stage" song while guarding the stage.
[Still from *Calamity Jane*, directed by David Butler, Warner, 1953.]

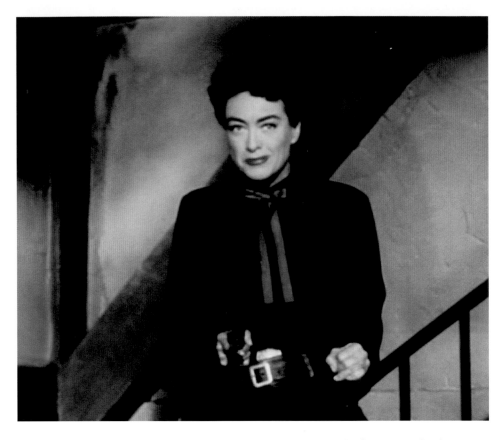

Joan Crawford as Vienna. Vienna points her revolver at a mob of townspeople who
have entered her saloon. She is accused of conspiring with stagecoach robbers and murder.
[Still from *Johnny Guitar*, directed by Nicholas Ray, Republic Pictures Corp., 1954.]

..........................

Vienna not only upsets notions of how women should look and act, she
also challenges society's double standards. "A man can lie, steal, and even kill. As
long as he hangs on to his pride, he's still a man. All a woman has to do is slip
once and she's a tramp," she tells Johnny Guitar. She refuses to apologize for her
checkered past, claiming defiantly, "I'm not ashamed of how I got what I have.
The important thing is I've got it."

To some critics, Vienna seemed sexless. Her body movements are mas-
culine, she wears pants in her saloon and when there's trouble, and she stands
erect and proud. Because she is strong and independent, speaks her mind, and is
butch in appearance, Vienna embodies features of female heroes in dime novels
and the personae of the Western characters Texas Guinan played. Vienna is a
little too independent, too manly, to avoid controversy. This is what makes her
role so interesting.

Gail Davis, starring as Annie Oakley, was a female action hero a girl could love: "Bull's-eyes! Annie Oakley hits the entertainment bull's-eye every week with her hard ridin,' straight shooting—and suspense![31] While the announcer speaks these words, the viewer watches Annie, in this 1954–56 children's television series, jump from her palomino, Target, onto a runaway stagecoach, saving the passengers from certain death. In the next shot she shoots a hole through the center of a playing card while standing atop a galloping Target.

Annie Oakley was the first fictional cowgirl with her own TV show, taking charge when necessary and performing superhuman feats. She frequently draws her revolver to shoot the gun out of a bad guy's hand. She recognizes the type of firearm by its sound. She is feared by the bad guys and loved by the good ones. She is athletic, quick of mind, perky, and smart.

Whereas the real Annie Oakley was a Wild West show shooting star from Ohio, the 1950s TV Annie is a Western cowgirl. She doesn't kill bad guys; she brings them to justice. Orphans, Annie and her brother, Tagg, live with their uncle in fictional Diablo County, Arizona. Their uncle is the sheriff, and his duties keep him busy and often out of town. This leaves the town in the hands of the sheriff's deputy, Lofty Craig, but Annie is smarter and cleverer than Lofty. In this setting, even while Annie is decidedly more skilled than Lofty, her heterosexuality is clearly defined—Annie is mother and caretaker for Tagg and a love interest for Lofty. Annie the television star is like the original Annie Oakley: she may wear pants instead of modest dress, but her hair is in pigtails, and her demeanor is happy and friendly. We know Annie will grow up and settle down someday. But not now, not in this episode.

> LOFTY: You're right, Annie, as usual. Now if you only listen to me . . .
> ANNIE: If I listened to you we'd be married.
> LOFTY: Uh huh.
> ANNIE [*giggling*]: Maybe one day I'll have time to listen to you, Lofty, but right now I've got to go wash the dishes. Come on, Tagg, you can wipe.[32]

Annie is different from other cowgirls, and on occasion Lofty comments on her independence and willingness to help catch criminals:

> ANNIE: Oh, wait a minute, Lofty. I'm going with you!
> LOFTY: I don't suppose it would do any good to say that you can't come with me?

Gail Davis as Annie Oakley shooting a Colt Police Positive Revolver in .38-caliber movie gun. Opening scene with Annie shooting at a playing card held in the hands of the sheriff's deputy, Lofty Craig.

[Still from *Annie Oakley*, Annie Oakley Productions, television series, 1954-57.]

....................................

[*Annie shakes her head no.*]
LOFTY: That it's too dangerous?
[*She shakes her head again.*]
LOFTY: That you'll just be in my way?
ANNIE: Not at all. You know you can't get along without me.
LOFTY: I'd sure like to try, just once.[33]

Annie is a traditional 1950s television heroine in cowgirl dress. Like Vienna, she is confident in what she does, doesn't hesitate to take charge when needed,

Gail Davis as Annie Oakley. After the bad guy shoots the tip of Annie's pigtail, she either nods in respect for his shooting ability or acknowledges that the bullet came awfully close.

[Still from *Annie Oakley* (*Sharp Shooting Annie* episode), Annie Oakley Productions, television series, 1954-57.]

..........................

and never apologizes for her behavior while saving the day. Unlike Vienna, Annie never meets up with really bad trouble, and at the end of the half-hour, life is back to normal in Diablo County. Annie is a reincarnated silent-film-serial heroine for girls and boys.

Although the ability of the fictional white male hero to save others had changed little by the 1960s, the white female's role was slowly shifting. While the behavior of male action heroes never needed to be justified, as the codes for masculinity were entrenched in Western, war, and detective stories, female action heroes proved their femininity and heterosexuality by displaying what was deemed proper behavior as well as dress. To counter their increasingly self-confident manner, their outfits became more feminine and sexualized over time.

By the 1960s, good-girl characters like Annie Oakley had become old-fashioned and soon were relegated to children's and family programming. The new female heroes who replaced them were more independent, choosing careers before marriage. As their skills and power grew, the size of their outfits shrank.

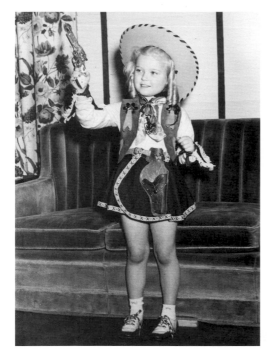

above: Cowgirl, ca. 1950-60. [Silver gelatin print, 3 ⅛" × 3".]

left: Cowgirl, ca. 1950-60. [Silver gelatin print, 4 ¾" × 6 ⁹⁄₁₆".]

..........................

Although representations of scantily-clad women had been common for decades in Western and crime comic books designed for adult male hetero-sexual audiences, they now began appearing on television and in film. In films women were highly sexualized, stepping right out of men's magazines onto the big screen (for example, *Barbarella* and *Bandolero!*—both in 1968). On television they were tamed somewhat for family audiences, which meant that producers had to look for locations where the heroine might plausibly shed her clothes, or plots in which she might work undercover—for example, as a hostess in a men's club. Since female action figures no longer necessar-ily needed men for protection, these resourceful women had to be sexually attractive and attracted to men—and to ensure that there was no misunder-standing about who they desired, their sexual preference had to show all over their bodies.

The female protagonists of the 1960s were still athletic, honest, ethical, and principled ladies. They knew the difference between right and wrong (this doesn't mean they always obeyed the law) and stayed cool under pressure. They were skilled with firearms, and now in martial arts as well. They rode beautiful horses or drove fashionable cars, and they were clearly attracted to, and attrac-tive to, men. Male love interests or husbands were added to reassure the viewer

about the heroine's sexuality. By the end of the narrative, however, the heroine needn't be in the arms of a man.

Because their outfits were tighter and because concealed carry worked to the private detective's or undercover agent's advantage, the weapons of choice, in general, were smaller. Instead of openly packing the holstered .38- or .45-caliber revolver of Westerns, with their four- to six-inch barrels, our new heroines kept their snub-nosed (two- to three-inch barrel) revolvers and semiautomatic pistols inside their purse, jacket, or pant leg.

Narratives also changed in the 1960s. Police and spy tales replaced the Western, and cowgirls became detectives and police officers. Unlike nineteenth-century female action figures, these twentieth-century crime fighters were trained to fight by hand, had access to high technology and a slew of detective gadgets, and were no longer alone; they often had partners or a police force to back them up. Guns were still at the ready, but generally, for television shows with female detective heroes from here on out, firearms were but one of many tools used to save the day.

...........................

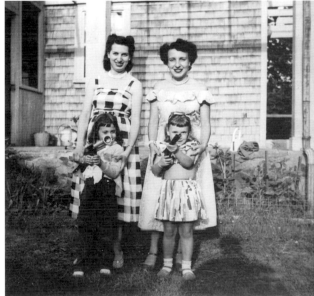

left: Studio portrait of cowgirl, ca. 1950-60.
[Silver gelatin print, 2 13/16" × 4 5/8".]

below: Two girls with moms, ca. 1950-60.
[Silver gelatin print, 3" × 3".]

This time the silent-film-serial heroine character materialized in numerous programs, including *Honey West* (1965–66), The *Avengers* (1966–69), *Policewoman* (1974–78), and *Charlie's Angels* (1976–81). Like most TV Westerns, these action shows' scripts catered to a male audience, but some girls and women also found the new heroines to their liking. What Gail Davis as Annie Oakley made acceptable on television for young girls and boys in the 1950s, female detectives now made acceptable to teens and adults, both male and female.

In the 1970s, black female action figures emerged in the wake of successful blaxploitation films. These women were in stark contrast to the white-bread, sanitized crime-fighting styles of 1960s and 1970s television programs. They signaled a major turning point for armed women who "owned" their guns. Bad guys and gals who messed with blaxploitation heroines always got their comeuppance. Although a few mainstream films in the 1960s and '70s included armed white women in feature roles, the films featuring black actors Pam Grier, Gloria Hendry, and Tamara Dobson took armed women to the next level—they picked up where Calamity Jane, Texas Bell, and Vienna had left off. Only this time it was the 1970s, with drugs instead of beer, and the landscape was black inner-city poor and working class. Blaxploitation heroines fought every lowlife criminal imaginable: drug dealers, pimps, psychos, as well as the cops. These female protagonists kicked butt and were not averse to killing the bad guy, as a *Foxy Brown* film ad from 1974 explained: "She don't bother to bring 'em back alive!"[34]

Because they fought an assortment of lowlife criminals, their arsenals expanded as needed—guns ranged in size from snub-nosed revolvers and semi-automatic pistols, to sawed-off 12-gauge shotguns, to high-capacity military-style weapons. Nothing was off limits—if the cops had them, if the bad guys had them, the women either had them or acquired them out of necessity.

The short-lived black action films of the 1970s began with the Melvin Van Peebles film *Sweet Sweetback's Baad Asssss Song,* whose movie tagline read: "Dedicated to all the Brothers and Sisters who have had enough of the Man."[35] The instant financial success of this film grabbed the attention of Hollywood, and other independent producers began producing a host of similarly focused films. These films were about drugs, poverty, and white oppression, and were laced with the ideology of 1960s militants Malcolm X and Huey Newton. Although they lacked any real revolutionary merit, they were vicariously satisfying to many in black communities, as evidenced by the profits generated during their heyday. Unlike the rare armed female protagonists of mainstream movies, blaxploitation films allowed for harder-edged female characters. In the

movie *Cleopatra Jones and the Casino of Gold,* the heroine (Tamara Dobson) and her one female pal confront an entire gang. In a 1975 theater promotional packet, Cleopatra is described as "normally a go-it-alone girl. But with her own life on the line in Hong Kong, she picks up friends and fast. Her best buddy is a pretty Chinese girl who just happens to be the Far East's most potent private eye. Together they tackle a whole gorilla gang and their warlord woman, the evil lady."[36]

Like their white mainstream counterparts, such black female action heroes boasted strength, stamina, skill, and intellect. Their sexuality was overt and heterosexual; their outfits revealed a lot of skin. These women were feared by bad guys and loved by good guys. Unlike most of their white counterparts in film and television, however, they felt more pain. They were beaten up, raped, and injected with drugs, and their families and loved ones were murdered, tortured, and turned into drug addicts. The police were ineffective or corrupt, and the legal system couldn't, or wouldn't, help them. In the 1970s, black female heroes were as tough as, if not tougher than, the men. A 1975 pressbook describes the Cleopatra Jones character as a woman who's "doing her thing with muscle and a gun."[37]

Many black Americans questioned the value of this type of female heroine, but that didn't stop people from attending the films. Pam Grier was one of the best-known and most successful actors in this genre. *Essence* magazine acknowledged her contribution to "super bitchiness" in 1980: "Pam Grier was the Black (s)exploitation movie. For five years she was the biggest, baddest 'mama' of them all. Although the titles changed, the plots of a Grier opus did not. Yet they were the financial bonanzas until the vogue for the Super Bitch character passed."[38]

Criminals who met Grier's characters didn't have a chance: "Don't mess with Foxy Brown. She's the meanest chick in town," read a tagline on the cover of a 1974 theater promotional packet. Grier's roles combined the independence and cunning of dime novel heroine Calamity Jane and Texas Guinan's characters in *The Gun Woman* and *Letters of Fire;* the skills and determination of Gail Davis in the *Annie Oakley* television show; and the resourcefulness and aptitude of *The Avengers'* Mrs. Peel and the Angels of *Charlie's Angels.* But Grier and other women of blaxploitation films exhibited qualities rarely portrayed by other female characters—moral outrage and the thirst for revenge. Once she realized that no one was going to help her, she took matters into her own hands. She fought back, violently. In *Foxy Brown,* Foxy cuts off the bad guy's penis and delivers it to his bad-gal wife in a pickle jar. In the revenge film *Coffy,*

Pam Grier as Foxy Brown. Foxy Brown shooting a bad guy with a snub-nosed revolver.
[Still from *Foxy Brown*, directed by Jack Hill, MGM, 1974.]

...........................

the heroine kills all the bad guys in over-the-top creative and gruesome ways. With guns a-blazing, Foxy Brown and Coffy are unstoppable. As described in a 1973 theater promotional packet, Coffy is out for vengeance: "Coffy . . . is an attractive young nurse who is determined to kill everyone responsible for destroying her eleven-year-old sister. . . . First she lures a pusher, Sugar-man . . . into a bedroom, blows his head off with a shot gun. Then she forces his driver to give himself a fatal shot of heroin."[39]

Pam Grier was ambivalent about many of her roles: "These Black exploitation films that I've been in and a lot of other Black actors and actresses have been in have been trash, on the most part."[40] But she also extolled what she felt were the merits of her characters to a reporter for *Jet* magazine in 1975. "I created a new kind of screen woman. . . . Physically strong and active, she was able to look after herself and others."[41] In 1980 she again spoke with a *Jet* reporter, proudly describing the influence her characters had on some women. "In my

films, I don't let men bully me, and I think women got a sense of power from watching. I've seen women in theatres smack men on the arm or side of the head and say, 'Hey man, the next time you give me trouble, I'm gonna give you trouble the way Pam Grier does,' it makes me feel real good."[42]

Many women were exhilarated by watching women beat up and kill bad guys or turn domestic chores upside down. I'm sure some women responded favorably to Gloria Hendry's character's behavior in Robert Clouse's *Black Belt Jones* (1974), when Black Belt patronizingly tells Hendry to stay put until he gets back and then offhandedly says, "Clear those dishes or something." She promptly unloads six rounds into the dishes and says, "They're done."

On the heels of blaxploitation films came the science fiction thriller *Alien* in 1979. Ellen Ripley, played by Sigourney Weaver, finds herself in trouble when an alien kills off the rest of her crew. Strong and skillful enough to use all the equipment and weapons on the spaceship, she saves her cat and herself. Ripley is fearless by the end of the movie.

Ripley was featured in four *Alien* films over eighteen years. She fights equally with men and saves herself, and a few others, along the way, using space-age technology and military firepower—the big guns. In Hollywood this means a mixture of real military-style machine guns combined with Hollywood fantasy—additional steel to make the superweapon look supermean and deadly. For example, according to the online Long Mountain Outfitters Movie Gun Gallery, the pulse rifles used in *Aliens* were "made of a shell with an upper casing using a .45 caliber M1 Thompson submachine gun [and] the lower is a Remington 870 12-gauge pump shotgun with a Franchi SPAS-12 shotgun exterior."[43]

Ripley's firepower notwithstanding, her seemingly superhuman abilities and survival instincts were not new. She was an amalgamation of all the armed female characters who had gone before her, with the addition of the survival instincts of Coffy and Cleopatra Jones.

Weary of Ripley's shallowness of character in *Alien 3,* a reviewer for the *Washington Post* wrote, "These days, she's just another girl with a gun."[44] As Ripley became more superhuman in her actions, her body more fit and hardened, the critics began to object. It's true that most of these female action films are formulaic—good girl kills bad guys and aliens—and that Ripley's behavior is somewhat predictable; yet expectations of what a female action hero should look like, and how she should behave, were addressed in the press ad nauseam: "There was no man more determined than Barbara Stanwyck, Bette Davis or Katherine Hepburn. These actresses were both strong *and* womanly. They

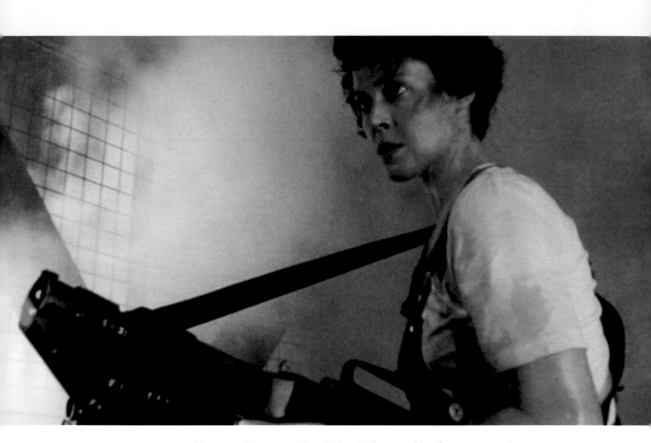

Sigourney Weaver as Ellen Ripley. Ripley searching for a young girl
who was snatched by one of the aliens.

[Still from *Aliens*, directed by James Cameron, 20th Century Fox, 1986.]

..........................

didn't surrender their grace, compassion, resilience—if we may say so, their
femininity—when they demanded social equality with men. They were look-
ing to live with the other sex, not wipe it out."[45]

From Westerns, to detective shows, to blaxploitation films, to science fic-
tion, armed female superheroes became equal to their male counterparts in
intelligence, skill, firepower, and even physical strength. The girl-next-door
and babes-with-bullets stereotypes surrounding the armed female continue
to exist in one form or another. But in the 1980s a much more eclectic
group of female gun toters in a variety of situations began to emerge. Working
women band together to defeat their boss (*Nine to Five,* 1980), a female hit
"man" proves as powerful as her hit man husband (*Prizzi's Honor,* 1985), a pri-
vate detective owns her own agency (*Moonlighting,* 1985–89), and the cast of
Star Trek: The Next Generation (1987–94) includes female crewmembers with
excellent phaser skills.

One of the most popular cop shows on television in the 1980s was *Cagney and Lacey,* a police drama featuring two female protagonists. The program premiered in the spring of 1982, after a made-for-TV movie aired in 1981. The single, career-oriented Chris Cagney and the happily married, working mom Mary Beth Lacey were older than most female leads, in their mid-thirties. They were also close friends and competent police officers, in charge of their actions, making arrests, and using their guns when necessary. Throughout the program's seven seasons there was controversy, however, beginning with the initial casting of actor Meg Foster as Cagney in the spring of 1982. CBS network executives worried that Foster's manner and look were too lesbian; so she was replaced the next fall with an actor they considered more feminine, Sharon Gless. In addition, both characters' wardrobes were carefully altered to make them look more feminine, in Lacey's case more motherly and in Cagney's more heterosexual.[46] The series was a big hit with women and ran until 1988. Unlike earlier women-with-guns shows, at times the scripts were overtly feminist. This working-class duo was allowed to tackle tough issues such as abortion, rape, spousal abuse, and working in a traditionally male environment—all the while carrying guns and being in charge.

Although popular fiction in the 1980s continued to focus primarily on young, white, heterosexual female heroes and their relationships, and women's bodies were still commonly objectified in popular entertainment, other types of characters were acknowledged and written about from time to time, thanks in part to the emergence of gay, lesbian, and minority politics and cultures; the influence of second- and third-wave feminism and girl power; and an increase in women holding influential positions in Hollywood.

Minority and alternative influences can be readily seen in 1980s and 1990s mystery, detective, science fiction, and vampire novels. Like blaxploitation superheroes, these women used all types of firepower, depending on their needs—undercover work required concealable weapons, intergalactic battles required the big guns. While a few of the key mainstream mystery authors—for example, Sara Paretsky, Patricia Cornwell, and Sue Grafton—made their mark early with heterosexual protagonists, the mystery genre grew rapidly as new markets were discovered. Some armed females did not need or want male support, sexually or emotionally. Lesbians, older women, butch women, and minority women appeared in novels targeted to specific audiences. Straight white female characters still dominate this market, but armed women have come a long way since dime novels, and today female protagonists exist for just about every taste—including Anita Blake, vampire slayer:

No one had been shooting at me yet; I was encouraged by that. But I had also been kidnapped and nearly killed. I did not plan on it happening again without a fight. I could bench press a hundred pounds, not bad, not bad at all. But when you only weigh a hundred and six, it puts you at a disadvantage. I would bet on me against any human bad guy my size. Trouble was, there just weren't many bad guys my size. And vampires, well, unless I could bench press trucks, I was outclassed. So a gun.[47]

While Anita Blake was slaying vampires in the 1990s, Hothead Paisan was slaying (sort of) misogynist men who got in her way. Hothead Paisan, the homicidal lesbian terrorist was, and still is, an enraged, violent (only when provoked) alternative comic-book lesbian with a gun. In 1991 Diane DiMassa created the homicidal terrorist, who voices the hate and resentment that some lesbians, straight women, gay men, and transgendered individuals feel when dealing with a racist, sexist, homophobic, conservative Christian, xenophobic America. As DiMassa explained in the introduction to the 1993 compilation of all the Hothead Paisan zines, "Hothead Paisan is angry."

> Maybe she wouldn't be quite so furious if everybody took up equal amounts of space in the world. Hothead is a flaming mouthpiece for those who must remember day after day that they are not less worthy, less deserving, less anything. . . . Hothead Paisan is, among other things, a battler for the right to take up a little space. She's a blend of child-like bewilderment—how could things have gotten so rotten?—and unapologetic reaction to the monsters around her.

Hothead shoots two white men as they harass her on the highway. In the next frame, women honk their horn and say, "Thank you!" Two female police officers claim they saw nothing. When a man on the sidewalk says, "Yo dyke!! You just ain't had da right one yet!" Hothead exclaims she must have "it" as she cuts off his penis. In between the violent acts, DiMassa leads us through the trials and tribulations of Hothead, who just wants to be with nice people, treated respectfully, and loved. In 1993, DiMassa wasn't sure Hothead would ever control her temper.

> People ask me if Hothead will ever calm down. I feel that she only reflects what is going on "out there," so I don't see her changing very

Hothead Paisan: Homicidal Lesbian Terrorist, by Diane DiMassa.
[San Francisco: Cleis Press, 1993. Reprint courtesy of Diane DiMassa.]

soon. The magic is that Hothead's behavior allows ME to be a calmer person. I hope for the day when she *can* calm down! But for now, Hothead will continue to act out the fantasies that we would never really carry out ourselves, even though we're thinking them.[48]

In 1999 the 428-page *Complete Hothead Paisan* was published. Hothead is still around, still pissed, and still armed with big guns—her arsenal includes the HeyHey 47, .357 magnum, standard issue devolver, the spudgun, and the gnawed-off shotgun.[49]

Mainstream action films used big guns, too—everything got bigger, louder, and more powerful in 1990s action films. Hard-bodied Sarah Conner (*Terminator 2: Judgment Day,* 1991), Ellen Ripley (two more *Alien* movies, 1992 and 1997), and Jordan O'Neil (*GI Jane,* 1997) are the female equivalents of the macho, testosterone-pumped characters played by Sylvester Stallone, Arnold Schwarzenegger, and Chuck Norris. No woman reaches the Schwarzenegger body aesthetic, although the butch marine in *Aliens,* Private Vasquez, comes close—but she gets killed off. Given the criticism the more feminine Sigourney Weaver and other female action heroes received for buffing up, a woman like Vasquez couldn't be allowed to save the day; this would be financially risky for mainstream film companies, given the homophobic disposition of many Americans.

While guns were getting bigger and fictional women were getting bolder,

........................

Linda Hamilton as Sarah Conner with a Colt Commander Rifle with a "flash eliminator," chambered for a 5.56mm (.223 Remington) cartridge. Sarah is preparing to assassinate the man she holds responsible for destroying the human race.
[Still from *Terminator 2: Judgment Day,* directed by James Cameron, Live/Artisan, 1991.]

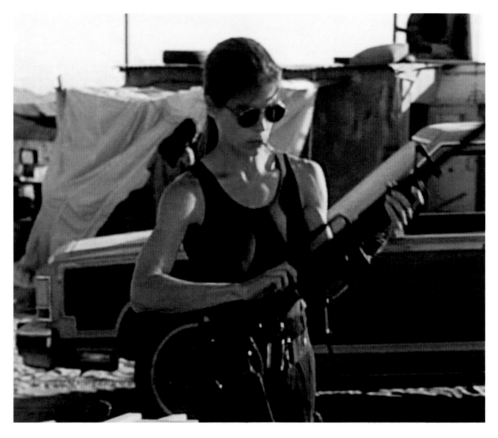

gun companies were marketing more aggressively to real women. *Women & Guns* magazine began publishing, NRA president Marion Hammer became known to nongun owners, a prostitute was arrested for killing her tricks with a handgun, and thirty thousand women served in the first Gulf War. The 1990s bumper crop of women-and-guns stories featured every type of fictional woman with a gun imaginable. Not only was she in the military, or with the police department, or otherwise saving the world from bad guys, she was also the criminal, the psychotic, and the kidnapper.

One of the most talked-about films of the 1990s was *Thelma and Louise* (1991), described by a *Newsweek* reviewer as "a genuine pop myth about two women who discover themselves through the good old American ways of cars and criminality."[50] Thelma and Louise are friends who want to take a vacation together, but their weekend gets complicated. After Louise shoots Thelma's rapist with Thelma's .38 revolver, the pair tries to escape to Mexico. Along the way, Thelma experiences her first orgasm and learns to rob gas stations and convenience stores, and together they shoot at, and blow up, a trucker's rig—because he won't apologize for harassing women.

Thelma and Louise was designed to appeal to a certain type of 1990s female sensitivity; it points out some of the stupid things men say and do to women, and it makes fun of men's behavior. The protagonists are two female friends in a cool car trying to have a good time, but men keep getting in their way. So they try to get away from men. For those male and female viewers who preferred the formulaic action movies, or women in less aggressive roles, this women's film with a bite was too much. As a reviewer explained it in *Time* magazine, Thelma and Louise aren't nice.

> What people sense, particularly in Davis' performance, is that she is getting off on her newly discovered taste and talent for gun-slinging outlawry. It's a kick, not so very different from, maybe part and parcel of, her newly discovered pleasure in sex. This is something nice girls—nice people, nice movies—are not supposed to own up to, let alone speak of humorously.[51]

Take the cowgirl out of the dime novel, place her on a spaceship or in a poverty-stricken ghetto, or put her in the military, and she'll teach many of the same values her nineteenth-century predecessors did. Most action films continue to maintain stereotypical female characters tagged as either good or evil. The female protagonists of the early twenty-first century are still generally athletic, honest,

POWER

...........................

SELF-DEFENSE

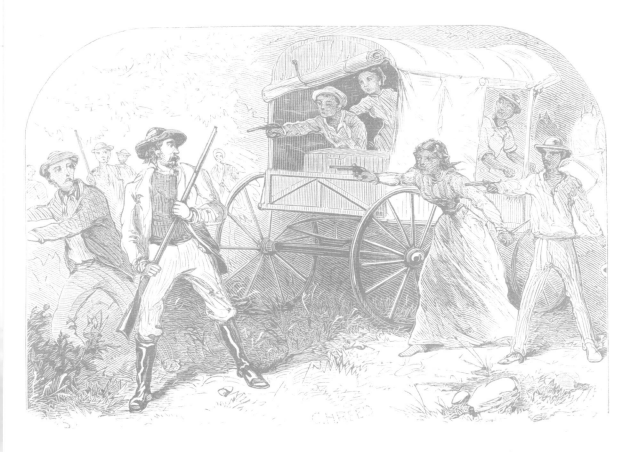

Five women in line, shooting pistols outdoors, ca. 1920.

[Silver gelatin on glass, 4" × 5". Reprint courtesy of the Underwood & Underwood Glass Stereograph Collection, Archives Center, National Museum of American History, Behring Center, Smithsonian Institution, Washington, D.C.]

Advertisements from this era reveal a lot about perceived female gun markets—who might be in danger and who needed a gun. For example, a Forehand Arms Company gun advertisement in an 1899 issue of the *Youth's Companion* shows a woman looking out her window at a man in the distance. One hand rests on a windowsill while the other grips a revolver at her side. Nestled among ads for Linene Reversible Collars and Cuffs, Mi-o-na Tablets for indigestion, and the Sears, Roebuck Consumer Guide, the Forehand ad states, "The firearm is perfectly safe for any lady to use who feels the need for protection."[12] As was typical in the late nineteenth century, this ad was placed in family magazines designed to attract the gentry, despite the fact that white working-class women, poor women, and women of color experienced greater violence.

Firearms manufacturers have always targeted white middle- and upper-class buyers, focusing on the potential for danger and counseling customers to plan in advance for their own protection. Maureen Christensen covered the early

ONCE IN EVERY WOMAN'S LIFE

The School-Teacher's Story

"He jumped from behind a tree and came toward me. He was powerful and desperate looking. The only thing that saved me was this COLT that brother Bert gave me when I took the school here. I thought then it was absurd to carry a pistol, but I will never again say that it is foolish for a woman to own a "COLT."

Write for free booklet, "How to Shoot," and Catalog No. 26

THE ARM OF LAW AND ORDER

"You can't forget to make a Colt safe"
COLT'S PATENT FIRE ARMS MFG CO. HARTFORD, CONN.

"Once in Every Woman's Life." Colt Firearms advertisement in *Literary Digest*, 10 February 1917, p. 356. [4⅝" × 6⅝"]

HARRIET TUBMAN.

Harriet Tubman with a muzzle-loading, half-stock percussion rifle. From Sarah H. Bradford, *Scenes in the Life of Harriet Tubman*

[Auburn, N.Y.: W. J. Moses, 1869. Reprint courtesy of the Rare Book, Manuscript, and Special Collections Library, Duke University, Durham, North Carolina.]

..............................

helping others: "I started with this idea in my head, 'Dere's two things I've got a right to, and dese are, Death or Liberty—one or tother I mean to have. No one will take me back alive; I shall fight for my liberty, and when de time has come for me to go, de Lord will let dem kill me.'"[18]

According to her contemporaries, Tubman was a tactical master; despite the arduous northward journey, fraught with peril, she and her charges were never caught. She armed herself with a pistol, should she run into the enemy, or should one of her charges think of turning back. When the physical and emotional strain of hiding for weeks became too much for some weary slaves, Tubman sternly insisted they press on, as William Still explained in his 1872 book, *The Underground Railroad:*

> She would not suffer one of her party to whimper once, about "giving out and going back," however wearied they might be from hard travel day and night. She had a very short and pointed rule or law of her own, which implied death to any who talked of giving out and going back. Thus, in an emergency she would give all to understand that "time were very critical and therefore no foolishness would be indulged in on the road" . . . so when she said to them that "a live runaway could do great harm by going back, but that a dead one could tell no secrets," she was sure to have obedience. Therefore none had to die as traitors on the "middle passage."[19]

Racist oppression in housing and employment, as well as unprovoked violent attacks and lynchings, continued after emancipation was declared in 1865. Freed slaves sought to acquire goods for survival, and, for many, a hunting rifle became a necessity. The rifle could double as a self-defense weapon, helping to level the playing field, as civil rights advocate and antilynching crusader Ida B. Wells-Barnett angrily explained in 1892:

> Of the many inhuman outrages of this present year, the only case where the proposed lynching did *not* occur, was where the men armed themselves in Jacksonville, Fla., and Paducah, Ky., and prevented it. The only times an Afro-American who was assaulted got away has been when he had a gun and used it in self-defense.
>
> The lesson this teaches and which every Afro-American should ponder well, is that a Winchester rifle should have a place of honor in every black home, and it should be used for that protection which the law refuses to give. When the white man who is always the aggressor knows he runs as great a risk of biting the dust every time his Afro-American victim does, he will have greater respect for Afro-American life. The more the Afro-American yields and cringes and begs, the more he has to do so, the more he is insulted, outraged and lynched.[20]

Certainly there were women in the first half of the twentieth century who were strong proponents of armed self-defense. Unfortunately, my research did not uncover any who were as vocal or influential as Tubman, Wells-Barnett, Oakley, or Topperwein.

Beginning with the powerful influence of the post–World War II civil rights movement, followed by the black power and feminist movements, the 1960s through 1980s witnessed a few women who stood out as controversial figures for declaring their right to bear arms to protect themselves, their families, and their communities.

Ida B. Wells-Barnett's words from the 1890s resonated with many black families during the 1950s and 1960s. A gun still had a "place of honor" in many black homes—and was ready for use, if necessary. Lois Patillo's experience in 1957–58 is one example. After the 1954 Supreme Court ruling in *Brown v. Board of Education* outlawed racial segregation in schools, confrontations between racist whites and their black neighbors increased. The city of Little Rock, Arkansas, attempted to comply with the ruling by integrating Central High School in the fall of 1957. After local police failed to subdue angry whites, President

Eisenhower reluctantly intervened, sending in federal troops. "Mob rule cannot be allowed to override the decisions of our courts," the president explained.[21] The troops remained at Central High until the school year ended. When interviewed about this yearlong ordeal, Lois Patillo, whose daughter Melba was escorted daily to the high school by soldiers in fear that angry whites might harm her, described the threatening phone calls they received routinely.

> PATILLO: They'd call me and say, "We're going to come and get her and hang her." I said, "Come right on I'm waiting for you." Sometimes I would hang up the phone trembling but told them to come right on because I'm waiting for you.
>
> REPORTER: Did you have something to protect yourself with?
>
> PATILLO: My mother was there. She knew which gun she was supposed to man. My son knew which one he was supposed to man, and I knew which one I was supposed to man. Meanwhile, we had a planned escape for Melba.[22]

According to historian Charles Payne, author of *I've Got the Light of Freedom: The Organizing Tradition and the Mississippi Freedom Struggle,* racist white Mississippians were unsuccessful at stopping the civil rights movement by violent intimidation because blacks were fighting back: "Part of the answer may have to do with the more aggressive behavior of Black people. Compared to the number of shootings in Mississippi, the number of people actually shot is fairly small. One reason for that may be that the night-time marauders had learned to keep a more respectful distance from their targets because the targets were increasingly prone to shoot back."[23]

The submissive behavior of earlier generations began to change noticeably in the 1950s and 1960s, when more blacks stepped up their demands for fair treatment and civil rights and armed themselves defiantly. Stories of successful self-defense spread among local communities, even when they were not published in mainstream newspapers. According to Payne,

> The cost of being racist was being recalculated. For a hundred years white supremacists had been declaiming their willingness to give their lives in defense of the Southern Way of Life, should matters come to that. Now matters had indeed come to that. Continuing the old tradition of racist violence was coming to mean that you really could lose your life or your liberty. A part of the calculus of change was that by the early sixties, there

POWER: SELF-DEFENSE

were more Black people willing to defend themselves at all costs than there were white people willing to live up to all the Confederate bluster.[24]

One of the best-known instances of blacks arming against a racist white community occurred in turbulent, Ku Klux Klan–controlled Monroe, North Carolina, where blacks had few rights as citizens in the 1950s. Led by Robert Williams, this black population demanded fair treatment for all. Black citizens wanted protection from the KKK in their neighborhoods, and they wanted whites who harmed blacks sentenced for their crimes. Because their requests were continually ignored, Williams and his neighbors armed themselves and took to the streets when necessary to defend themselves and others against a racist police department and white community.

Williams's wife, Mabel, along with other women in the community, trained in armed self-defense. It was the men who played the protective role, however, keeping guard and standing together, weapons displayed, whenever the Klan drove down the street. They carried weapons at all times, brandishing them when necessary to stop an attack or to defend someone. Women trained in case things got out of hand or the men weren't home.

The consequences of Williams's outspoken resistance to white racism were severe. Williams and his family were forced to escape to Cuba after trumped-up charges were brought against him. While in Cuba, he transmitted his ideas to the United States via radio, and in 1962 he wrote the highly influential *Negroes with Guns*. In the prologue to the book, Williams explained his reasons for arming:

> Because there has been much distortion of my position, I wish to make it clear that I do not advocate violence for its own sake or for the sake of reprisals against whites. Nor am I against the passive resistance advocated by the Reverend Martin Luther King and others. My only difference with Dr. King is that I believe in flexibility in the freedom struggle. That means that I believe in non-violent tactics where feasible. . . . Massive civil disobedience is a powerful weapon under civilized conditions where the law safeguards the citizen's right of peaceful demonstration. In civilized society the law serves as a deterrent against lawless forces that would destroy the democratic process. But where there is a breakdown of the law, the independent citizen has a right to protect his person, his family, his home and his property. To me this is so simple and proper that it is self-evident.[25]

Although Williams spent most of the 1960s abroad as a fugitive, his words had an impact on young blacks who were critical of passive resistance to white oppression. The best-known black militant group of this era was the Black Panther Party for Self-Defense, based in Oakland, California.[26] Huey Newton and Bobby Seale, who founded the Black Panthers (1966–82), embraced Williams's ideas wholeheartedly. The Panthers' rhetoric spoke to angry black men and women, and chapters were formed around the country. For the Black Panthers, the need to arm themselves was "self-evident," and was reflected in the seventh point of their ten-point platform.[27]

WE want an immediate end to POLICE BRUTALITY and MURDER of black people.

We believe we can end police brutality in our black community by organizing black self-defense groups that are dedicated to defending our black community from racist police oppression and brutality. The Second Amendment to the Constitution of the United States gives a right to bear arms. We therefore believe that all black people should arm themselves for self-defense.[28]

Photographs of Black Panthers dressed in black, some wearing dark shades and berets and holding firearms, alarmed many Americans. Their display of firepower was an open declaration of defiance. According to Todd Gitlin, author of *The Sixties: Years of Hope, Days of Rage,* while protesting the arrest of party leader Huey Newton on charges of murder, "paramilitary teenagers in black berets and leather jackets" stood on the steps of the Oakland courthouse "chanting 'The Revolution has co-ome, it's time to pick up the gu-un,' with 'Off the pig!' tossed in on the back-beat."[29] Of course these statements fueled fears held by ignorant whites that blacks were naturally prone to violence. The Panthers' behavior also worried many sympathetic whites, as well as many blacks and other American minorities who opposed this armed belligerent posturing as a strategy to bring about equity between the races.

Some female members were quite active in the Panther party. Angela D. LeBlanc-Ernest, in her essay "The Most Qualified Person to Handle the Job: Black Panther Party Women, 1966–1982," credits Tarika Lewis with being the first woman to join the party, in 1967. Within a year Lewis was a female section leader, performing a variety of duties, including weapons training. LeBlanc-Ernest quotes Lewis from a videotape of a conference proceeding held in 1990: "When the guys came to me

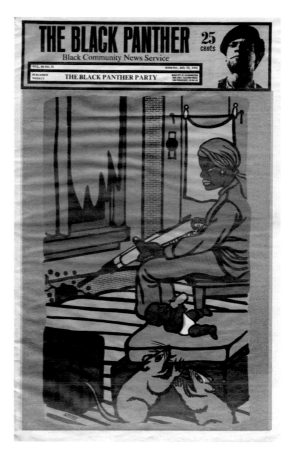

Black Panther Party Newsletter, 1969. Masthead design and artwork by Emory Douglas.

[11 ½" × 17 ⅜". Reprint courtesy of Emory Douglas.]

..........................

and said 'I ain't gonna do what you tell me to do 'cause you a sister,' I invited 'em to come on out to the weapons range and I could outshoot 'em."[30]

The Black Panther branches that sprang up in cities across the United States all subscribed to the party platform. The contributions and roles of women were handled differently, depending on sectional leadership. According to Afeni Shakur, women of the Harlem and Bronx sections of the party were not accorded the same privileges as men. Shakur believed in the party, however, so she fought for equal rights and responsibilities within the movement. In Jasmine Guy's 2004 book *Afeni Shakur: Evolution of a Revolutionary,* Shakur explains:

> I was pushing and pushing for women to have more rights in the party. I felt we were all soldiers, together. I pushed for weapons training classes for the women. My section always had weapons training courses. I would lead the Political Education classes to ensure that we were learning the same thing the men were learning. From dismantling weapons to using them. We were soldiers. Lumumba [head of Harlem Black Panthers] kept telling me women weren't qualified. "Train them, and they will be!" I argued.[31]

According to LeBlanc-Ernest, Kathleen Cleaver was "the most prominent and influential woman during the formative stage of the Black Panther Party."[32] Cleaver joined the party in 1967. She was the first woman to sit on the organization's central committee, held the title of communication secretary, and served as the assistant editor of the *Black Panther Party* newsletter. She was married to Panther Eldridge Cleaver, who held the title of minister of information until 1968.

I spoke with Kathleen Cleaver in April 2005 and asked about her perceptions and experiences with firearms while with the party. I was struck by the way women and men were represented in the *BPP* newsletter, standing alongside each other, guns and other weapons exposed. Cleaver explained, "That was the functioning concept. Men and women together, defending themselves, the community." Panthers proficient in the use of firearms, including a few women, taught other Panthers how to use them. Curious about this, I asked whether women or men talked about how the women would display their guns in public. Cleaver corrected my use of the term "display" and "armed women" when talking about the gun's role in the Black Panther Party, emphasizing the importance of understanding the Panthers' reasons for arming: self-defense.

It was like this: Black Panthers were going on patrols; they were not displaying weapons. They were engaged in patrols or engaged in a certain activity. When they went to the protest in Sacramento they were protesting a bill that was going to prohibit them from carrying weapons. There was an executive mandate requiring and insisting on people defending themselves. So saying "display weapons" takes it out of context. What we were talking about was defending ourselves. We're in a state of siege, the police are attacking people, kicking down their doors, beating people up regularly. They were doing it across the board, to black people in all black communities. This was how the police functioned. So we have an organization that was challenging not only that kind of violence, but there was a discussion about what constituted violence. Every way blacks were exploited, or oppressed, we saw as a form of violence. Bad housing was violence. Poor education was violence. The inability to get jobs was violence. Unfair trials were violence. So we were in a situation that was violently harming us, and our movement was to defend our community against that. What we were talking about was a black freedom struggle.[33]

In a 1968 issue of the *BPP* newsletter Cleaver's campaign poster showed her standing in the doorway of her home with a 12-gauge, short-barrel shotgun. She was a member of the Peace and Freedom Party and was chosen to run for the state's eighteenth assembly district seat in San Francisco. The title of one of Malcolm X's speeches, "The Ballot or the Bullet," was her campaign slogan. She explained why the original photograph was made and how the image was later used in her campaign.

What happened in the case of the photograph that you have of me, was that Eldridge Cleaver and I were married. He was on parole, which means that he was barred from owning or possessing weapons. But the police have come and kicked down our door, so the discussions between us was that we needed to be in a position to defend ourselves. It was not illegal to have a weapon in the home. It's illegal for him to have a weapon, but it's not illegal for me to have a weapon. So the way this photograph came about was to challenge the circumstance of being essentially like a sitting duck—sitting around waiting for the cops to come kick down our door.

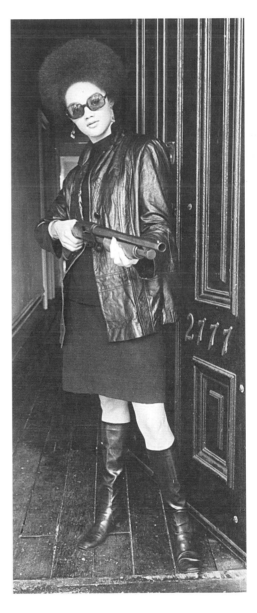

So I bought a riot shotgun and a very large pistol, and to make this public we took a photograph of me standing in the doorway of my home with the shotgun, which was the exact same kind of shotgun the police carried. And we published the image in an underground newspaper to see what they would do. "You kicked our door down once, now if you kick it down again . . ." So it was a political message. Do you see what I'm saying? It's not necessarily about displaying weapons, it's about challenging the state and asserting the right to self-defense and the best way to do it. We weren't trying to be secretive about it, we wanted to see what they were going to do.

It was a good picture so we decided to use it when I ran for office.[34]

Cleaver did not win the election, but her photograph and the political poster made a clear statement about the way the Panthers felt in 1968 and the public image they sought to project.

..........................

Kathleen Cleaver standing in the doorway of her home holding a 12-gauge Stevens Model 620-A riot gun, 1968.

[Photograph by Alan Copeland ©1968. Reprint courtesy of Alan Copeland.]

Women's Press Collective humor, *The Women's Gun Pamphlet: By and for Women*
[San Francisco: Women's Press Collective, 1975), pp. 18, 37. Reprint courtesy of Judy Grahn.]

The collective considered a firearm an effective self-defense weapon for a woman. Unlike earlier gun advocates, however, the collective's members made sure their readers knew they were angry with a legal system that allowed perpetrators of violence against women—rape and domestic violence specifically—to get off with little or no jail time. They were also politically active, working to change an unfair legal system. The collective's goals were to help women—mostly poor and working-class straight and lesbian women—many of whom lived and traveled through dangerous neighborhoods to get to and from work. To this end, with the Garcia case fresh in their minds, they also addressed the politics of self-defense, describing in detail how a woman would probably be charged with murder for defending herself, and the importance of fighting for those who were incarcerated. "Now is not the time for women to disarm for fear of retaliation. Now is when the attack on women is mounting and women must be prepared. If men have nothing to fear from the law when they attack us, then they better fear for that gun in our little female hands."[41]

Another pro-gun feminist group active in the antirape movement was Women Armed for Self-Protection (WASP), based in Dallas, Texas. In 1974 its members created a flyer explaining who they were—it was dominated by a photographic image of a woman holding a rifle, with the text, "Men and Women Were Created Equal and Smith & Wesson Makes Damn Sure It Stays

That Way." A leaflet they produced ended with the lines: "We are women . . . we are armed. We repeat . . . we are WASP. We are prepared to sting. We support immediate and drastic retaliation against all rapists."[42]

Most active feminist groups in the 1970s and 1980s were opposed to firearms. While violence against women was a major concern, in their minds a firearm was not a reliable weapon for self-defense. Some argued that guns were too dangerous to keep around, especially if children were in the house. Others were concerned that a gun could easily be taken away from the victim. Some felt that learning how to fight with your body was more effective, given that it was generally illegal to carry guns. Most feminist journals and newsletters either ignored guns as a method for self-defense or reluctantly acknowledged them in passing. Like the Women's Press Collective, however, a few vocal feminists supported the use of firearms, and a smattering of articles appeared in radical feminist publications from this era. Ann Sheldon, writing for *Women: A Journal of Liberation* in the early 1980s, asked her readers to consider the irony of opposing armed self-defense by using an alien from another planet as the narrator of her editorial. The alien, reporting from earth to its home planet, explained how women refused to use the one weapon likely to bring "the little human to equality with the big one," and how women were brainwashed to fear "weapons and . . . the very idea of resistance."[43]

In 1977 the Panther Party suspended activities; and from my research it appears that by the mid-1980s pro-gun feminists who were still active in the feminist movement no longer published flyers about firearms or strategies for armed self-defense. But publications for women did not stop

........................

Women Armed for Self-Protection flyer, 1974. This is probably a Marlin Model 336C carbine or a 336SC sporting carbine.
[8½" × 11". Reprint courtesy of WASP ©1974.]

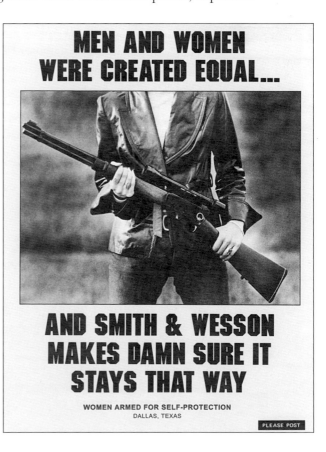

Author, radio personality, firearms instructor, and Smith & Wesson spokeswoman Paxton Quigley
with .38-caliber Lady Smith & Wesson Revolver, Los Angeles, California, 1996.
[Chromogenic print. Photograph by Nancy Floyd.]

for long. In the late 1980s Ann Sheldon's sentiments were echoed in the pages
of Paxton Quigley's book *Armed and Female* (1989) and Sonny Jones's magazine
Women & Guns (1989–present), although both publications wrote primarily for a
conservative or mainstream audience.

By the 1990s it appeared that some women were willing to pay for armed
resistance training, as courses became highly specialized, catering to a variety of
needs. Women could practice at a gun range on ladies' day for example, or they
could participate in a one-day workshop on self-defense for women. If they
had the money they could spend a weekend at a prestigious tactical training
facility taking classes involving mock attacks and break-ins.

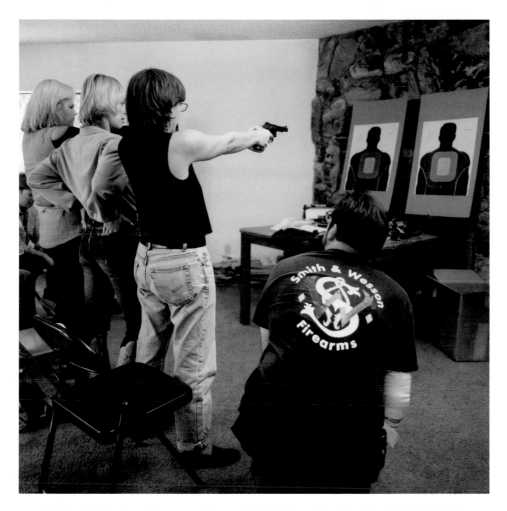

Paxton Quigley teaching women how to site their target, Los Angeles, California, 1996.
[Chromogenic print. Photograph by Nancy Floyd.]

The 1990s version of the Women's Press Collective pamphlet was Gila May-Hayes's book *Effective Defense: The Woman, the Plan, the Gun.* While the intended audience was quite different from the collective's, the book addressed the important and practical details of armed self-defense. Originally published in 1994 and now in its second printing, May-Hayes tells readers how to talk to a police officer after using a gun in self-defense, and how to prepare for the psychological effects of killing someone, even if justified.

Sensing an increased interest on the part of women to have their own firearms, in the late 1980s and the early 1990s the weapons industry began designing a larger selection of firearms for a woman's smaller grip. With publications by and for women shooters increasing, the creation of a women's division

Insight Technology advertisement, M6 Tactical Laser Illuminator on a 9mm Glock 34.
Inside front cover of *Women & Guns*, January-February 2003.

[Reprint courtesy of Insight Technology, Inc.]

within the National Rifle Association, and the news media alerting Americans that gun women were on the rise, it's no surprise that the ads increased.

Like the advertisers at the beginning of the twentieth century, firearms manufacturers of the past twenty years have used many of the same formulas—the classic alone-at-home and at-home-with children images, for example, but instead of the woman sitting up in bed with a sleepy child beside her, she crouches next to the bed, phone held to her ear. Her other hand holds a semiautomatic accessorized pistol with a laser spotlight.[44] Outdoor images have also been updated: now she jogs in the park with a concealed weapon, drives through the night with a gun by her side, and hikes by herself in the West, as in a 2006 Smith & Wesson ad: "I hike alone, I bike alone, I climb alone. But with my Smith & Wesson, I'm never

Safety Hammer Double Action Revolver.

This is a pocket revolver with the hammer of such convenient form as to avoid danger of catching when inserting or withdrawing from the pocket. The upper part of the hammer is rounded over and checked to admit of half cocking for loading, or full cocking for deliberate aim. As nearly accident proof as any weapon can ever be made.

It is a safe revolver to have about the house and the peculiar form of the hammer makes it particularly adaptable for a pocket arm—there being no points or corners to cause accidental discharge.

It is just the revolver to give its owner a sense of security and confidence whether in the pocket or under the pillow.

20

Safety Hammer Double Action Revolver.

Description:

32 Caliber, 6 Shot. 2½ Inch Barrel. Weight, 16 ounces. C. F., S. & W. Cartridge. 38 Caliber, 5 Shot. 2½ Inch Barrel. Weight 15 ounces. C. F., S. & W. Cartridge. 44 Caliber, 5 Shot. 2½ Inch Barrel. Weight, 18 ounces. C. F., Webley Cartridge with Loading Gate. We can furnish with 4½ and 6 Inch Barrels, and the 32 and 38 Calibers with Patent Loading Gate. Finish—Nickel or Blue.

For home protection, every household should have a revolver. We recommend this as a reliable arm for the purpose.

21

"Safety Hammer Double Action Revolver." Harrington and Richardson Arms Co. catalog no. 6, Worchester, Massachusetts, ca. 1900, pp. 20-21.

[Reprint courtesy of the Warshaw Collection of Business Americana-Firearms, Archives Center, National Museum of American History, Behring Center, Smithsonian Institution, Washington, D.C.]

. .

alone."[45] Guns and children are still a concern, but unsupervised children holding guns are no longer represented as safe, even when the gun has a trigger lock.

A hundred years ago Annie Oakley spoke to a *Cincinnati Times-Star* reporter about the necessity for women who travel alone to carry concealed weapons to protect themselves.

Every woman who has to go out at night and expects to travel some dangerous locality [needs] to learn the correct use of a good 32–caliber revolver and to carry such a weapon with her for her own defense. For years at night, when I had occasion to go out alone and expected to

pass any rather secluded locality, I have been prepared in case of any danger. And I have a plan of my own for having it in a position for ready use. I carry an umbrella loosely furled under my arm and in the fold of this article I keep the weapon concealed. . . . In case of attack I have only to slip the finger on the trigger and point my weapon. . . . For the woman living in the lonely farmhouse, and for the business woman returning home late at night from work, the knowledge of how to use a pistol is a Godsend.[46]

Another *Cincinnati Times-Star* article, perhaps from the same time period, is accompanied by photographic halftones of Oakley illustrating her concealed-carry techniques. The captions read, "Picture No. 1 shows Miss Oakley walking calmly along with the deadly weapon concealed under the umbrella"; "No. 4 shows how instantly an attack from behind can be met," and so on.[47]

A century after Annie Oakley encouraged women to arm themselves while alone and away from home, many U.S. states have passed legislation allowing citizens to carry concealed firearms. I too have that privilege—I carry a Georgia firearms license in my wallet. This means that unless there's a law or ordinance strictly forbidding it, I can carry a concealed weapon anywhere in Georgia. I applied for my license a few months after moving to Atlanta, in 1996. I applied because I could. In Southern California, acquiring a concealed-carry permit was nearly impossible. Even going to and from a shooting range was strictly regulated: by law I was required to transport my unloaded firearm in a locked case in the trunk of my car.[48] So when I moved to Atlanta and learned how easily I could acquire a permit, I thought, what the heck? I might need it some day.

Today, forty-eight states have some form of right-to-carry provision, allowing citizens to apply for a license to carry a concealed firearm. Unlike California, which is a "may issue" state—meaning permits are dispensed at the discretion of the authorities where you live, Georgia is a "shall issue" state—meaning that if you meet all the requirements, you get a license. Because I'm not a convicted criminal and have no record as a mentally unstable person, it was pretty easy to obtain a permit in Georgia. All I did was show my photo ID, prove my residency with a phone bill in my name, pay a few fees totaling less than $50, allow myself to be fingerprinted, and wait about ninety days. A portion of the fees covered background checks proving that I was over twenty-one, was not a felon, and hadn't committed any of the crimes deemed important enough to bar gun ownership to Georgia citizens, like drug dealing or a history of spousal

abuse. In addition, if I had been an inpatient of a mental hospital or alcohol or drug treatment center, I would have needed five years of clean health. It's a little more complicated than that, but you get the idea.

You'd think my permit would come with an instruction manual, but my concealed-carry card only tells me, in vague terms, what I can't do. It's up to me and all permit carriers to research and understand the laws. Since most of us don't know exactly where to find this kind of information, from time to time I'm sure a few of us get into trouble for carrying in the wrong place.

We gun people get permits so we can legally carry our self-defense weapon wherever we go. I've had a permit for ten years now, but I've never taken advantage of the privilege, for two reasons. First, having a carry permit doesn't mean I can carry a gun anywhere I want. After much research I think I understand the state of Georgia, as well as Dekalb and Fulton County laws and regulations. It's my understanding that I can't carry a gun to places where people gather or on publicly owned property. Loaded weapons are banned where alcohol is served and in state parks. So that leaves out just about every place I go: work, movie theaters, parks, bars, and most restaurants. I feel safe while shopping at the Little Five Points Pharmacy and Movies Worth See-ing video store, so I wouldn't carry there anyway. The Taco Bell closest to my house has a bulletproof drive-up window, so maybe that's a good place to carry. I can carry a loaded gun in my car, but I don't really need a permit as long as I store the gun in the glove compartment, the console, or set it out in open view on the seat. The advantage of having a permit is the ability to carry my gun anywhere I want inside the car. I'm not quite sure where else to put my gun, and my friends won't let me in their cars if I'm armed, so this privilege doesn't help me.

I guess I could carry my gun while I walk my dog around my neigh-borhood. Armed robberies and shootings occur in the area, but I'm pretty sure my sixty-pound pup, Ripley, deters most criminals—yes, she's named after Sigourney Weaver's character, Ellen Ripley, from the *Alien* series. But even if a criminal ignored or shot Ripley, there's still the second reason I don't carry: if someone pulls a gun on us while we're out and about, I'm not trained for a shootout or how to avoid one—even though I've taken a few armed self-defense courses in the past.

Lyn Bates taught me this. Bates is a highly skilled shooting instructor, a self-defense columnist for *Women & Guns* magazine, and vice president of the sixteen-year-old nonprofit group Arming Women Against Rape and Endan-germent (AWARE). I met her in 1998 when I drove to Massachusetts to inter-

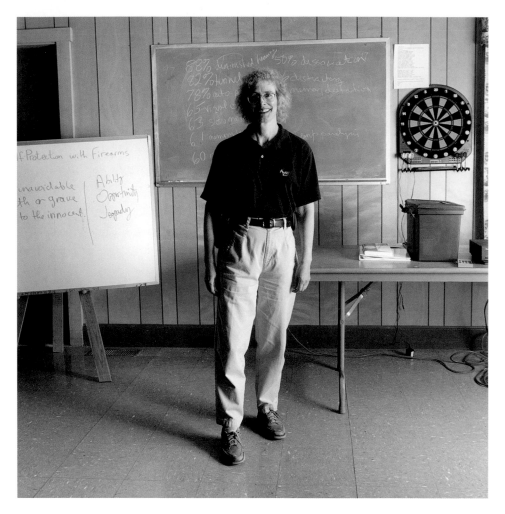

Self-defense instructor Lyn Bates with.45-caliber Colt Combat Commander/Officer's Model,
at a self-protection with firearms class hosted by Arming Women Against Rape
and Endangerment, Harvard, Massachusetts, 1998.
[Chromogenic print. Photograph by Nancy Floyd.]

view her and see what AWARE was all about. I attended one of her classes,
"Self Protection with Firearms." This was a two-day, sixteen-hour course, with
classroom activities on day one and shooting on day two. The first day covered,
among other things, the ramifications and responsibilities of armed self-defense:
what it takes to shoot someone, the effect killing a person has on the shooter's
mental state, and how to hold someone at gunpoint—all the practical sorts of
things I should know if I want to carry.

Bates understands the importance of firearms training for women who
want to use guns for self-defense because she teaches tactical self-defense classes

POWER: SELF-DEFENSE

for women who are in danger. Author of the 2001 book *Safety for Stalking Victims: How to Save Your Privacy, Your Sanity, and Your Life,* she emphasizes that even trained professionals screw up when adrenaline flows and events happen quickly. In her opinion, which is confirmed by other instructors, shooting at targets on a shooting range will not give a woman many of the skills necessary to perform under adverse conditions. "Just because you know how to handle a gun safely doesn't mean you are going to know how to shoot it accurately," she says, "and just because you know how to line up the sights and pull the trigger doesn't mean you are ready to deal with an armed confrontation. Getting appropriate training is really important. . . . A gun in the hands of someone who is appropriately trained does provide real security."[49] There are many reasons why we need training, if we plan to use our guns for self-defense purposes. I've included four here.

1. *Could I really shoot someone?* For some women, just yelling a forceful "No" is hard—I learned this while at a Paxton Quigley self-defense class in 1995. I, along with four other women, had to practice before we got it right. I'm a loud person by nature, so this surprised me. Yet, as Martha McCaughey explained in her 1997 study of women's self-defense training, a woman's inability to act out and fight back can be cultural: "Womanhood, as it is socially defined, is precisely what women must overcome when learning to fight."[50] According to McCaughey, while women are praised for their feminine, nonaggressive, polite manners, these qualities go counter to fighting back in self-defense. Accordingly, without training, I might find it difficult, perhaps impossible, to pull the trigger when in imminent danger.

. .

Women & Guns, June 1996.

[Reprint courtesy of *Women & Guns* magazine.]

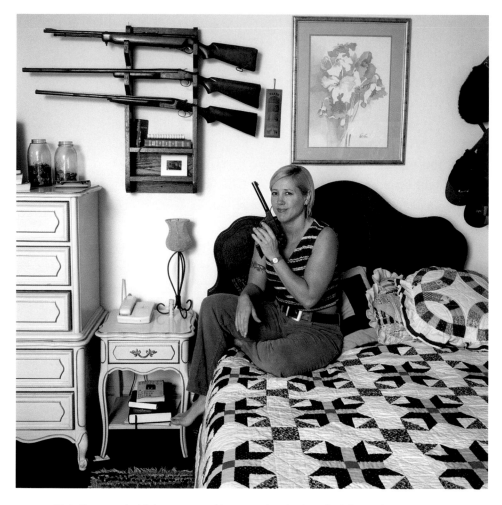

Clair Sherwood with her guns and her grandmother's quilt, Atlanta, Georgia, 1997.
Sherwood's firearms: J. Stevens 12- and 20-gauge shotguns, .22-caliber
H-D-Military, and 22.-caliber Wards Western Field no. 484.

[Chromogenic print. Photograph by Nancy Floyd.]

and shoot her. But they saw him leave, and he was tried and convicted.
He got life without parole. Well, six years later one of the witnesses died.
He appealed. He got off. Today he walks free up in those mountains.[55]

While Sherwood said she could have avenged her grandmother's murder
at any time, she contemplated what purpose this would serve now, with her
grandmother gone. "You know, I have many guns, and I could go up there and
knock on the guy's door and take him out. But what's that going to do? It's just
going to put more heaviness on my heart. My grandmother is fine, wherever

she is, and I know that man will be taken care of worse than anything I could do to him."

Even when untrained, some women are prepared to defend themselves with a gun. In 1996 I interviewed a woman who asked to remain anonymous. She had heard suspicious sounds outside her San Francisco studio late one night. Even though she had no firearms training, she loaded her uncle's .45-caliber Colt revolver.

> I moved into this studio and was here really late one night and heard a sound and got really nervous. I didn't have a phone yet, and there's only one door. So I loaded one of my uncle's guns and went out in the hall. No one was there. Not knowing much about the gun, I became preoc-cupied with how to de-cock the hammer; it was sprung really tight. As I was slowly trying to let it down, it slipped and the gun went off into the floor. I jumped about a mile. I stood there in complete horror thinking that someone was downstairs and I just shot him. But there's a photo lab downstairs, and it was two in the morning so, of course, no one was there. I just stood there shaking for a while.
>
> I really didn't have any other way to defend myself, and there was no way to call anyone. I had been raped before, and I just wasn't going to have that happen again. I remembered thinking a lot about whether I would really shoot someone. Could I really? Or am I just going to wave it around when I get out there? And I thought, well, I should at least give them a chance to run down the stairs. And, well, maybe I could try for the leg. Although I did go through these things in my mind, the reality was . . . nobody's gonna touch me. I don't give a shit if I have to fight with this gun . . . nobody's gonna touch me.[56]

Women teaching women armed self-defense has changed over the years, from Annie Oakley, to radical feminists and Black Panthers, to a full-fledged line of courses meeting a variety of needs. When the Women's Press Collec-tive published its pamphlet, feminists, lesbians, and poor working-class women had little information catering to their particular situations. Today, informa-tion about self-defense is abundant, with some gun groups taking advantage of the Internet. Take the Pink Pistols, for example. Begun initially as a local club in Boston in 2000, the Pistols grew quickly after *Newsweek* ran a story on the organization, and today the Pistols are part of an eclectic network of gun groups sending their messages via the Web. "We are dedicated to the legal,

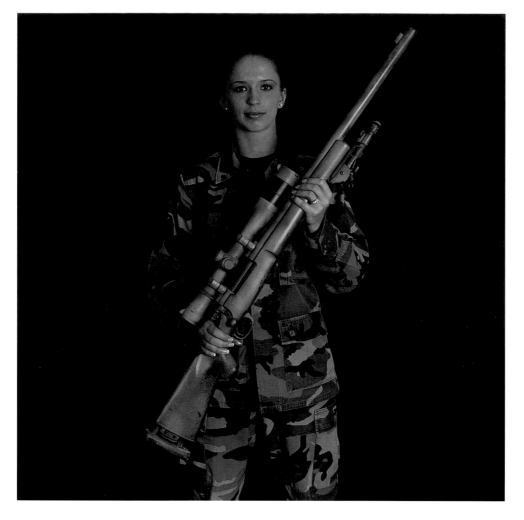

A1C Ashley-Ann Cady with M24 (Remington 700 bolt-action rifle),
Moody Air Force Base, Lowndes County, Georgia, 2006.

[Chromogenic print. Photograph by Nancy Floyd.]

Airman Cady, member of the 824th Security Forces Squadron, is the first active-duty air force female to become a sharpshooter (better known as a sniper) after completing the close precision engagement course at the National Guard Marksmanship Training Center, Camp Robinson, North Little Rock, Arkansas. Cady had completed three tours in Iraq when this photograph was made.

Cady: The rifle itself is standard issue, what sharpshooters get. But when you get it you taper it to your needs as far as sizing the butt stock, zeroing the scope. You are the one who maintains it; you're the one who does all the work on it. We do all the adjustments. If it's broken, we fix it. If it's broken and we can't fix it, we take it back to the manufacturer. So it's us, and the guy who made it.

.............................

previous page: Women's Rifle Team with Winchester Model 52 target rifles,
Reserve Officer Training Corps (ROTC) members, University of Denver, January 1952.

[Reprint courtesy of University of Denver Special Collections and Archives.]

DIRECT 6 FIRE

........................

> Growing up, I was the sneaky one, always wanted to do spy games
> and stuff like that. As I got older I was more into the FBI, CIA-
> type route. I got into high school and wanted to go to college and
> get out and do FBI or CIA, but as time went on I decided military
> would be my best option—so I could get free schooling and
> experience and have something better than someone just getting
> out of college. Came in and wanted to be a cop so I could get a
> law enforcement background. The SWATs [Special Weapons and
> Tactics] came down and it was just something that I was interested
> in—I'd never tried it before and never fired a weapon before basic.
> It was just something to try, a challenge.[1]
>
> —*Airman Ashley-Ann Cady, 824th Security Force Squadron, U.S. Air Force*

wanted to be a superhero when I was five years old. I sang the Mighty
Mouse theme song daily, while I pretended to fly through the air, sav-
ing damsels in distress from an evil villain. My earliest career choices were
Mighty Mouse, a knight, or Roy Rogers—never Dale Evans. Nothing
against Evans: she just didn't do all the things Rogers did, the things male
action heroes did—the things I wanted to do. Jimmy was thirteen and totally
immersed in Western and war movies at the time. I admired him and his cow-
boy ways. As a girl, however, even at a young age and feeling like a superhero
in my play, I knew I would never be like him.

Things are different now. Today, girls can look to their older brothers and
imagine following in their footsteps. Thanks to legislation in the 1960s and
1970s and the women who struggled to pave the way for equal rights, many
jobs requiring firearms are now open to women. Girls can grow up to be
just like their brothers—or just like their sisters. This doesn't mean the path is
smooth or easy to maneuver. In truth, there is still resistance to women work-
ing alongside men in the protective services. But professional women have
fought the battle for equal access and equal pay for a long time, and today's
recruits have their sisters' collective roadmap to guide them.

Detective Leslie Ramonas with her squad on the last day before deploying to Iraq, Salt Lake City Police Department, December 2003. Ramonas's police pistol is a Glock 9mm.

[Digital file. Reprint courtesy of Leslie Ramonas.]

surly, masculine-type stereotype who shoots from the hip with both barrels, but as she says, 'I am a lady with a gun, a police captain, mother, student, instructor—but, most of all, female.'"[10]

Today, women train in the academies with men and compete with them for jobs and promotions. This doesn't mean they're always treated equally or fairly. Bringing charges for sexual harassment or discrimination has never been easy. Because of the inherent difficulties in the legal process, many victims choose not to file a complaint or initiate a lawsuit. Some women quit, some move on, and some stick it out, hoping the problem will go away.

Detective Leslie Ramonas stuck it out and made a career in both police and armed security work. She left the U.S. Air Force in 1985 and in 1987 joined the Salt Lake City Police Department. It was a challenge for her at first, both as a rookie and as a female, but armed with her military experience and

determination, she proved herself in the line of duty and garnered respect from her peers. She's worked narcotics, vice, gangs, and patrol.

> In the beginning there were some naysayers in the Police Department but the law overruled them, and over time I eventually proved myself. I've done undercover, narcotics work that was frightening at times, I've been shot at, hit, bit, and scratched. Punched, you name it. One of my trainers told me this, he said, "If I go in and get a black eye, or a shiner, or if I go in and I get a broken nose, you better have a broken nose too." That was his philosophy. He didn't care who I was, male or female. I have lived up to that. When I lived up to that, and I did that a few times, not necessarily a broken nose, but ripped up uniform, dislocated shoulder, whatever, I was more accepted. So after going on so many calls and getting into so many fights I earned my reputation.[11]

Ramonas had worked alongside men while in the military, and she was prepared to run the gauntlet of tests put before her by her superiors and her peers. Luckily, she worked with a trainer who didn't seem to care about gender. Once women like Sampson and Ramonas infiltrated police departments and proved themselves capable and reliable, they helped break down gender barriers for the next generation of female cadets. This was Trudy Boyce's experience. Lieutenant Boyce trained at the Atlanta Police Academy in the late 1980s:

> There were only two women in my class, myself and one other woman, in a class of about thirty officers. There's a lot of diversity in the Atlanta police department, and I was one of the gang. That's part of the academy experience, that whole bonding thing—there are no differences when you put on this uniform in terms of what you do for each other. So I really enjoyed the camaraderie, the family aspect—the family feel of being a person who wears a police uniform.[12]

Taking one step at a time, women's roles evolved from the custodians of women and children, to desk jobs, to undercover work, to street policing, to lieutenant, to police chief.

As more women became crime fighters, their looks became a nonissue for practical reasons. Women were partnering with men on street patrols, and their backup ability took precedence. The performance of femininity did not elicit power and strength in women, and eventually women were given uniforms and

look like she will use her gun. Another way, as Jenkins attested, is by street manner. On the street, the officer's body posture is attentive: shoulders back, legs slightly apart, eyes looking out—observing everything. She's alert and performing a commanding authoritative posture. It's part of the training that all police officers receive at the academy. Boyce explained it this way:

> We can't do this job well, and safely, without being prepared for the unexpected. We have to be able to read people and be ready for any situation. We're taught to be aware of where people's hands are. We're taught to stand tactically so that our body, our weapon side, is facing away from people. Police officers are taught to always have their hands clear if they can, or be prepared to clear their hands so that they can get to whatever weapon is needed in a violent situation.
>
> I think the fact that we have on all this stuff—and it's mysterious to most people; they don't know what we can do and what we can't do—I think it seems intimidating. But it's not so much important to be intimidating as it is to communicate to people that we're on top of the situation, that we know what's going on, and that we're prepared to deal with whatever comes our way.

Although police officers seldom shoot their guns, they may often draw the weapon from their holster. Reasons to pull a weapon include searching an abandoned building, assisting with a warrant, or chasing after an armed suspect. In the late 1980s and early 1990s, Boyce was a patrol officer in one of the roughest neighborhoods in Atlanta. She said she drew her weapon, on average, once a night: "I would always pull a gun in a situation where I felt like there was a potential for a life-and-death situation." While

Women & Guns, January-February 2002.

[Reprint courtesy of *Women & Guns* magazine.]

.........................

researchers look to newspaper accounts, military records, and stories published by the cross-dressing women to reconstruct their history. DeAnne Blanton and Lauren M. Cook, authors of *They Fought Like Demons,* uncovered 250 women who participated in the Civil War.[17]

Women who chose to cross-dress during the Civil War had practical as well as patriotic reasons for joining up: soldiering paid very well for poor and working-class women. Like men, women provided for themselves and their families while participating in the war. Sarah Wakeman's letters make clear her reasons for joining: she enjoyed the freedom and the income obtained by cross-dressing, arming herself, and taking up a male profession. She wrote home to her family:

I can tell you what made me leave home. It was because I had got tired of stay[ing] in that neighborhood. I knew that I Could help you more to leave home than to stay there with you. So I left. I am not sorry that I left you. I believe that it will be all for the best yet. . . . When I get out of this war I will come home and see you but I Shall not stay long before I shall be off to take care of my Self. . . .

I [am] enjoying my Self better this summer than I ever did before in this world. I have good Clothing and enough to eat and nothing to do, only to handle my gun and that I can do as well as the rest of them.

I don't want you to mourn about me for I can take care of my Self and I know my business as well as other folks know them for me. I will

.........................

she's drawn her weapon many times in the past, she's never squeezed the trigger.

Although some female police officers may still experience opposition to their presence in police work, and some may still feel ambivalent about their cop role in relation to their femininity, female officers expect to have guns and to be prepared to "deal with whatever comes their way." Girls have role models unimaginable to their counterparts in the late nineteenth and early twentieth centuries, and boys, like the son of Chief Sampson, now have female heroes.

My youngest, he was seven or eight, and he would always want me to come to his school to eat lunch with him. He never wanted his daddy; his daddy's in sales, his mom was the chief of police. That was a big deal to him—he'd always pick his friends to sit around the table with us when I was there. One day we were having lunch, and I got a page. I left to answer the page, and evidently while I was gone he had informed all of his friends of what was going on. So when I got back a few minutes later he asked, "Momma, did you have to shoot somebody?" I said, "No, I did not. I just went to make a phone call." I think he was bragging to his friends, "There goes my momma again, she's going to shoot somebody."[14]

MILITARY

Like female police officers, military women fought long, hard battles for inclusion; real changes occurred only after civil and equal rights legislation was passed in the 1960s and 1970s and their work uniform, equipment, and expectations became equivalent to men's.

During American wars and the pioneer era, white Americans were frequently called upon to defend their homes—if they had one—and their country. Most white women stayed home, but a few chose to follow their men to the battlefield, performing as laundresses, cooks, or nurses. Not all women followed the path of military helpmate, however. During each war or conflict at least a few women chose not to follow the men as assistants but rather to fight alongside them. In 1782, for example, Deborah Sampson donned men's clothing and enlisted in the Continental army, serving for a year and a half without being discovered as a woman.[15] During the War of 1812, Lucy Brewer served three years as a marine, and Sarah Borginis achieved the rank of brevet colonel in the army.[16] It's difficult to estimate how many women crossed-dressed to become soldiers. Contemporary

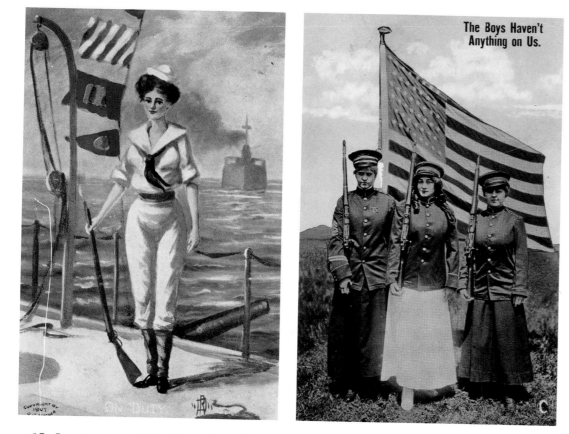

"On Duty," postmark 1908. G. C. Mather ©1907.
[Postcard, 3⅜" × 5⅜".]

"The Boys Haven't Anything on Us," no postmark, ca.
1907. The rifles are U.S. .30-caliber rifles, Model 1903.
[Real photo postcard, 3⅜" x 5⅜".]

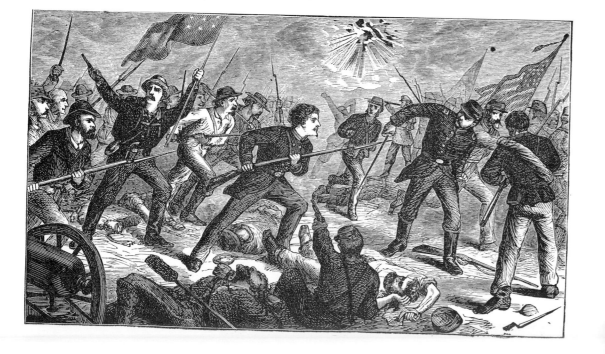

Dress as I am a mind to for all anyone else [cares], and if they don't let me Alone they will be sorry for it.[18]

Like Wakeman, Lizzie Compton enjoyed the life of a Civil War soldier. Compton was a girl who preferred male clothing and doing boy's work. Barely in her teens, she joined the Union army, passing as a boy, but was found out and discharged many times. In 1864, when she was sixteen, she was profiled in the *New Orleans Daily Picayune*. At the time, she was in jail for refusing to put on women's clothing and change her habits. She disappeared after someone posted bail. The *Picayune* article detailed her unconventional story: "This girl, familiar with the use of a musket, understands the manual perfectly, has performed picket and other duties of camp and field, and delights in the service. She recites camp incidents and scenes with the ardor of a youth of twelve, and longs to be with her old companions in arms. When asked if she had no fears, she replied that she was some 'skeered' in the first battle, but never since."[19]

Because the war was fought across civilian territory, some noncombatants armed themselves for self-defense. Female fortitude was admired, and narratives of women's exploits were printed in books, newspapers, and magazines. *Women of the War: Their Heroism and Self-Sacrifice,* published two years after the war ended, portrayed women manning cannons, defending their homes, acting as nurses, and participating in covert operations. Along with these heroics, the book's author, Frank Moore, included symbolic victories that had little or no impact on the war but that were profoundly important to the victors and created heroic legends to inspire future generations.

One such story concerns the daughters of a Mrs. Taylor of Danville, Kentucky, who had a Union flag flying over her house. A dozen Confederate soldiers arrived to take it down. Taylor's two daughters met the men at the door and declared that they would resist any attempts at removal. The soldiers returned to camp and "reported that it would require a full company to remove the flag." A captain was sent to accomplish the task, with a hundred men in support.

> The young ladies now came to the door, each armed with a revolver, and holding the glorious banner between them. They replied to the Confederate captain that they had vowed never to surrender that flag to traitors, and declared their intention to shoot the first rebel that polluted it with his touch. After hesitating a few moments, the officer withdrew his force, and reported that in the exercise of his discretion he had not found it advisable to remove the colors referred to.[20]

Legendary women of past wars lived on during this period. Revolutionary War heroine Nancy Hart's story was well known to the Confederate women of LaGrange, Georgia, some of whom took Hart's name for their group. Mrs. Leila C. Morris, a member of the Nancy Harts, recounted her personal recollections to the Daughters of the Confederacy in Atlanta on 17 December 1896. With all able-bodied men away at war, Morris thought LaGrange was vulnerable. Using humor, she described their training habits:

> We boldly marched through the streets with guns on our shoulders and banners flying. Our rendezvous was Harris' grove, where twice a week we drilled and practiced target shooting. I do not remember the exact size of our regulation target, but am quite positive it was smaller than a barn door and larger than a mustard seed. . . . After weeks of diligent practice, we became brave and indifferent to the snap of the cap, the flash of powder, the kick of the gun, and we became expert marks-women.[21]

The Nancies encountered Union soldiers toward the end of the war. Luckily for the Nancies, upon "seeing the charmingly militant array formed to meet him," the colonel in charge spared their lives and their homes.[22]

The Nancies picked up guns for a short time and dispensed with them once the war was over; and their community praised them for their bravery. This was not the case for most of the women who put on male clothing to disguise their gender and then volunteered for service. Cross-dressing women like Sarah Wakeman and girls like Lizzie Compton didn't defend their hometown while the men were away, they went off with the men to battle. And for this they had double duty—to keep from being shot by the enemy and from being exposed by fellow troops. To be caught could mean jail, being ostracized by the community, or disowned by their families. There were rare exceptions: a few women found their greatest support among the men they fought alongside, particularly later in life, when they applied for pensions.

The stakes were highest for African Americans during the Civil War. A slave's experience was conflicted, her labor passing from slave owner to Union regiment. If Union army troops overran a rebel contingent, the slaves became "contraband." As contraband, these women, men, and children traveled with the unit, assisting in the war effort by providing the same services that whites would. In 1862, fourteen-year-old Susie King Taylor was freed by Union soldiers and then spent the remaining war years traveling with a black army regiment as a laundress. Her other duties included teaching her comrades and their families to read, as well as

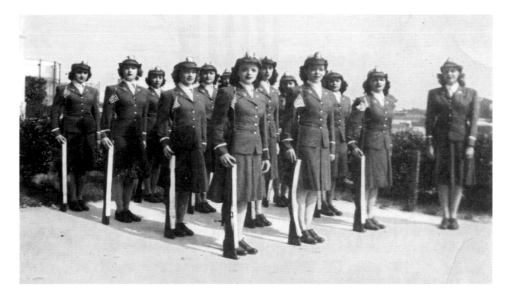

Gun drill routine with drill rifles, ca. 1940s.
[Silver gelatin print, 4 ¼" × 2 ⁷⁄₁₆".]

..........................

Subsequent wars saw even more women involved in service work. During World War II, the lack of white manpower was severe, forcing the War Department to recruit male minorities. When men of all races were sent to the front to fight, women were heavily recruited for support roles. American women were encouraged to contribute to the war effort; it was considered patriotic, honorable, and dutiful for young women to sign up for noncombat roles. For the first time, women in the military officially served in roles other than nursing. A 1944 recruitment ad in *Look* magazine stated, "I'd rather be with them—than waiting for them." A white woman is shown walking up a ship's gangplank, looking at the viewer and smiling:

> I admit there's a funny lump in my throat. But here I am, loaded with my overseas pack. Climbing up the side of the biggest boat I've seen— and glad of it. . . . For as a Wac [Women's Army Corps], I'm really working for victory. Sharing the hard parts of war. And the glory that will come. I'd rather be with him—in the Army . . . than waiting back home—thinking up things to make the time go by—listening to the news—wondering when it'll all be over.[28]

Women joined the U.S. Army, Navy, Coast Guard, and Marines. Basic training was adjusted to fit women's perceived abilities; most did not receive fire-

PROFESSIONAL: POLICE AND MILITARY

arms or firearm instruction. One exception was the Women Air Service Pilots (WASP), who were issued .45-caliber handguns so they could be assigned to duties requiring the transport of top-secret equipment when needed.[29]

Sara Chapin Winston was a WASP, although she was never assigned a top-secret task. Her letters home reveal both the tension and irony of women moving into new roles. While assigned to Mather Field in Sacramento, California, for B-25 transition training in 1943, she described her class and her training to her mother: "We're in a class with 60 boys (all officers just graduates) and of course [we] are the 1st class [of women]—so we really have to be good. They must resent us and I dont blame 'em. . . . In G/S the inst. keeps saying 'when you get to combat———'—which sounds funny to us—we're getting exactly the training they get—except bombing etc."[30] In one of Winston's letters she tells how a captain at the El Toro Marine Base in Southern California offered to let her fly F4 fighter planes if she made it down his way. "Damn but I'd like to fly fiters! [sic]" was her response.[31]

Josette Dermody Wingo joined the navy in 1944 and taught sailors how to use antiaircraft guns at Naval Station, Treasure Island, in San Francisco Bay. Wingo echoes Winston's experience of male mistrust of women in uniform. In her book *Mother Was a Gunner's Mate,* she gives an example of how another navy WAVE (Women Accepted for Voluntary Emergency Service) instructor attempted to counter the disdain some sailors felt for women as gun instructors, by answering a sailor's question without letting him get the upper hand. Wingo's friend "never lets on that she notices the guys are unhappy about a girl instructing them. Especially instructing them to shoot guns. A girl who never would see combat."[32]

By the 1960s some military women were receiving training and participating in target practice. Some even shot competitively. Sadly, what happened on the shooting range was still forced to stay on the shooting range. Former navy lieutenant Donna Dean's story is typical:

> I entered the Navy in the 1960s, and there were no objections to women learning to use weapons for target shooting or competition. So, as an Ensign, I took it upon myself to learn, and qualified at the Expert level. I qualified in the required three firings and won the permanent medal with E. It came to be that I was stationed in Washington, D.C., a few years later, and the area was subject to constant bomb threats and alerts. One night I was Duty Watch Officer for my command, and the word came down that all Duty Watch Officers in the area were to wear side arms because of large-scale bomb threats. At this time, female officers were not permit-

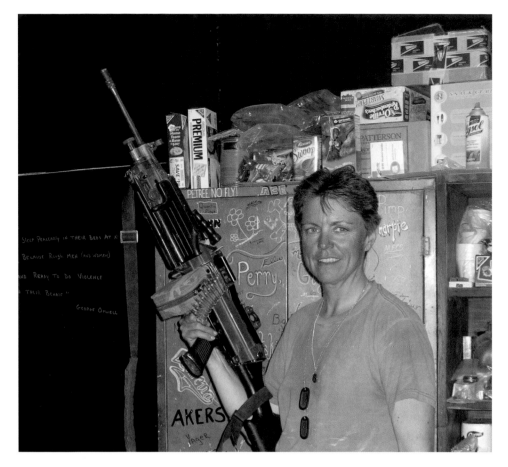

Army Reservist Sergeant Leslie Ramonas holding "the Boss," her M249 Squad
Automatic Weapon (SAW) after a long mission, ca. June 2004.

[Digital file. Reprint courtesy of Leslie Ramonas.]

her right hip; her left arm is draped by her side. A friend snapped the photo,
just as friends have snapped photos in wartime for as long as they have had per-
sonal cameras. The machine gun becomes ordinary in this picture. Ordinary—
another prop, like the crackers and cookies above her head and the names
inscribed on the locker. In the second year of the second Gulf War, Ramonas's
photograph became a typical war photograph—important only to those who
know and love her. To her right, on the chalkboard in neat handwriting, is a
quotation attributed (incorrectly) to Orwell with a glaring addition to the text:
"People sleep peaceably in their beds at night only because rough men (and
women) stand ready to do violence on their behalf. George Orwell."

Today, women join the military for many of the same reasons as their cross-
dressing Civil War sisters: to get away from home, to earn a steady paycheck, to

find job opportunities, and to have an adventure. In exchange for engaging the enemy in a firefight, some women will be allowed to advance further up the military ladder and compete for high-level positions.[47] Benefits come with a price, however—those who survive enemy fire may also suffer from battle injuries, watch comrades die, and return home suffering from posttraumatic stress disorder. America's female warriors now experience many of the same advantages and disadvantages as their male counterparts. One hundred years after the *Saturday Evening Post* editorial asked readers if they really wanted women to see battle, women are "on the battlefield and getting all shot up and torn up, and [there is] a band of vultures sitting near by waiting for [them] to lose the power of menacing motion."[48]

For the past fifty-two years a parade has officially opened the League City Village Fair in my hometown each May. I remember watching the parade each year, collecting the candy thrown by numerous folks atop floats, and gesturing for the firefighters and police officers to sound their alarms and sirens. The Clear Creek High School band participated every year, marching in formation while playing a variety of upbeat tunes. Horses were always in abundance on the parade route, with riders of all ages sitting astride their beasts. There were also beauty queens and baton twirlers, Girl Scouts and Boy Scouts, and fancy cars and fancy floats for just about every business interest in town. And there were the veterans. Some walked, some were pushed in wheelchairs, some road on floats, and some sat in cars.

As always, this year the parade begins at the League City Elementary School campus on Saturday morning at ten. The parade travels north on Kansas Street for a few blocks before turning west on Main Street. The house I grew up in, the house my parents rented from 1959 to 1979, once sat two doors east of this intersection, on the north side of Main, before it was torn down in 1998.

The last time I saw the parade was in 1997. My sister Cathy, her two daughters, and I were standing on the southwest corner of Main when the local Vietnam veterans group made its way to the corner. Parades move slowly, so the veterans stood at the corner for quite a while. We started up a conversation with one of the men Cathy knew. Once he realized that Jimmy had lived right there on Main, he told the other veterans and they asked us questions about Jim. Eventually the veterans moved on, but our loss, made new again, clouded my thoughts for a while.

Before Jimmy left home for boot camp in 1967, he prepared his guns for

heroic characters in fiction, it was only when large numbers of professional women were allowed to prove themselves in the line of duty, beginning in the 1990s, that a significant body of images and stories representing these women as brave, powerful, intimidating, aggressive, adventurous, competent—and equal to their male counterparts—began to be published. The photographs collected in this book serve as evidence of their professional achievements.

Today's professional women, especially those stationed in Iraq and Afghanistan, are having a profound impact on us. Sadly, it took war for many of us to believe in their capabilities. I'm not suggesting that their battle for parity has been won. I am suggesting that as the news reports, accompanied by positive images of women in combat and patrolling our streets, continue, it becomes more likely that the next few generations of girls who prefer physical and strategic play, and who wish to use their skills in adulthood, will demand that they be allowed to enter one of the few remaining professions currently reserved for men. As twenty-first-century girls continue to imagine and create new worlds of possibility for themselves in their play, they are preparing for a future they will help transform.

I believe that Annie Oakley would be pleased to know that, over the past century, women have proved themselves again and again with their firearms, and that, like many of us, she would be happy with the advances made by professional women. However, we must be careful not to think of such women as somehow more virtuous than men, somehow able to change the military or police force into kinder, gentler places because of our views of women as mothers and nurturers. On city streets and in combat, women with guns will battle many of the same demons as the men; and like men, some will use the authority that comes with carrying a weapon to behave dishonorably. As Oakley reminds us, "anything a man can do a woman can do practically as well." This, we must remember and must teach our daughters, applies not only to marksmanship or professional competence but to cruelty and dishonor. Even as we pursue equality for women, we must take seriously the ponderous responsibility that always comes with freedom.

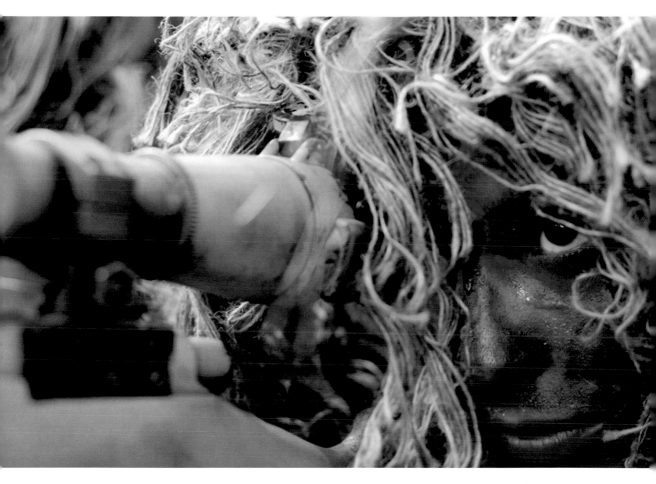

Airman Cady during training, close precision engagement course at the National Guard
Marksmanship Training Center, Camp Robinson, North Little Rock, Arkansas, 2005.

[Digital image. Reprint courtesy of the U.S. Air Force.]

. .

Cody, Wyoming; Newton M. Romig, "Annie Oakley's Patriotic Service to Be Remembered," August 1918, ibid.

8. "Not Believed Here," 13 August 1903, clipping, Garst Museum, Greenville, Ohio.

9. Riley, *Life and Legacy of Annie Oakley,* 76–83.

10. Quoted in Deborah Grace Winer, *On the Sunny Side of the Street: The Life and Lyrics of Dorothy Fields* (New York: Schirmer Books, 1997), 149.

11. Ibid.

12. Annie Oakley Foundation website, www.annieoakleyfoundation.org/.

13. "'Calamity Jane,' the Wild West's Wildest Product, Dead," *Bozeman Avant Courier,* 7 August 1903, 1–2.

14. James D. McLaird, *Calamity Jane: The Woman and the Legend* (Norman: University of Oklahoma Press, 2005), xiii. Roberta Beed Sollid, in *Calamity Jane* (Helena: Historical Society of Montana, Western Press, 1958), also took a critical look at Jane's life and the myths that surrounded her.

15. Bullwhackers are those who drive a team of oxen. Apparently oxen are ornery and drivers sometimes feel they have to whip them to get them to move.

16. According to McLaird, in the earliest newspaper report of Calamity Jane that he has found, she was seventeen years old and already drinking excessively. James D. McLaird, telephone conversation with author, 9 September 2006.

17. Calamity Jane, *Life and Adventures of Calamity Jane.*

18. "Turned Book Agent," *Helena (Mont.) Daily Independent,* 18 September 1896, 6.

19. "Calamity Jane," *Denver Daily Rocky Mountain News,* 10 June 1877.

20. Sollid, *Calamity Jane,* 22.

21. "'Calamity' Lands in Jail for Being Too Frisky," *Billings (Mont.) Gazette,* 25 November 1902, 6.

22. Richard Slotkin, *Gunfighter Nation: The Myth of the Frontier in Twentieth-Century America* (New York: Atheneum, 1992), 63–87.

23. "Calamity Jane: Deadwood Champion," *Yankton (S.D.) Daily Press and Dakotian,* 8 August 1877, 2.

24. "Calamity Jane Here," *Chicago Daily Inter Ocean,* 28 January 1896, 1.

25. It's unknown how many girls read dime novels written for boys and men, although it's likely that they had the opportunity and that some would have read and enjoyed them.

26. Quoted in "'Calamity Jane,' Wild West's Wildest Product."

27. Warren Newman, e-mail to author, 16 May 2006.

28. There are a few formal portraits of Jane in a dress in which she is posed appropriately for the times.

29. According to the Adams Museum website, Jane mostly wore dresses. http://adamsmuseumandhouse.org/store/photos_detail.php?detailid=50 17 March 2006. McLaird confirms this in *Calamity Jane,* 4–5.

30. Even the ownership of a horse in a late 1880s photograph is suspect. Roberta Sollid captions the photo "With Satan" and explains that the horse was Jane's (plate XV). On the other hand, James McLaird says that the horse was misidentified and was actually borrowed from a local cowboy (*Calamity Jane,* 182).

31. Another possibility is that the original photograph was a daguerreotype and that after a negative was made from the original, perhaps the negative was flipped before printing. I doubt this because I flipped the commercial portraits on my computer and her face doesn't appear to match correctly.

32. As mentioned above, the latest depiction of the Calamity Jane character occurs in the current HBO drama series *Deadwood.* Set in Deadwood, South Dakota, in 1876 (after Custer's defeat at Little Big Horn), this Jane is a far cry from the heroic Jane with guns drawn, sitting astride a spirited stallion with the wind blowing through her long dark hair. Not only does the *Deadwood* Jane wear a loose-fitting leather outfit designed to make the actor, Robin Weigert, "feel more mas-

culine," costume designer Katherine Jane Bryant thought "some people might think she's a man at first glance." Weigert's Jane has many weaknesses, including alcohol, and no sexual allure. In fact, Bryant puts Jane in a filthy outfit: "I wanted to show that this person hasn't taken off these clothes or taken a bath in months. I wanted the audience to almost be able to smell her." HBO online, www.hbo.com/deadwood/behind/sets_and_costumes/costumes_janeutter.html.

NOTES TO CHAPTER 4

1. "The 101 Ranch Cowgirls, Bless 'Em," in *Miller Brothers and Arlington 101 Ranch Real Wild West* (Wild West show program), 8–9 August 1915, Marland's Grand Home, private 101 Ranch Collection, Ponca City, Oklahoma.

2. Col. Prentiss Ingraham, *Buffalo Bill's Girl Pard, or, Dauntless Dell's Daring*, Buffalo Bill Border Stories, no. 77 (New York: Street and Smith, 1908), 119–120.

3. Edward Lytton Wheeler, *Bob Woolf, the Border Ruffian, or, The Girl Deadshot*, Deadwood Dick Library, no. 9 (Cleveland: Westbrook Co., 1899), 1:4.

4. Edward Lytton Wheeler, *Deadwood Dick in Leadville, or, A Strange Stroke for Liberty*, Deadwood Dick Library, no. 23 (Cleveland: Westbrook Co., 1899), 8.

5. Mrs. George Spencer, *Calamity Jane: A Story of the Black Hills* (New York: Cassell, ca. 1887; reprint, Mitchell, S.D.: Dakota Wesleyan University Press, 1978), 128.

6. Edward Lytton Wheeler, *Deadwood Dick on Deck, or, Calamity Jane, the Heroine of Whoop-Up: A Story of Dakota* (New York: Beadle and Adams, 1885), 27.

7. See Shelley Stamp, *Movie-Struck Girls: Women and Motion Picture Culture After the Nickelodeon* (Princeton: Princeton University Press, 2000); and Robert Sklar, *Movie-Made America: A Cultural History of American Movies* (New York: Vintage Books, 1994).

8. Manifest Destiny was successful, and the inference was that the "savages" were now civilized and willing to share their traditions with their conquerors. Ironically, performing in Wild West shows was one of the few ways in which Native Americans made a decent living working for the white man.

9. *Buffalo Bill's Wild West: Historic Sketches and Program* (New York: Fless & Ridge Printing Co., 1894), 23.

10. Glenda Riley covers this in great detail in *The Life and Legacy of Annie Oakley.*

11. "Western Girl Company," *Utica (N.Y.) Sunday Journal*, 11 January 1903.

12. Quoted in "Miss Lillian T. Smith, the California Girl, and Champion Rifle Shot," *Buffalo Bill's Wild West* (program guide) (London: Allen, Scott & Co., 1887).

13. Michael Wallis, *The Real Wild West: The 101 Ranch and the Creation of the American West* (New York: St. Martin's Press, 1999), 309.

14. "Miss Lillian T. Smith," *Buffalo Bill's Wild West,* 49. 15. Handwritten last will and testament of Lillian Smith, probate case #3637, Noble County, Oklahoma, photocopy in the Ponca City Library, Ponca City, OK.

16. Lillian Smith grave marker, Ponca City, Oklahoma.

17. Sklar, *Movie-Made America*, 1994.

18. "Introducing the Cast of 'The Red Glove,'" *Moving Picture Weekly,* 8 February 1919, 14.

19. "Fighting Blood," ibid., 10 November 1917.

20. Quoted in "Texas Guinan to Be Starred in Short Length Dramas Made by Frohman Amusement Corporation," *Moving Picture World,* 1 February 1919.

21. Edward Weitsel, "The Girl of Hell's Agony," ibid., 21 June 1919, 1833.

22. "The Gun Woman," ibid., 2 February 1918, 719.

23. For an excellent account of Guinan's life, see Louise Berliner, *Texas Guinan: Queen of the Nightclubs* (Austin: University of Texas Press, 1993). Her bibliography of Guinan was used extensively here.

24. Texas Guinan, "My Life—and How!" *New York Evening Journal,* 4 May 1929, 4.

How to Protect Themselves," ca.1902–8, Annie Oakley's scrapbook, Buffalo Bill
Historical Center, McCracken Research Library, Cody, Wyoming.
———, "Rifle Expert Talks of Women and Firearms," ca. 1905–8, Annie Oakley's scrapbook,
Buffalo Bill Historical Center, McCracken Research Library, Cody, Wyoming.
The Commonwealth, "Harriet Tubman," 10 July 1863, 1.
———, "Harriet Tubman," 17 July 1863, 1.
Crowther, Bosley. "'Johnny Guitar' Opens at the Mayfair," *New York Times,* 28 May 1954, 19.
———. "Musical Western Horses into Paramount with Calamity Jane Holding the Reins." *New
York Times,* 5 November 1953, 40.
Deadwood (S.D.) Black Hills Daily Times, "'Calamity Jane!' This Fearless Indian Fighter and Rover
of the Western Plains, in Deadwood," 5 October 1895.
Denton (Texas) Lasso, "Gallant Aggies Give TSCW Rifle Match," 19 April 1940, 4.
———, "TSCW Riflers Show Aggies How to Shoot the Works," 14 March 1941, 2.
Denver Daily Rocky Mountain News, "Calamity Jane," 10 June 1877.
Denver Post, "Texas Guinan, Queen of Night Clubs, Is Dead in Vancouver," 6 November 1933, 10.
Diaz, Tom. "Report Says Women, Combat, Don't Mix." *Washington Times,* 3 July 1985.
Ebert, Roger. "Alien Resurrection." *Chicago Sun-Times,* 26 November 1997.
Egelhof, Joseph. "Painful Query: Can Women Take Combat?" *Chicago Tribune,* 8 September
1976, 3.
Ehrenreich, Barbara. "Feminism's Assumptions Upended." Op-ed. *Los Angeles Times,* 16 May
2004.
Emerson, S. H., and Abby Hopper Gibbon. "For Women Police Matrons." *New York Daily Tri-
bune,* 19 January 1891, 5.
Feron, James. "West Point Women Draw Duty in Combat Branches." *New York Times,* 25 Janu-
ary 1980.
"For Home Defense: Annie Oakley Offers Services to the Government," ca. 1917. Clipping,
Annie Oakley's Scrapbook, Buffalo Bill Historical Center, McCracken Research Library,
Cody, Wyoming.
"George Washington Girls Win National Rifle Championship," 1927. Clipping, Gelman Library,
George Washington University, Washington, D.C.
George Washington Hatchet, "Women Riflers Excel as Shots: George Washington Keeps N.R.A.
Championship for Third Successive Year," 1929. Clipping, Gelman Library, George Wash-
ington University, Washington, D.C.
"Great Crowd Here to See Wild West Show," 21 July 1902. Clipping, Western History Collec-
tions, University of Oklahoma, Norman, Oklahoma.
Green, Dorothy E. "Miss Taylor Tops Shots." *Washington Post,* 22 January 1928, M19.
———. "Telegraphic Rifle Match." *Washington Post,* 18 December 1925, 18.
Greenville (Ohio) Daily Advocate, "Annie Oakley Dies Here Last Evening," 4 November 1926.
Guinan, Texas. "My Life—and How." *New York Evening Journal,* 29 April–25 May 1929.
Halloran, Richard. "Blacks and Women Find Roads for Advancement Through Life in Military."
New York Times, 26 August 1986, B24.
———. "Women, Black, Spouses Transforming the Military." *New York Times,* 25 August 1986,
A1, A14.
Hannah, Dogen. "U.S. Military Women Prove Combat-Worthy." *Detroit Free Press,* 8 April 2005.
Helena (Mont.) Daily Independent, "Her Life Has Been Wild One," 3 April 1901, 5.
———, "Turned Book Agent," 18 September 1896, 6.
Hellinger, Mark. "All in a Day." *New York Daily Mirror,* 7 November 1933, 13.
Herman, Edith. "Plebes: Separating Women from Girls." *Chicago Tribune,* 8 September 1976, 1, 3.
Hinson, Hal. "Alien 3." *Washington Post,* 22 May 1992.
Hunter, Stephen. "'Alien Resurrection': Birth of the Ooze." *Washington Post,* 28 November 1997.
James, Caryn. "Women Cops Can Be a Cliché in Blue." *New York Times,* 15 April 1990, 17.

Joliet Daily Republican, "Annie Oakley's Advice," 30 July 1904.

Kahlenberg, Rebecca R. "On the Defensive." *Washington Post,* 11 March 2005, T56.

Kihss, Peter. "Woman Sleuth Always Avoids Looking Tough." *New York World-Telegram,* 11 June 1937, 4.

Kristoff, Nicholas D. "Chicks with Guns." *New York Times,* 8 March 2002, A21.

Livingston (Mont.) Enterprise, "Calamity Is Dead," 8 August 1903, 1.

Los Angeles Daily News, "Calamity Jane Film Snubbed by Governor," 31 October 1953.

Los Angeles Daily Times, "Petticoats: First Woman 'Policeman,'" 13 September 1910, part 2.

Los Angeles Times, "First Woman 'Policeman,'" 13 September 1910, 9.

———, "Look Out: First Police Woman Is on Their Trail," 14 September 1910.

———, "Policewomen in L.A. Beat Long Odds to Gain Equal Status," 10 February 1985, Metro section, 2.

———, "Unsung Policewomen Aid Crime Prevention," 12 November 1934, 5.

McCombs, Phil. "Women See Combat Roles as Key Step to Equality." *Washington Post,* 23 December 1976, A1, A8.

McCormack, Patricia. "NOW Hails Women in Military." *Los Angeles Times,* 11 April 1980, 11F.

McDermott, Florence. "Sports in a Nutshell." *Denton (Texas) Lasso,* 14 March 1941, 2.

Meyer, Janet. "Annie Get Your Gun: Meditations on Women, Firearms, and Survival." *Village Voice,* 19 January 1993, 91, 133.

Milne, Richard. "Intimate and Surprising Fact in the Girlish Private Life of Demure Mary Louise Cecilia Guinan—Dear, Bashful 'Tex'!" *Boston Sunday Post,* 14 June 1931, 5.

Moore, Molly. "Army Opens More Jobs to Women." *Washington Post,* 15 November 1988, A17.

Morrison, Patt. "Get a Grip, Guys: This Is Fantasy." *Los Angeles Times,* 22 July 1991, 5.

Murphy, Carule. "Female Marines Get 'in-the-Mud' Field Training." *Washington Post,* 14 February 1977.

Newark (N.J.) Advertiser, "Crack Pistol Shot Ready for Robbers," 16 February 1906.

New Orleans Daily Picayune, "A Strange Story," 6 March 1864, 7.

New York Daily Tribune, "Annie Oakley Hurt in Theatre," 13 November 1902, 2.

———, "Fashion Set by President Followed by Many," illustrated supp., 1 March 1903, 2.

———, "Ladies and the Pistol," 18 February 1902, 6.

———, "Many Expert Women Riders Who Never Hesitate to Take a Six-Rail Fence in Order to Be in at the Death," 15 November 1896, 5.

———, "Miss Oakley Ties Van Allen Pigeon Shooting Oakley," 17 January 1902, 5.

———, "Officials Puzzled About Sending Her Name for National Reserve," 29 August 1906, 3.

———, "To Care for 'Calamity Jane,'" 13 July 1901, 5.

———, "Woman Police Sergeant," 29 May 1901, 5.

New York Evening Journal, "Gungirl Seized on White Way," 1 May 1929, 19.

New York Times, "'Calamity Jane' Is Dead," 2 August 1903, 2.

———, "Dr. Carver's Record Beaten," 4 April 1885, 5.

———, "Dr. Carver's Young Rival: A Twelve-Year-Old Girl Who Wants to Meet the Champion Rifle Shot," 21 August 1884, 3.

———, "Female Police Commissioner: Kansas Has One in Leavenworth, Appointed by the Populist Governor," 29 October 1893, 20.

———, "Mayor Lauds Woman For Arresting 2 Men," 18 June 1937, 23.

———, "Miss Leale at the Bisley Range," 19 July 1891, 4.

———, "Ladies Day at Creedmoor: The Directors of the National Rifle Association Entertaining the Ladies," 27 June 1878, 3.

———, "Lady Gay Shoots Pigeons: Rose Coghlan Breaks the Ladies' Record in a Ten-Bird Match," 7 May 1887, 1.

———, "A Mountain Romance," 8 April 1877, 4.

———, "Pistol Practice for Ladies," 24 September 1872, 4.

Juno, Andrea, and V. Vale, eds. *Angry Women*. New York: Re/Search, 1991.

Kasper, Shirl. *Annie Oakley*. Norman: University of Oklahoma Press, 1992.

Kelly, Caitlin. *Blown Away: American Women and Guns*. New York: Pocket Books, 2004.

Klein, Kathleen Gregory. *The Woman Detective: Gender and Genre*. Urbana: University of Illinois Press, 1988.

LeBlanc-Ernest, Angela D. "The Most Qualified Person to Handle the Job: Black Panther Party Women, 1966–1982." In *The Black Panther Party Reconsidered*, ed. Charles E. Jones, 302–34. Baltimore: Black Classic Press, 1998.

Leonard, Elizabeth D. *All the Daring of the Soldier: Women of the Civil War Armies*. New York: W. W. Norton, 1999.

Limerick, Patricia Nelson. *The Legacy of Conquest: The Unbroken Past of the American West*. New York: W. W. Norton, 1988.

Lorentzen, Lois Ann, and Jennifer Turpin, eds. *The Women and War Reader*. New York: New York University Press, 1998.

Manning, Captain Lory, and Vanessa R. Wight. *Women in the Military: Where They Stand*. 3d ed. Washington, D.C.: Women's Research and Education Institute, 2000.

Martin, Susan E. *Breaking and Entering: Policewomen on Patrol*. Berkeley and Los Angeles: University of California Press, 1980.

———. "Think Like a Man, Work Like a Dog, and Act Like a Lady: Occupational Dilemmas of Policewomen." In *The Worth of Women's Work: A Qualitative Synthesis*, ed. Anne Statham, Eleanor M. Miller, and Hans O. Mauksch, 205–23. Albany: State University of New York Press, 1988.

Martin, Susan E., and Nancy C. Jurik. *Doing Justice, Doing Gender: Women in Law and Criminal Justice Occupations*. Thousand Oaks, Calif.: Sage Publications, 1996.

May-Hayes, Gila. *Effective Defense: The Woman, the Plan, the Gun*. Seattle: Firearms Academy of Seattle, 1994.

McCaughey, Martha. *Real Knockouts: The Physical Feminism of Women's Self-Defense*. New York: New York University Press, 1997.

McCaughey, Martha, and Neal King, eds. *Reel Knockouts: Violent Women in the Movies*. Austin: University of Texas Press, 2001.

McLaird, James D. *Calamity Jane: The Woman and the Legend*. Norman: University of Oklahoma Press, 2005.

Metcalf, George R. *Black Profiles*. New York: McGraw-Hill, 1968.

Meyer, Leisa D. *Creating GI Jane: Sexuality and Power in the Women's Army Corps During World War II*. New York: Columbia University Press, 1996.

Mills, Kay. *From Pocahontas to Power Suits: Everything You Need to Know About Women's History in America*. New York: Penguin, 1995.

Mitchell, Billie. "The Creation of Army Officers and the Gender Lie: Betty Grable or Frankenstein?" In *It's Our Military, Too! Women and the U.S. Military*, ed. Judith Hicks Stiehm, 35–59. Philadelphia: Temple University Press, 1996.

Moore, Frank. *Women of the War: Their Heroism and Self-Sacrifice*. Hartford: S. S. Scranton & Co., 1867.

Morrow, Laurie, and Steve Smith. *Shooting Sports for Women*. New York: St. Martin's Press, 1996.

Munt, Sally. *Murder by the Book? Feminism and the Crime Novel*. New York: Routledge, 1994.

Nachbar, John G. *Western Films: An Annotated Critical Bibliography*. New York: Garland, 1975.

Nelson, Mariah Burton. *The Stronger Women Get, the More Men Love Football*. New York: Harcourt Brace, 1994.

Norton, Mary Beth. *Founding Mothers and Fathers: Gendered Power and the Forming of American Society*. New York: Knopf, 1996.

Payne, Charles M. *I've Got the Light of Freedom: The Organizing Tradition and the Mississippi Freedom Struggle*. Berkeley and Los Angeles: University of California Press, 1995.

Peach, Lucinda Joy. "Behind the Front Lines: Feminist Battles over Women in Combat." In *Wives and Warriors: Women and the Military in the United States and Canada,* ed. Laurie Weinstein and Christie C. White, 99–135. Westport, Conn.: Bergin & Garvey, 1997.

Penley, Constance, Elisabeth Lyon, Lynn Spigel, and Janet Bergstrom, eds. *Close Encounters: Film, Feminism, and Science Fiction.* Minneapolis: University of Minnesota Press, 1991.

Quigley, Paxton. *Armed and Female.* New York: St. Martin's Press, 1989.

———. *Not an Easy Target.* New York: Simon and Schuster, 1995.

Rapping, Elayne. "Centralizing Feminism: Thelma and Louise." In Elayne Rapping, *Media-tions: Forays into the Culture Wars,* 63–66. Boston: South End Press, 1994.

Rich, B. Ruby. *Chick Flicks: Theories and Memories of the Feminist Film Movement.* Durham: Duke University Press, 1998.

Riley, Glenda. *The Life and Legacy of Annie Oakley.* Norman: University of Oklahoma Press, 1994.

Schurman, Lydia Cushman, and Deidre Johnson, eds. *Scorned Literature: Essays on the History and Criticism of Popular Mass-Produced Fiction in America.* Westport, Conn.: Greenwood Press, 2002.

Segrave, Kerry. *Policewomen: A History.* Jefferson, N.C.: McFarland and Co., 1995.

Self, Robert O. *American Babylon: Race and the Struggle for Postwar Oakland.* Princeton: Princeton University Press, 2003.

Shirley, Glenn. *"Hello Sucker!" The Story of Texas Guinan.* Austin, Texas: Eakin Press, 1989.

Singer, Ben. *Melodrama and Modernity: Early Sensational Cinema and Its Contexts.* New York: Columbia University Press, 2001.

Skaine, Rosemarie. *Women at War: Gender Issues of Americans in Combat.* Jefferson, N.C.: McFarland and Co., 1999.

Sklar, Robert. *Movie-Made America: A Cultural History of American Movies.* New York: Vintage Books, 1994.

Slotkin, Richard. *Gunfighter Nation: The Myth of the Frontier in Twentieth-Century America.* New York: Atheneum, 1992.

Smith-Rosenberg, Carroll. *Disorderly Conduct: Visions of Gender in Victorian America.* New York: Knopf, 1985.

Sollid, Roberta Beed. *Calamity Jane.* Helena: Historical Society of Montana, Western Press, 1958. Reprint, Helena: Montana Historical Society Press, 1995.

Stamp, Shelley. *Movie-Struck Girls: Women and Motion Picture Culture After the Nickelodeon.* Princeton: Princeton University Press, 2000.

Stange, Mary Zeiss, ed. *Heart Shots: Women Write About Hunting.* Mechanicsburg, Pa.: Stackpole Books, 2003.

———. *Woman the Hunter.* Boston: Beacon Press, 1997.

Stange, Mary Zeiss, and Carol K. Oyster. *Gun Women.* New York: New York University Press, 2000.

Still, William. *The Underground Railroad.* Philadelphia: Porter and Coates, 1872.

Tonso, William. *Guns and Society: The Social and Existential Roots of the American Attachment to Firearms.* Lanham, Md.: University Press of America, 1982.

Tucker, Phillip Thomas. *Cathy Williams: From Slave to Female Buffalo Soldier.* Mechanicsburg, Pa.: Stackpole Books, 2002.

Tuska, Jon, and Vicki Piekarski, eds. *Encyclopedia of Frontier and Western Fiction.* New York: McGraw-Hill, 1983.

Viorst, Milton. *Fire in the Streets: America in the 1960s.* New York: Simon and Schuster, 1979.

Wallis, Michael. *The Real Wild West: The 101 Ranch and the Creation of the American West.* New York: St. Martin's Press, 1999.

Walton, Pamela L., and Manina Jones. *Detective Agency: Women Rewriting the Hard-Boiled Tradition.* Berkeley and Los Angeles: University of California Press, 1999.

43; ladies day, 37, 49, 158; outdoor, 39, 42;
 safety and risks, 37–38, 41–43
Single Action Shooting Society (SASS), 66–67,
 73, 223n29
slavery, 145–147
Slotkin, Richard, 89
Smith, Lillian Francis (Princess Wenona), 104–106
Sollid, Roberta Beed, 88, 92n30
Somers, Terry, 188
sports shooting, 43, 45–75. *See also* gender
 integration
Stanwyck, Barbara, 113
Still, William, 137, 146
stopping power, definition of, 35

Taylor, Helen, 56
Taylor, Suzie King, 195–196
Terminator 2: Judgment Day, 130
Texas Guinan. *See* Guinan, Mary Louise Cecelia
Texas State College for Women Rifle Team, 56,
 59–60
Thelma and Louise, 131
Tubman, Harriet, 145–147

Velazquez, Loreta Janeta (Lieutenant Harry T.
 Buford), 192–193
vengeance in fiction, justified, 99–101, 109,
 111–112, 122–125, 128
Ventriloquist's Trunk, 96

Wakeman, Sarah Rosetta (Private Lyons),
 193–194
Walcamp, Marie, 107–109
wars, in the Persian Gulf and Iraq, 202–204,
 210–211
WASPs, 199
WAVEs, 199
Weaver, Sigourney, 9, 22, 38, 125–126, 130, 163
Wells-Barnett, Ida B., 145, 147
Westmoreland, William, 202
Wilbourn, Barbara, 46
Wild West shows, 97, 102–106
Williams, Cathy, 196
Williams, Robert, 149–150
Wingo, Josette Dermody, 199
Winston, Sara Chapin, 199
Wise, Margie, 46
Wolf, Sandra, 168
Women & Guns magazine, 2, 131, 158; cover
 images, 74, 165, 190
Women Armed for Self-Protection, 156–157
women in combat roles, opinion of, 202
Women's Gun Pamphlet, 31, 137, 154–156
Women's Press Collective, 31, 137, 154–156